EVERYDAY SKETCHING & DRAWING

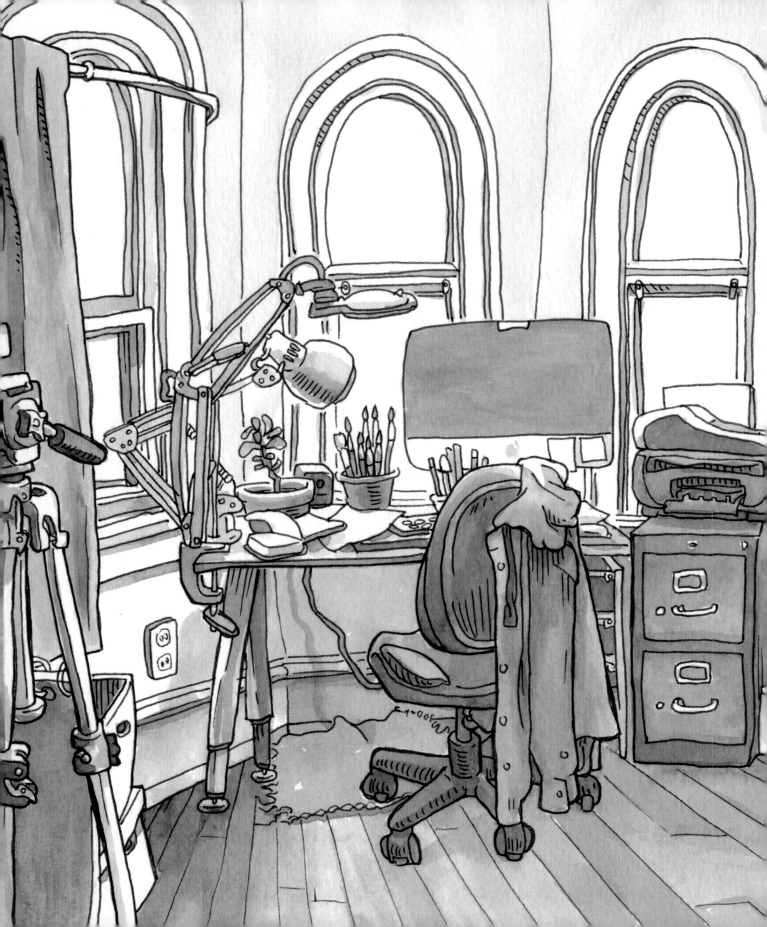

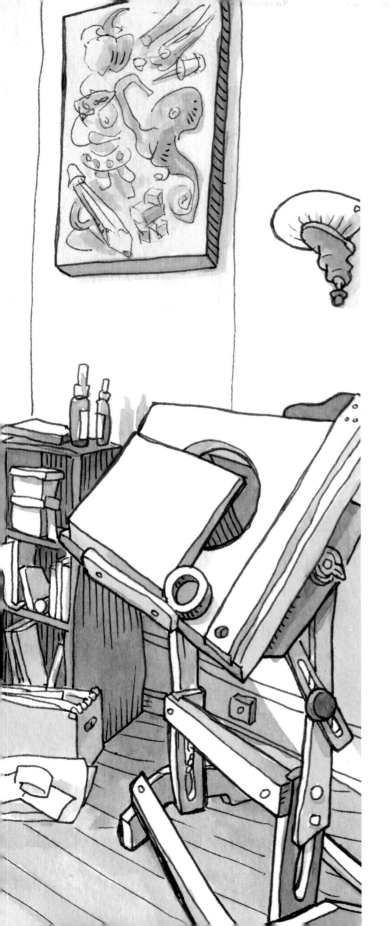

EVERYDAY
SKETCHING
& DRAWING

5 STEPS TO A UNIQUE AND PERSONAL
SKETCHBOOK HABIT

STEVEN B. REDDY

FOREWORD BY GARY FAIGIN
AFTERWORD BY STEPHANIE BOWER

MONACELLI STUDIO

Credits

PAGES 2–3: *My Studio*

PAGE 6: *Bryn's House*

Published in the United States by Monacelli Studio,
an imprint of The Monacelli Press

Library of Congress Cataloging-in-Publication Data
Names: Reddy, Steven B., author.
Title: Everyday sketching and drawing : five steps to a unique
and personal sketchbook habit / Steven B. Reddy.
Description: First edition. | New York : Monacelli Studio, 2018.
Identifiers: LCCN 2017034692 | ISBN 9781580935050
Subjects: LCSH: Drawing--Technique.
Classification: LCC NC730 .R43 2018 | DDC 741.2--dc23
LC record available at https://lccn.loc.gov/2017034

ISBN: 978-1-58093-505-0

Printed in Singapore

Design by Jennifer K. Beal Davis
Cover design by Jennifer K. Beal Davis
Cover illustrations by Steven B. Reddy

10 9 8 7 6 5 4 3 2 1

First Edition

MONACELLI STUDIO
The Monacelli Press
6 West 18th Street
New York, New York 10011

www.monacellipress.com

To all of the teachers and bosses who understand that just because
we're sketching, it doesn't mean we're not paying attention.

ACKNOWLEDGMENTS

Thanks to Gabriel Campanario, the father of Urban Sketchers (urbansketchers.org), for creating a worldwide community of sketchers who "record our world, on location, one drawing at a time," and for his personal friendship and encouragement. Thanks also to Danny Gregory, whose books about sketchbook journaling helped popularize what I once believed was my solitary obsession.

Huge thanks to Gary Faigin for founding the Gage Art Academy in Seattle, where drawing representational images from life never goes out of fashion, and to artist and teacher Stephanie Bower for her inspirational drawings and dedication to sketching by hand.

Thanks to Victoria Craven at Monacelli Press for her faith in the project and to Jenny Beal Davis for designing the beautiful book you have before you. I am also greatly indebted to my editor, Julie Mazur Tribe. In addition to the Herculean task of organizing my thoughts, she patiently helped this Luddite learn to use software that is second nature to everybody else.

Thanks to all of the artists who bravely record their personal thoughts, ideas, struggles, and embarrassments. Their candor is an inspiration. By drawing and writing my own books, I hope to uphold my humble side of the visual dialogue.

I also want to thank the public elementary students of Seattle Public Schools for being great instructors. For twenty years I've risen every morning eager to get to the classroom and have them teach me something new. It's been an adventure and a pleasure.

CONTENTS

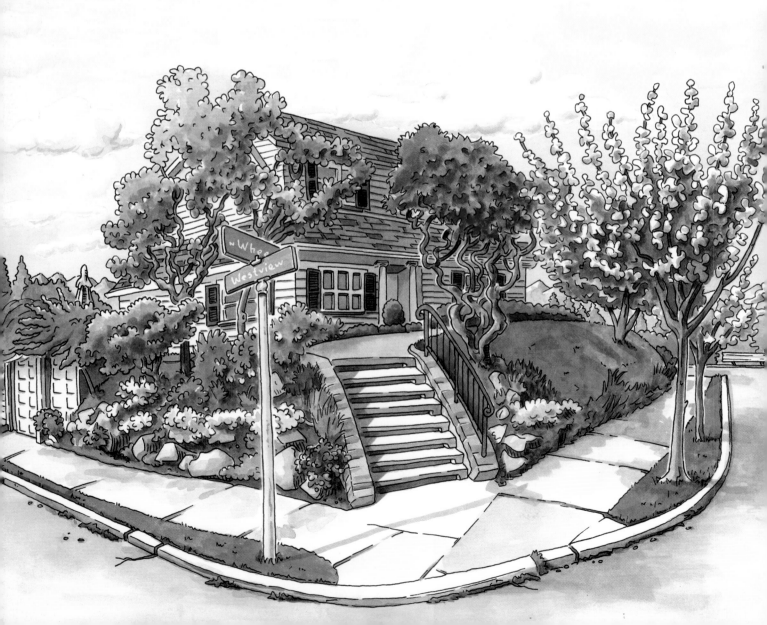

FOREWORD

Future sketchers of the world, put down your smartphones and pick up your pens! Never before have so many people been recording their homes, companions, and celebrations—but with gadgets, rather than sketchbooks. The desire to savor and preserve experience in the form of images is what Steve Reddy focuses on in this book. But if you read even a few pages and then continue relegating that task to an app, you weren't paying attention. Drawing, Steve tells us repeatedly, focuses us on the act of seeing. And no matter how many megapixels your phone might have, its circuitry does not help you learn to look, or to record your life in a personal or expressive way.

Steve starts this book by recalling the journey that energized his now-daily habit of drawing his surroundings. It turns out that one of the earliest examples we have of an artist doing the same thing is also a diary of travel studies. In the early 1500s, German painter Albrecht Dürer walked across the Alps on his way to meet Leonardo da Vinci in Italy. (They missed each other.) Looking at Dürer's drawings, one can see his obvious excitement and curiosity about the alpine landscapes and sturdy mountain villages he passed and observed for their own sake, with no overriding religious or narrative purpose. This was new in art. Similarly, Reddy finds in his exotic surroundings—statues in Bangkok, Chinese water closets, Singapore mosques—a treasure trove of fascinating, unfamiliar details, and his attention hardly wanes when he returns home. Here is the mundane and the overlooked, the sheer oddness and particularity of the coffee shop, the corner house, and the market, portrayed with respectful and fond attention, as though being seen for the first time.

Steve is also a close observer of something else besides his everyday surroundings: the way people learn. Readers will notice immediately that they are in the presence of a gifted and empathetic instructor, more than familiar with the problems and hesitations beginners like to think are unique to themselves. I've never read a how-to book that felt more like being in an actual class, with the teacher's encouraging voice in one's ear, anticipating our questions and needs. Besides a good teacher's encouragement to persist, Steve provides us all the tools we need to do so: the exact steps, equipment, paper, and even time frame (1–2 hours) that he used for most of the drawings in the book. Steve leaves nothing to chance, repeatedly showing us photos of his subject matter so we can compare them with the results.

Many people believe that drawing what one sees is a difficult, esoteric skill available only to the talented. Steve does as much to demystify and dethrone that misconception as he can fit between two covers. He makes the crucial point that you, too, can do this! And he clearly believes it, based on long classroom experience. By the time we finish the book, we do, too.

Like all born teachers, Steve shares everything and holds back nothing. He lists the challenges he has when he draws: the omissions and distortions, the necessity to depart from the real. I defy you to sketch your next set of stairs without thinking of Steve fearlessly pointing out (we wouldn't have noticed it otherwise) that his Chinese stairway accidentally terminates in mid-air. "That's the way it goes sometimes," he confesses. Soon he is exhorting us to welcome our "mistakes" as a certificate of authenticity, not a detriment.

Making art takes energy and commitment; "talent" is highly overrated. Steve role models this sort of dedication, his life literally built around drawing. At a loss for a subject? This book serves as a catalog of what to draw—namely, everything. Life happens; Steve draws it. His partner has surgery? He draws her in her hospital room. He decides to go on a diet? He draws his food as a way to motivate himself. Bathrooms are not off-limits, nor are piles of debris, cars, tools, machinery, and tangles of any sort, all of which get his pen excited.

In a way, this book is like a very clever trap, set for the student who is interested but ambivalent about getting started. One by one Steve demolishes every possible objection and hesitation. Don't have the time? He's got that one covered (page 27). Nothing interesting to draw? See my preceding paragraph, and chapters 1–10. No studio? The materials Steve describes fit in a bag or backpack, and can be pulled out in an instant (he draws while waiting in line). No ability? As Steve demonstrates, sketching in the straightforward and non-perfectionist way he describes is a door into drawing for any motivated student.

This book can also be read as a diary, as it's unusually biographical. We learn about Steve's neighborhood, his favorite joints, his family, his vehicles, his collections. The travel stories (I love the one about the Mexican guard with an AR-15) are fascinating, and tell us about Steve as an adventurer and charmer of strangers; drawing opens doors! As part of his project to get us, too, drawing our lives, Steve wants us to see how it enriches his. Every picture includes a detailed caption putting it in the context of his life. By the time we're done reading, we want to try it ourselves.

Students at Gage Academy here in Seattle can study with Steve in person; this enthusiastic, straightforward, and eminently practical book is the next best thing. Don't read it unless you're

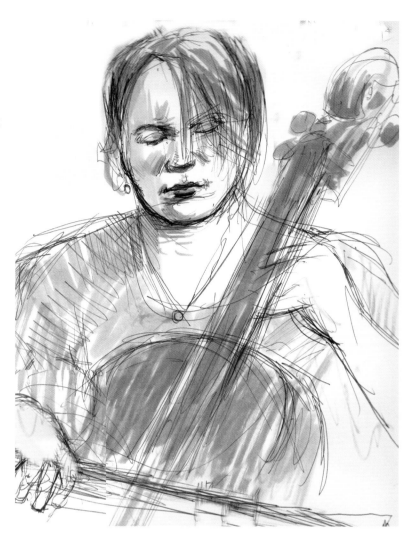

prepared to take on a new challenge in life, and leave a personal, visual record behind—but you've already made that choice, so bully for you!

<div align="right">

GARY FAIGIN

**CO-FOUNDER AND ARTISTIC DIRECTOR OF
GAGE ACADEMY OF ART IN SEATTLE, WASHINGTON**

</div>

ABOVE

One of the many, many drawings I've done while attending my son's recitals and concerts. Musicians make great models, as long as there's enough light in the auditorium to see your sketchpad.

INTRODUCTION: YOUR LIFE, YOUR DRAWINGS, YOUR WAY

"The only work worth doing—the only work you can do convincingly—is the work that focuses on the things you care about. Your job is to draw a line from your life to your art that is straight and clear."

—DAVID BAYLES, *ART AND FEAR*

"Why doesn't everybody draw all the time?"

My adult students at Gage Academy of Art in Seattle were busy sketching still lifes when I asked this question aloud. They chuckled politely and kept drawing, but I wasn't being completely rhetorical. Why *doesn't* everyone draw all the time? Because it's hard? Getting myself to the gym in the morning is hard. Carrying a sofa up four flights to my studio is hard. Drawing is merely pushing a pen around on a piece of paper! My elementary school students love to draw, so how hard can it be?

"Ah, but it's hard to draw *well*," my students might have been thinking. Well, what does it mean to "draw well"? I suspect that to most people, drawing well means drawing *like someone else*—someone whose work has been validated by those who know what good drawing is. I have degrees in art and teaching, have been drawing my entire life, and should probably know what good drawing looks like. I don't.

What I do know is what *my* drawings look like, and I came to know what my drawings look like by doing a lot of them. I have no magical talent, no special gift for drawing. But I draw every day. And I'm lazy, so if drawing were difficult, I wouldn't do it. I would rather draw than do anything else. I'd rather draw than finish writing this sentence.

OPPOSITE *Miri's Snack Shack*

Biking around Seattle on a sunny day, my partner Donna and I stopped for ice cream at this Winnebago-turned-café. You can see her in pink, sketching me as I sketched her from the shade of a nearby tree.

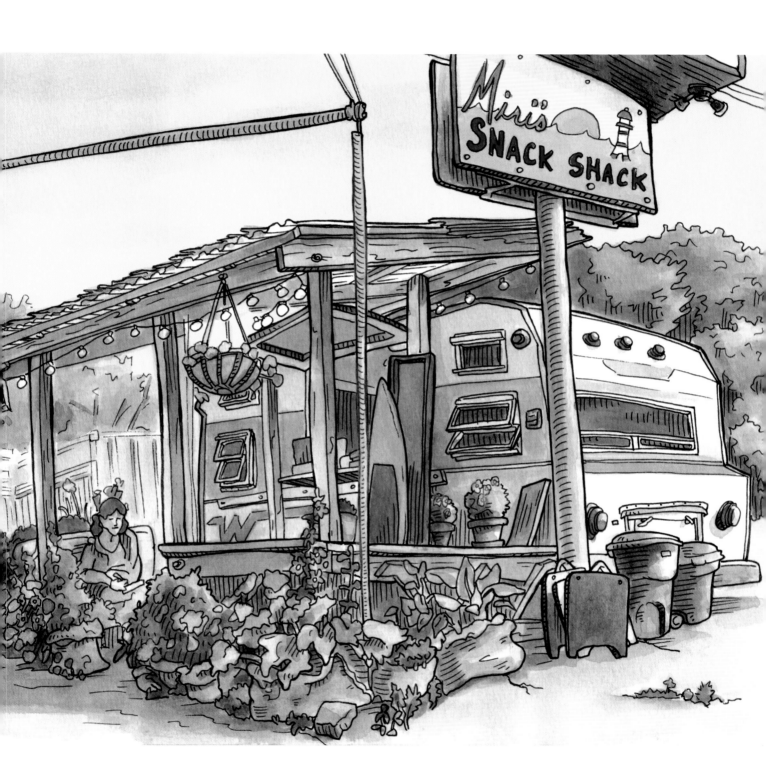

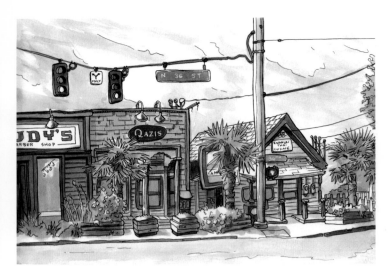

What about drawing makes it seem difficult? Perspective. Symmetry. Proportion. Realism. Accurate color. These principles and elements of drawing can be objectively judged and criticized. You can be graded on how straight your horizon lines are, how carefully you aligned your horizontals with your vanishing point, how *real* your drawings look. Concern over these academic constructs is what makes drawing feel difficult.

But these drawing conventions, much like the definitions of words, change over time. Drawing theories and styles go in and out of vogue based on opinion and consensus. If your goal is to produce art for a trend-following ad agency, or to market your work to an audience invested in these trends, this book will not be much help. You'll find no rules, no diagrams illustrating perspective and vanishing points, nothing about the Golden Mean or Fibonacci's Spiral, no tips for replicating photographic images.

Typically, what adult sketchers consider "mistakes" are the very things that make their drawings uniquely their own. Distortions and interesting variations are erased and redrawn, as if the goal is to create an image that success-fully hides any trace of the artist who made it. You have a unique and personal contribution to make. The purpose of this book is to encourage you to use everything you currently know about drawing to make the most sincere drawings you can at this point in your practice.

ABOVE, LEFT *Rudy's Barbershop*

Urban Sketchers, a growing network of artists who "sketch the world, one drawing at a time," met up one Sunday morning to capture Seattle's Fremont neighborhood. This drawing, along with most of the others in this book, was completed in less than two hours.

ABOVE, RIGHT *Glo's Coffee*

It should be apparent from this sketch that proportion, perspective, and accuracy in general are not primary concerns for me. If you draw directly without fussily erasing and worrying about the final results, you can't help but draw in a style that is uniquely yours.

OPPOSITE, TOP *Swanson's Nursery*

Your choice of subject matter reveals something about you. While my friends drew the beautiful flowers and garden decorations at this large nursery, I was drawn to the geometry and detail of the gardener's tool shed and surrounding clutter.

OPPOSITE, BOTTOM *Stimson-Green Washroom*

The Seattle Urban Sketchers met to draw the Stimson-Green Mansion, a beautifully preserved cultural landmark. With an entire mansion to draw, the room with the most interesting detail and geometry (to my eye) was the upstairs bathroom.

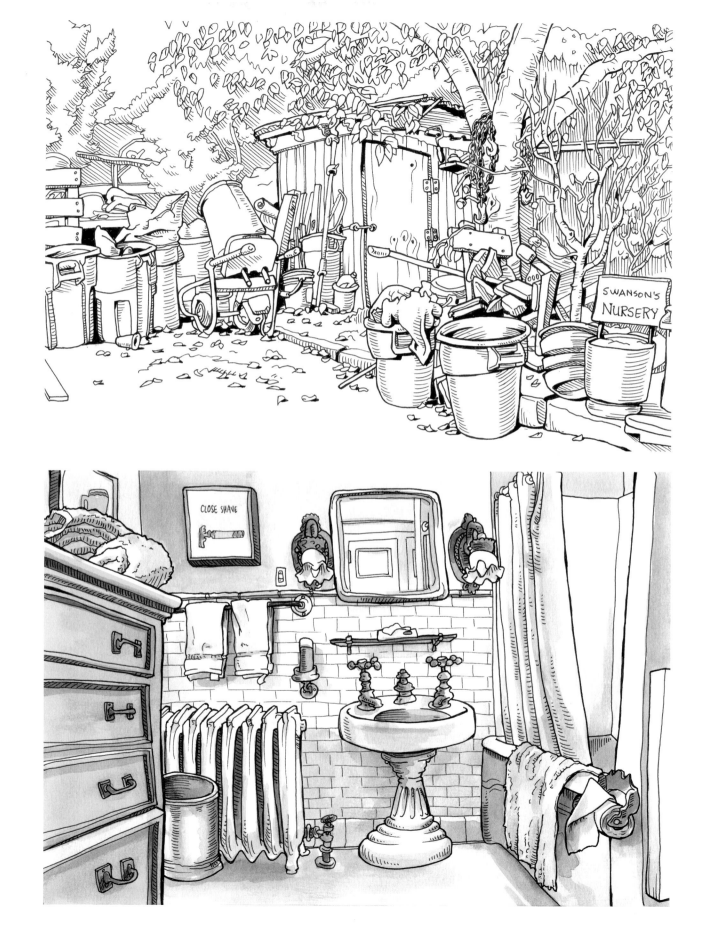

Chocolati

The cube-like solids in this drawing may appear at first glance to be drawn in perspective, but like all my sketches, it was drawn without a boring horizon line or tedious vanishing points, one box at a time.

A LITTLE BIT ABOUT ME

In high school, a friend showed me his private journal: an 11- by 8½-inch hardbound book of drawings, clippings, scripts, notes, and candid, personal musings. I was moved by his candor and excited by the potential of sketchbook journaling. I bought my own sketchbook and started writing and drawing in it. By spring the book was full, and in June I started the next one.

Those early books are rough and naive. The text is not as interesting to me now, but the early drawings still resonate. I love how the time and attention required to draw from observation captured not just the scene but, magically, the feelings I had at the time, the sounds and conversations that were the soundtrack of the drawing. You look back *into* a drawing and recall friends and experiences. I don't get that experience from a photograph. Compared to the investment of time and energy spent on a drawing (and regardless of any qualitative assessment), a photo feels as slight and impersonal as the time it took the shutter to snap.

High school sketchbooks

I still remember, decades later, what these doodles refer to: a sketch of the bench I wanted built for our high school production of *Carousel*, a tree-house inspired by a letter to my future son, a Russian church drawn on location (my first "urban sketch"), a portrait of Ray Bradbury.

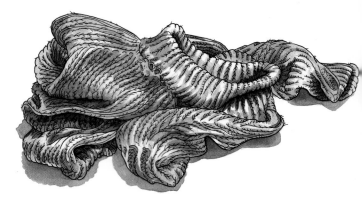

Flash forward to many years later, when I was working as an elementary school teacher in Seattle. In 2010, inspired by drawing groups such as Urban Sketchers, Everyday Matters, and the Artist's Journal Workshop, I gave up my classroom, sold my house, and moved to China to draw. Initially planning to join the Peace Corps, I received a last-minute offer to teach English in the ceramic capital of the world. The Jingdezhen Ceramic Institute provided me with room and board for as long as I wanted to stay in exchange for teaching a few hours a day. It was an opportunity I couldn't resist.

I began visually recording the experience even before I left Seattle. Rather than put my things in storage, I gave away everything but my sketchbooks. A minimalist at heart, I didn't have a lot to part with. More important to me than the objects I acquire are the people I meet, the places I visit, and the experiences I have. Still, some possessions were hard to let go of for sentimental reasons: an unraveling sweater I bought in high school, an assortment of Hawaiian shirts, several palmwood tikis. I sketched my clutter in my journals as a kind of farewell memento. Then I donated, sold, or gave it all away.

TOP, LEFT *Decluttering*

I filled several pages of a sketchbook with drawings of my possessions before I gave them all away.

TOP, RIGHT *Wool Sweater*

I bought this wool sweater when I was fifteen, for fifty dollars I'd earned bagging groceries after school in Anchorage, Alaska. I wore it for thirty-five years until it literally fell apart.

BOTTOM *Hawaiian Shirts*

These shirts were perhaps an attempt to compensate for the gloomy, overcast skies of Seattle. My fourth- and fifth-grade students liked it when I wore them in the classroom.

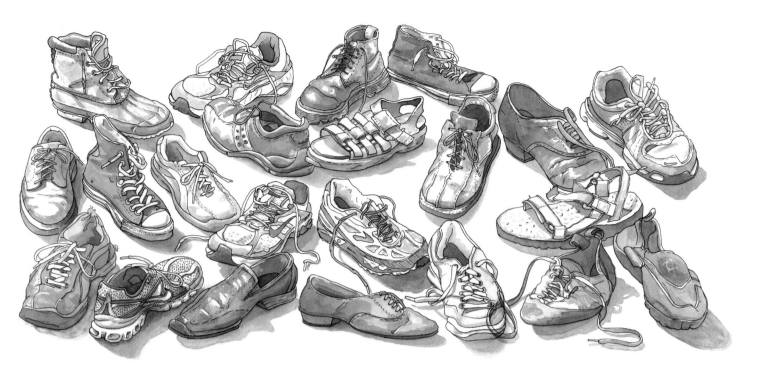

ABOVE *Shoes*

I was shocked to see how many pairs of shoes I owned. Rock-climbing, swing-dancing, snow boots, and running shoes were activity-specific, but it was hard to justify so many others. Here I've drawn only half of what I'd collected, and just one shoe from each pair!

RIGHT *Tiki Kitsch*

Remnants from my tiki-themed man-cave: mugs that came with Polynesian drinks, souvenirs from students on Hawaiian vacations, a vase that once held a gift of Lucky Bamboo, a clay vessel that was a demo from an art lesson, and a cannibal bobble-head.

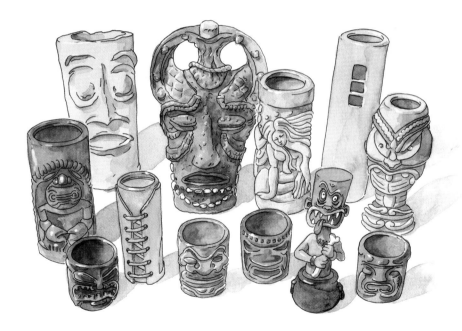

Every day at the Ceramic Institute, when I wasn't teaching English, I ventured out to draw. I filled sketchbooks with drawings of the city, pottery studios, temples, and my students' homes.

Danny Gregory, author of *An Illustrated Life*, saw my work online and invited me to contribute a chapter to his next book, *An Illustrated Journey*. This simple recognition encouraged me to keep going. I finished the term, said good-bye to my students, and left to sketch Southeast Asia. I'd brought only two suitcases for the year and still I felt over-burdened. I gave one, fully packed, to some students, and with only my sketchbook and pens, traveled to Thailand and Singapore to fill more sketchbooks.

Local Urban Sketchers groups welcomed me by organizing sketch-crawls in Bangkok and Singapore. Fully addicted to sketching, I then spent another month drawing in Mexico.

TOP *Foot Massage and Fine Dining*

Unable to read Chinese, I copied these signs as if they were abstract patterns. Then my students translated them for me in the classroom.

BOTTOM *Rainbow's Studio*

The best and most lavish meal I had in China was made by a student using only a hotplate. I drew the floor of her pottery workspace and gave her the drawing as a thank you.

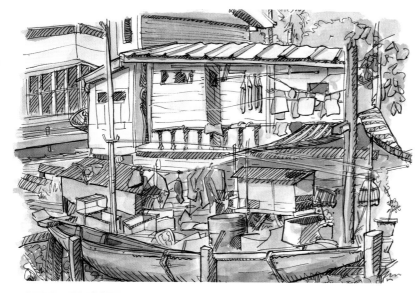

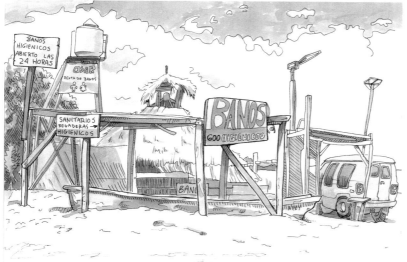

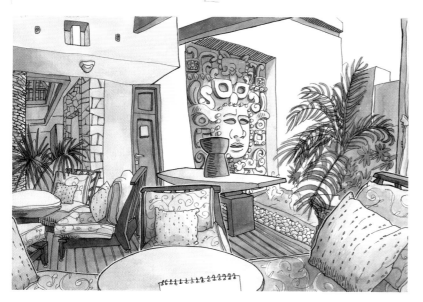

TOP *Bangkok Homes*

An avid walker, I enjoyed leisurely strolls through Bangkok's non-touristy neighborhoods, mingling with locals, losing myself in the strange and unfamiliar. It was more than one hundred degrees when I drew these waterfront homes while standing in the shade of a tree.

CENTER *Baños*

I drove a small quad onto the beach in El Golfo, Mexico, and, with my sketchbook on my lap, passed an afternoon sketching in the sun.

BOTTOM *Hotel Lobby*

In Acapulco, I got so badly sunburned that I had to stay indoors for a few days. Undaunted, I sketched the lobby of the Grand Mayan Hotel.

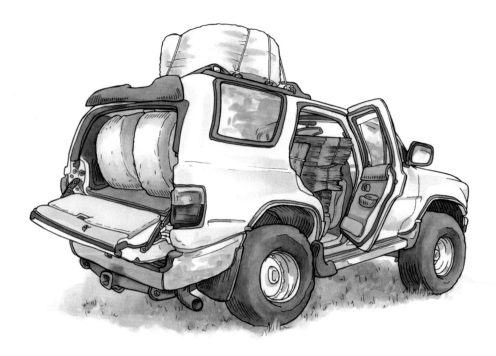

Before returning to Seattle, I bought an old car in Los Angeles and sketched all along Route 66 until I reached my birthplace near Sidney, Iowa, where I sketched for another month. Finally, I came home to Seattle with a renewed daily sketching habit that has stayed with me ever since.

It's now many years later and while I still haven't bought a new television, toaster, or leather jacket to replace the ones I gave away, in my studio is a large bookcase filled with illustrated journals. My sketchbooks are my most prized possessions, an irreplaceable and ongoing record of a life deliberately observed.

A second large bookcase in my studio is filled with the published sketchbooks of other artists, many of whom I've met on my sketching journeys. I get enormous pleasure and inspiration from looking at the personal work of others and reading about their artistic choices and the evolution of their drawings. These artists have worked hard to create and share lifetimes of drawings, for which I'm grateful.

Sketchbook journalists converse in slow motion with other artists and writers through their work. Like a message in a bottle, ideas and impressions are recorded and years later (we hope), someone gets the message. My bookshelves contain a great, complicated, and messy visual conversation. My sketchbooks are a humble effort to contribute to this sprawling visual dialogue.

ABOVE *Four-runner*
On my way home from Mexico, I bought this old Toyota for a road trip through the Southwest. (In this drawing, it's loaded with mailing supplies for shipping my soon-to-be-published journals.)

OPPOSITE, TOP *Downtown Sidney*
There's not much left of this little farming town where my ninety-seven-year-old grandmother still lives.

OPPOSITE, BOTTOM *Old Barn*
Mean green flies had me for lunch while I sat on the roof of my car and sketched this barn.

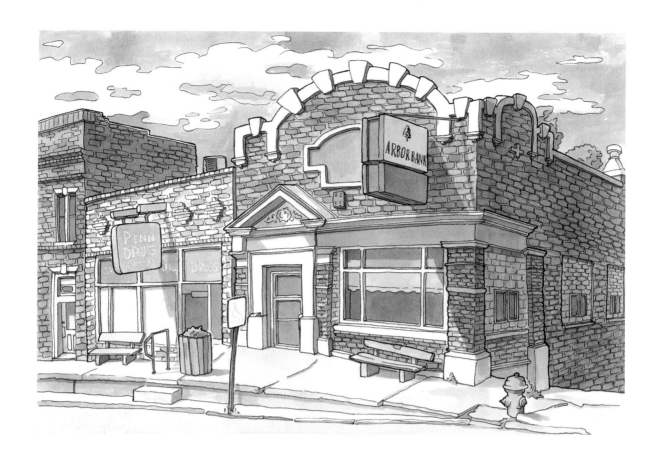

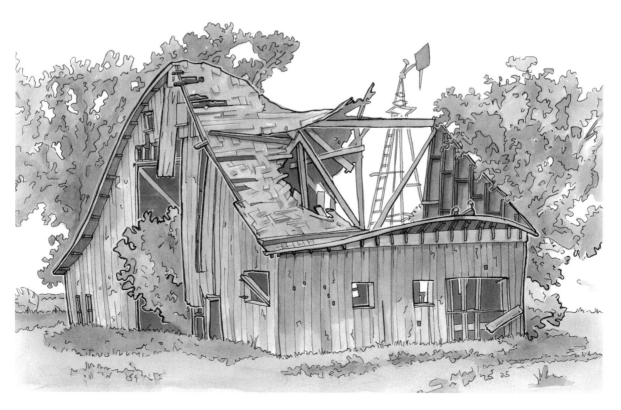

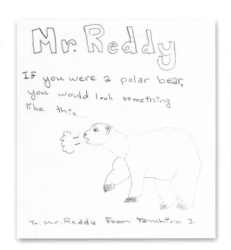

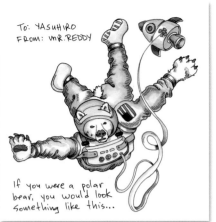

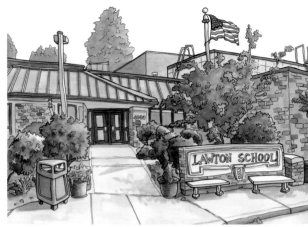

DRAWING IS FOR EVERYONE

Drawing is a universal language that spans cultures, time, and age. I've been teaching in Seattle public schools for more than twenty years and I know, from experience, that drawing can be taught just like reading and writing. A sentence starts with a capital letter and requires a subject and a verb. Words have correct spellings. Your story's protagonist needs a goal. Similarly, drawing has conventions: distant objects appear smaller than close objects. We prefer a drawing with contrast and balance. Closer objects will be more saturated and detailed than distant objects.

Every one of my elementary school students loves to draw. Each day I come home with a small stack of colorful drawings given to me by my students. They draw while I read aloud, when they finish an assignment early, or as a "free choice" activity. They are not all *gifted* students, but drawing requires no special talent or insight. The idea of talent is sort of insulting, really. "Talent" is just another word for patience and dedication. You need an open, non-judgmental vantage point, and practice.

It's easier to teach drawing to children than to adults, who tend to be more critical of their efforts. Children are enthusiastic about the process and not overly concerned about the final product. They easily part with a drawing they've just finished, even when it's quite detailed and clever. They'll hand me drawings and say, "Here, you can have this."

"Are you sure?" I'll ask. "You don't want to keep it or show your parents?"

"Nah," they'll shrug. "I'll make more."

As a teacher, I do what I can to preserve that impulse to create: the instinct to express visually the current moment.

If we simply follow the rules of "correct" drawing, our drawings will look and feel similar to each other's. What do you do *after* you've

ABOVE, LEFT AND CENTER *Polar Bears*

A visual exchange with one of the many charming and creative kids I've had the pleasure of teaching.

ABOVE, RIGHT *Lawton Elementary*

My home-away-from-home for more than twenty years.

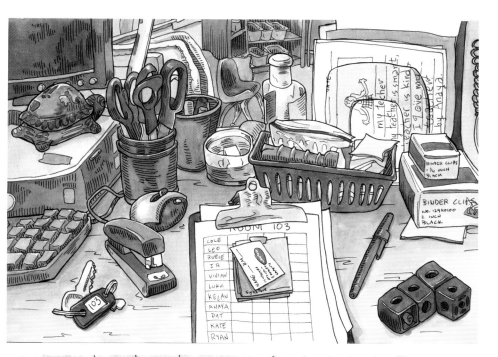

learned the rules? A glance through the drawings in this book will show I'm not interested in photorealism, or even accuracy and proportion. I want my work to reflect my character and idiosyncrasies. I'm flawed and irregular (just ask my partner). Why shouldn't my work follow suit?

Writers often break the rules of grammar and syntax, but they know the rules and break them with intent. Similarly, visual artists bend, break, or ignore altogether the conventions of perspective and proportion to suit their drawings. With practice, we can learn to manipulate these conventions intentionally to better reflect our personalities, viewpoint, and style.

Sadly, some of the most creative kids lose the impulse to draw. Worse, they learn to ignore it. A parent or friend will critique a drawing, or offer unsolicited advice about how "realistic" it looks—as if that is the point of drawing. Even

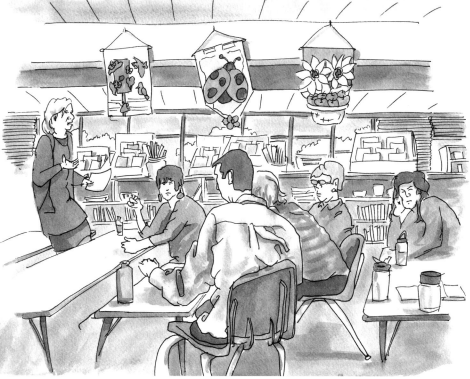

TOP *Teacher's Desk*

Although I have given up my own classroom, I still enjoy subbing for my friends and former colleagues. I drew Mrs. Hylton's desk while the kids were at lunch.

BOTTOM *Staff Meeting*

After a long day of teaching, faculty meetings were an opportunity to relax with some doodling.

well-intentioned compliments subvert the point of drawing from an activity to a result. A student will notice that his friend gets more attention for her drawings, and conclude that, by comparison, he's "not that good of an artist." When the goal shifts from playing with pictures to producing something of value, it becomes an assignment, and some students will give it up as "too hard."

To prepare creative children for the day when someone says, "That doesn't look *real*," I remind them that realism is what cameras are for. Some people forget what art is, I warn them, so don't listen.

I draw every day because I love everything about drawing: the initial idea or inspiration; the inherent potential in a new piece; the sur-

prise at seeing how the drawing resembles *and deviates from* my initial idea; the satisfaction of following through and completing a sketch; the response I get from others who enjoy looking at the work; and just as important, the personal enjoyment and satisfaction from my own work. Though my drawing approach is based on close observation, I'm less concerned with creating the illusion of reality and more interested in communicating. I draw to share the details of what I've seen and where I've been.

At the heart of this book is a five-step method for sketching any subject, whether a still life, person, or street scene. It's the same

Notes

My staff meeting "notes" were not always on point.

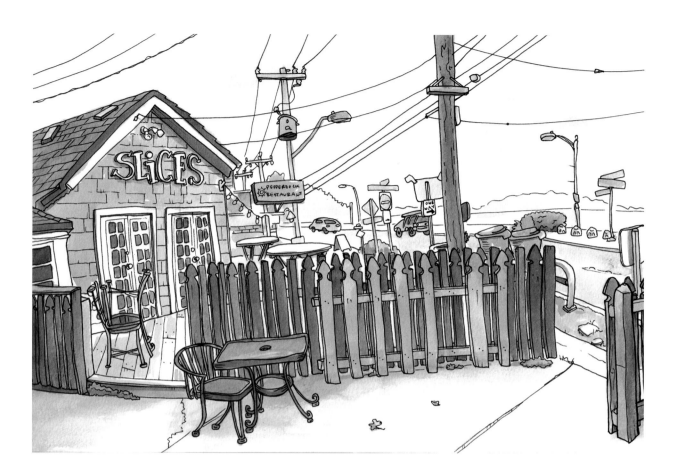

tried-and-true technique used successfully in my workshops and online classes, as well as in almost all of my own fully rendered paintings.

You may find it helpful to work through the book chronologically, following the suggestions and re-creating the demonstrations as if you were a student in my class. The lessons have been organized to incrementally build the experience and confidence needed to create personal drawings in your own unique style. And since, over the years, I've learned to anticipate most of my students' concerns and questions, I address these same questions where they are most likely to occur.

That said, you may prefer to read the entire book first before deciding which chapters inspire you or best suit your current level of experience. If you do this, remember that the goal is to put pen to paper. The sooner you dive in, the sooner you will see progress and start filling sketchbooks of your own.

My hope in writing this book is to help you get drawing soon and regularly. Starting today, I hope. If you already draw, I hope to supercharge your output the same way my favorite sketchers inspire me. I want to see your drawings. I want to peek inside your life and learn what it's like to be you. I'll show you mine if you show me yours.

Slices Pizza

On a chilly day, I sat in the comfort of a coffee shop and drew the view through the window. I enjoy the challenge of drawing whatever scene presents itself. These spontaneous drawings illustrate my days more honestly than if I hunted for sketch-worthy subjects or more staged views.

THE SKETCHING HABIT: THERE'S ALWAYS TIME TO DRAW

"We are full of reasons why painting right this very minute isn't such a good idea—the ferry is about to leave, it may rain at any moment, there's no comfortable place to sit... our brains come up with a hundred reasons not to pick up the brush."

—ELEANOR BLAIR

Before we discuss technique, I want to dispel the number one excuse potential sketchers make for not sketching: "I don't have time." You have the *interest*. (You're reading this book, after all.) You have the *ability*. (We're not compelled to pursue projects that are impossible.) Drawing can be *taught*. (I've been successfully teaching students of all ages for decades.) But yes, I understand, you are a busy, busy person.

Ready for some tough love? You're not too busy to draw. We all have exactly the same number of hours in the day. Turn off the television. Draw while you listen to podcasts. While eating lunch, draw that sandwich. If you commute to work on public transportation, draw the interior of the bus, train, or whatever vehicle you're in. Have to drive? Carpool and draw your fellow commuters. Draw the view out the window. Draw from a photo if you must, or doodle out of your imagination. Are you a list maker? Instead of writing words, draw objects to represent the to-do items. Draw during work breaks. Do you Sudoku? Work crossword puzzles? You could be sketching. How much time do you spend looking at your phone, scrolling through Facebook, or playing Words with

OPPOSITE *My House*

We don't get a lot of sunny days in Seattle, so any chance I get I draw outside. After a full day of teaching, I sat on the sidewalk and drew my home for the cover of my second memoir.

Friends? If you use that time to pay attention to your surroundings and record your life in drawings, you will soon fill a sketchbook.

We're all overbooked, in a hurry, anxious to move on to the next thing. Still, there are many times every day when we are forced to wait. Waiting is an annoyance, a necessary evil to be endured. But think about it: we simultaneously complain about not having time, and then complain when time is forced upon us! On hold with the cable company or stuck in line at the post office? Do a drawing and have something to show for your precious time. Sitting at the DMV? On jury duty? With a sketchbook at hand, you can look forward to waiting.

Even in their highly regimented and over-scheduled days, my elementary students find time to draw. On the rare days when I don't assign them time for sketching, I still come home with drawings of animals, landscapes, people, and fantasy characters to file away or display on my refrigerator. My students draw during lunch, at recess, while waiting their turn during a math game, or while having a snack.

If they can do it, so can we.

ABOVE, LEFT *Second Grade Classroom*

I love being a teacher and occasionally substitute in elementary classrooms. It's busy, exhausting work, but also fun and rewarding. While the kids are at recess, lunch, or in the gym, I relax by sketching the details of the room.

ABOVE, RIGHT *Ryan's Monster*

Students remind me every day how to draw for the sake of drawing, without judgment, joyfully lost in the moment.

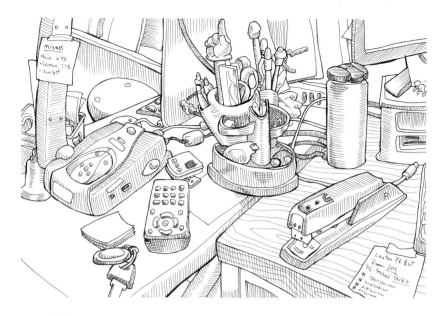

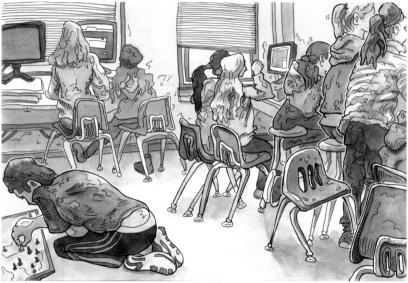

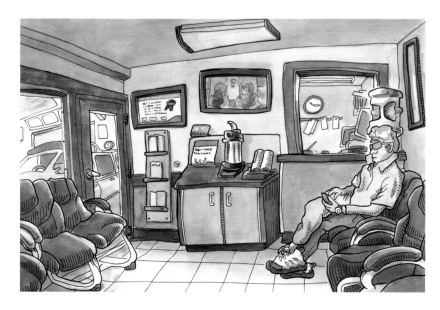

TOP *Mrs. Misner's Desk*

Drawn while the kids were at lunch.

CENTER *Moving Targets*

I thought they'd hold relatively still while using the computer lab, but these energetic and fidgety kids were a fun challenge to sketch.

BOTTOM *Jiffy Lube*

It's become something of a game to try to complete a drawing in the time it takes the mechanics to change my oil and pressure me into replacing my wiper blades.

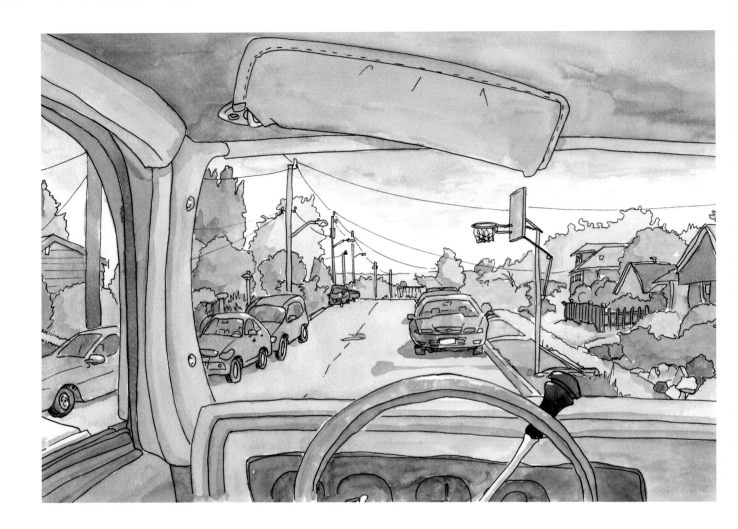

LETTING GO OF PERFECTION

The objective with these kinds of rushed, quick impression sketches is not to create a masterpiece, but to record the moment, much like a diary entry. The sketch is a by-product of paying attention to the moment. While drawing, keep your head up and your eyes on your subject. There's no information on your sketchbook page, nothing to learn by staring at the marks you've already made. When time is up, the sketch is done. Let your mantra be: "Not perfect; finished."

It used to take me a long time to find just the right spot to draw. Everything had to be right: the lighting had to be just so, the scene had to have the right amount of detail. I'd scout around, rechecking a location like a dog circling its bed before settling down. I've learned to relax and dive in. I often sketch while waiting: sitting in a car, during a lunch break, even in the dentist's office waiting for the anesthetic to take effect.

Pre-Dash Dashboard

My running partner often keeps me waiting before a race. On this particular morning, rather than impatiently tapping my foot or drumming my fingers, I came prepared to draw while I waited in my car in front of her house. Relationship counselors should encourage sketchbook journaling as a peace-keeping strategy. "Take your time, my friend. I've got a drawing to finish."

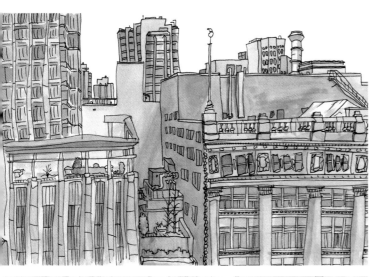

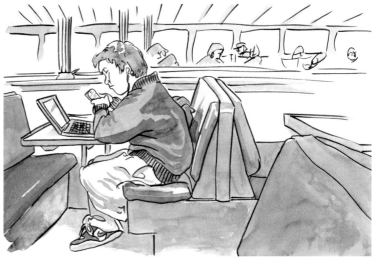

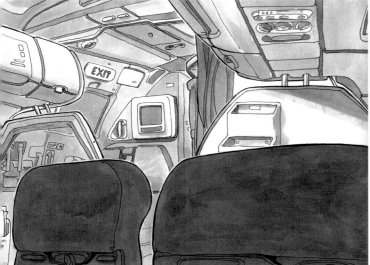

TOP, LEFT *Four Seasons View*

When it was time to check out of our hotel in Vancouver, British Columbia, I was the first one packed. I pulled a chair up to the window and drew the view while my co-travelers finished packing in peace.

TOP, RIGHT *Ferry Commuter*

This plugged-in teen had several electronic devices all going at once; I was impressed by his ability to multitask. I felt like a Luddite with my analog brush pen and old-fashioned sketchbook of plain old paper.

CENTER *In Flight*

Sketching while flying can take your mind off the cramped leg room and your neighbor's elbow hogging the armrest. Be careful, though: changing cabin pressure will cause Uni-ball ink pens to leak all over your clothes and hands.

BOTTOM *Waiting at Seatac*

This is just one of many sketches drawn while waiting at the airport. We used to see this view while waiting for a friend or loved one to arrive. Since 9/11, we only see it while waiting to board the plane ourselves.

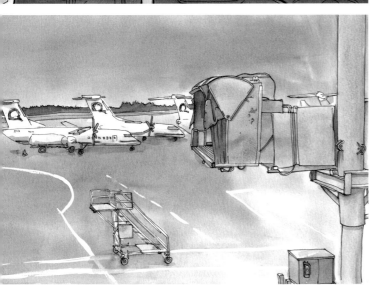

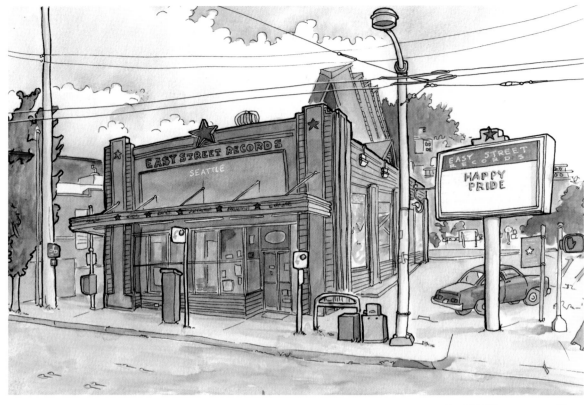

ABOVE *Easy Street Records*

Before moving to China, I sold my large collection of music CDs. It took a while for the store to go through them and come up with an offer. I waited across the street and drew the store, with my 1977 Chevy Nova visible in the parking lot.

CENTER *DDS*

BOTTOM *ENT*

I am a patient patient when kept waiting by the doctor or dentist. It can even be disappointing when they show up before I finish my sketch. I'd only completed the contour outlines of each of these exam room drawings before the doctor appeared. I had to complete them from reference photos I snapped at the end of my visits.

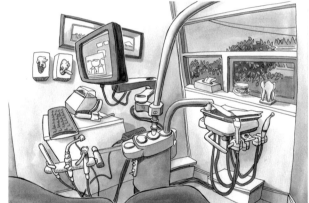

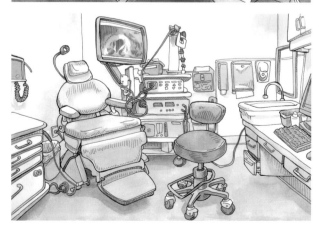

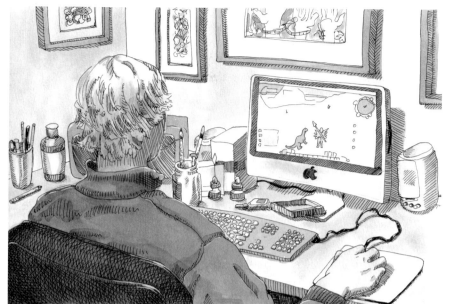

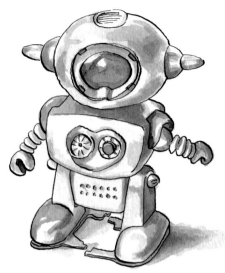

My sketchbooks include a record of what matters to me: my city, my friends, and my students. Drawings of my son, his toys, and places and activities we've shared become magic portals back to specific moments, with all the feelings and sense memories of the time spent together. The split second it takes to snap a photo can't compete with the focus and attention contained in a drawing.

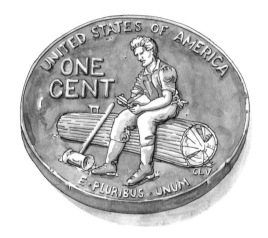

TOP, LEFT *Kalen at the Computer*

My son, Kalen, asked me to watch him play on the computer. Though I don't share his enthusiasm for video games, I was happy for the opportunity to draw him during a rare moment of sitting still.

TOP, RIGHT *Toy Robot*

Have only a few minutes? Take the micro view and draw something small and simple. This drawing is loaded with memories. Kalen grew so frustrated with this toy's programmed demands for attention that he wrapped it in a towel and buried it in his toy box.

ABOVE *Penny*

When Kalen was young, he and I were walking to the park one day with our baseball and gloves when I noticed this penny on the ground. Even without my glasses I could tell it was somehow different. "Kalen," I said, "what's the deal with this penny?"

He picked it up and looked it over. "It's brand new. 2009."

"But what's on the back?"

"Oh. It's like a... it's a lumberjack reading a book."

"What? How do you know it's a lumberjack?"

"Because he's sitting on a log and his axe-thingie is lying next to him so he can read."

"Why would he be reading?" I asked.

"What, lumberjacks can't read?"

"But what book would he be reading?"

"How do I know?" he laughed. "*Logging for Dummies.*"

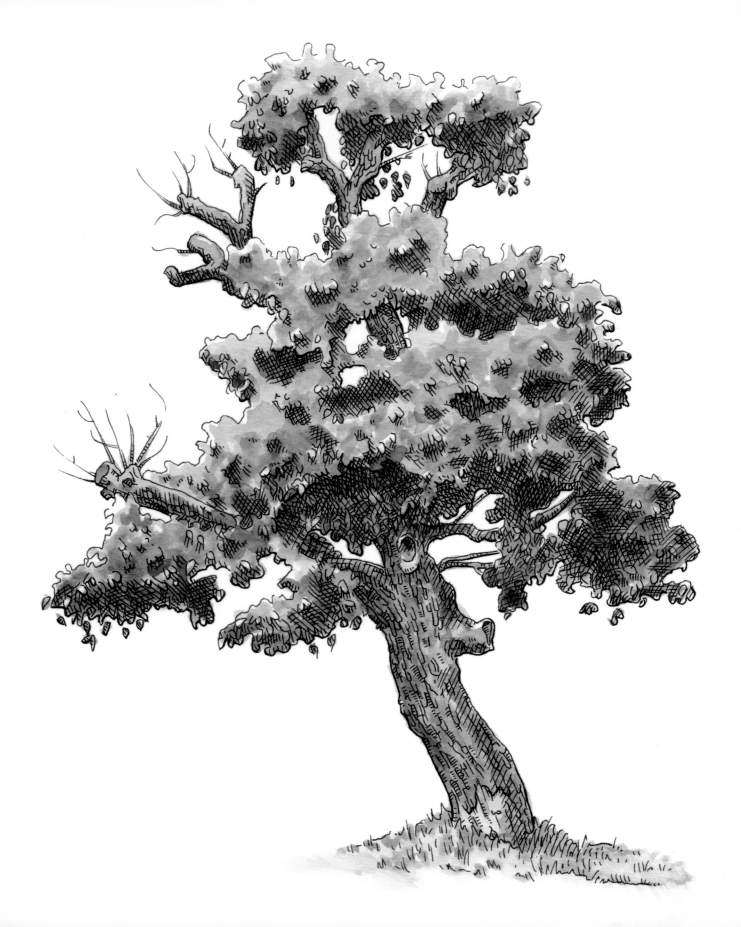

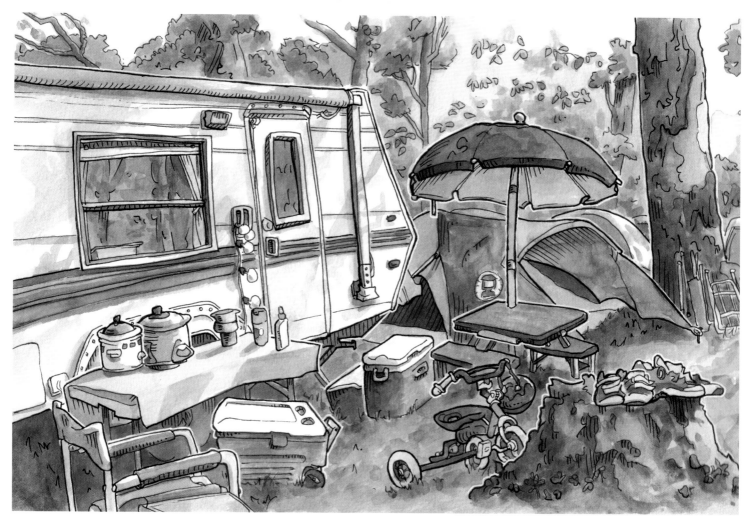

OPPOSITE *Tree*

Some of my college students in Jingdezhen, China, would join me on sketch-crawls. I sketched this tree while waiting in a park for them.

ABOVE *Family Reunion*

At our family reunion, I drew my cousin's campsite with my back to the campfire, enjoying the smell of s'mores and charred hot dogs.

RIGHT *Charles's Cameras*

While visiting my cousin Charles in Long Beach, California, I sketched his collection of old analog cameras.

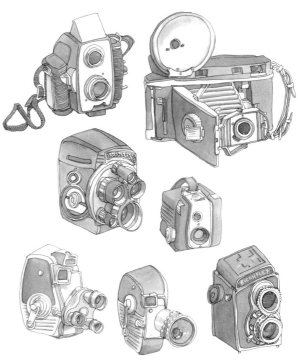

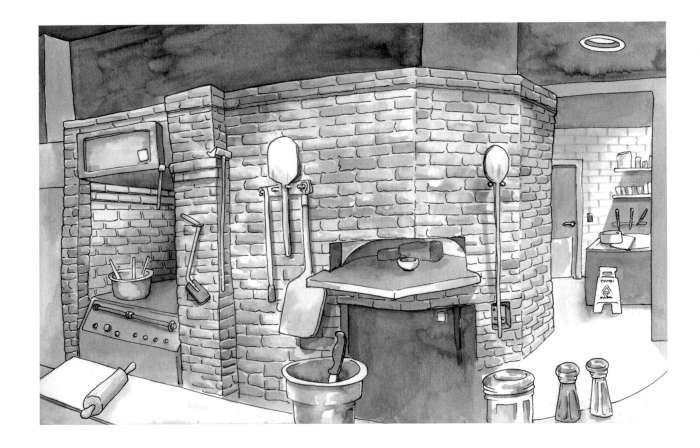

The hesitation to put pen to paper we sometimes feel is not because drawing is hard, but because we're anxious the drawing will not look the way we envision. If you judge the success of your drawing solely on how well it represents objective reality, you are negating the reason you, and not a camera, make your drawings. Embrace the deviations and you'll see that your drawing is a more accurate reflection of how you see the world. Did you draw something "too large?" That was the part of the scene that caught your attention. Did you leave something out? That's because you were not as interested in that thing. Your drawing shows what *you* were looking at. If your drawing doesn't live up to your expectations, then you are noticing that your current skill needs to

catch up to your improving ability to *see*. This is a good thing! Be surprised. Let your drawing make you laugh. Get out of the way and let the drawing be what the drawing will be. Then draw another one.

You already have the desire to draw, a personal style, and all the skills and knowledge you need to create the best work you can right now. Perhaps you have a vision of the kinds of drawings you want to make. Maybe you want to recapture the spontaneity that my students bring to drawing. Maybe you simply

ABOVE *Waiting for Dinner*

While at a local favorite restaurant, I was happy that our order took long enough to let me finish the basics of this drawing of the pizza oven. I finished shading it after dinner.

need some encouragement and inspiration. I believe—as my students demonstrate every day—that you will become more confident, more productive, and more satisfied with your drawing by embracing and expanding on your already innate, unique way of seeing and drawing.

I hope this book will inspire, encourage, and prompt you to begin (or continue) your own daily habit of drawing and sharing your unique view of the world, and I look forward to adding your book of drawings to my shelves. You'll be in great company.

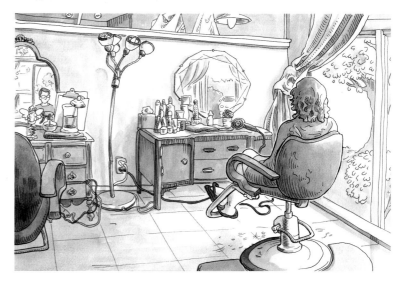

TOP *Donna's Haircut*

CENTER *Kalen's Haircut*

BOTTOM *My Haircut*

Whenever I see forlorn husbands waiting outside department-store dressing rooms or bored parents idling in their cars in front of an elementary school, I think, "They need a sketchbook." These three drawings were finished while waiting for haircuts: my partner's, my son's, and my own.

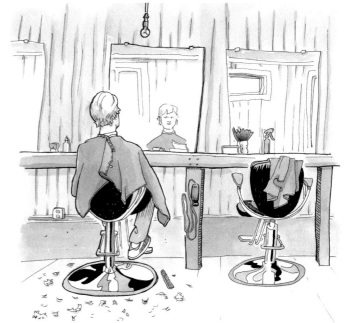

MATERIALS: IT'S NOT ABOUT THE PEN

"Oh, please do not ask me about what paints I use and which brushes I like! The art materials don't matter because art is all about relationships and harmony, which can be achieved with any paints. What matters is how you use the materials."

—ALEKSANDER TITOVETS

A lot can be written about tools and materials and still only scratch the surface of your options. A visit to any art supply store can quickly become overwhelming. Just when you get accustomed to a sketchbook or brand of ink, manufacturers discontinue your favorite products and art supply stores change their inventory.

I sketch with friends who build custom, portable travel kits out of Altoid tins and film canisters. They "MacGyver" ingenious devices for holding inks and watercolors to the edges of sketchbooks as they draw. They chat about technical pens, brands of watercolor, and the advantages of different weights of paper. They create complex charts comparing watercolor brands and build detailed graphs of pens and inks.

My own materials haven't changed much over the years, evolving only gradually on a need-to-grow basis. I'm less interested in tools than in helpful ways of seeing. The artistic principles and elements I mull over while drawing would be the same if I were scratching contour lines in sand with a stick: focus on the scene with the goal of understanding the objects and their relationships and translate them into drawings, whatever the tools. I want my drawings to say, "Look at this. We pass by or handle these objects every day until they become invisible and taken for granted. But look how interesting they are!"

OPPOSITE *My Tools*

My simple tools fit easily into a satchel, which I never leave home without. I have duplicate tools in my studio so I don't need to repack my supplies when I head out to draw.

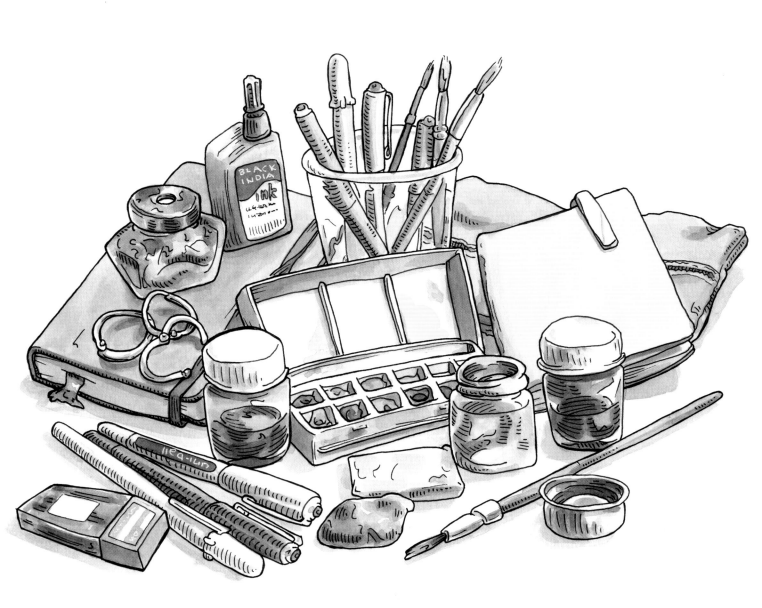

WHAT'S IN MY BAG

It helps to keep your materials simple and compact. My preferred instruments are commonly found in office supply stores or are easily ordered online. With unwieldy requirements you may be hesitant to head out. Even worse is to arrive on location and realize you've forgotten your "special" brushes or sketchbook. With a lightweight satchel or backpack always ready to go, you'll have fewer obstacles to keep you from diving in.

Here is a complete list of my favorite tools and materials. They are dependable and well-suited to the techniques described in the following chapters.

Paper

When I began sketchbook journaling, I used cheap, student-grade sketchbooks with thin nonabsorbent paper that wrinkled if I applied washes. They were the cheapest books available, and because I drew for my eyes only, it didn't matter to me that the books should last. In the margins of those early books are to-do lists, phone numbers, drafts of school assignments, and rambling diary entries. If someone asked to see them, I felt a need to read over his shoulder, ready to flip quickly past pages of sentimentality, ill-formed fantasies, regrets, and obsessions.

But when sketching became a daily habit and I began to take drawing more seriously, I wanted more robust paper. India ink washes and watercolors require heavier paper that can hold several layers of wet media. I no longer use my sketchbooks for to-do lists, financial calculations, and fretful midnight worries. Although some sketchbook journalists incorporate text with interesting results, I have separate, lined notebooks for all that.

The best paper for working with pen, ink, and watercolor is cold-press multi-purpose (or all-purpose) paper, which is a cross between watercolor paper and drawing paper. On coarse watercolor paper, the sharp nib of a pen will pull up the fibers and the line may skip and stutter across the rough paper surface. Smooth, hot-press drawing paper takes too long to dry and will not absorb the many ink washes and watercolor layers that I apply.

After experimenting with different sketchbooks and paper, I prefer Canson Montval All-Purpose spiral sketchbooks and buy them in bulk from my local art supply store. This paper is the perfect blend of absorbency and smoothness. I pull out the spiral bindings and replace them with three or four one-inch binder rings because otherwise the edge of the drawing near the binding won't lay flat on a scanner's glass plate, causing the drawing to be out of focus. The rings are easy to unsnap, so pages can be removed and scanned flat. The binder rings also allow me to swap pages and organize sketchbooks by subject. I have books that contain, for example, only still lifes, exteriors, or diary comics.

Pencils

It can be a challenge to give up a dependence on pencils and erasers but liberating when you do. The minimal pencil work we'll do will be quick and gestural and erased all at once when we finish inking. Soft leads such as a 2B or softer are easier to erase. Pencils without erasers will help you avoid the temptation to tighten up and become too fussy from the start. If you use a mechanical pencil you won't need a sharpener, but broken leads and mechanical glitches can be distracting nuisances when you're in the flow of a drawing. I like Kimberly 2B pencils by General Pencil, but I've borrowed pencils from baristas and grocery clerks in a pinch and it's made no difference.

Erasers

Kneaded erasers are soft, last a long time, and can be pulled apart into smaller sizes. (Once, while I was sketching in Acapulco, a group of local kids gathered around to watch. I gave each of them paper from my sketchbook and tore my eraser into smaller pieces for them to share.) Pink erasers dry out and leave streaks on your drawing. Vigorous rubbing wears down your paper's tooth. I like the kneaded erasers by Prismacolor.

Drawing Pens

I prefer to draw with a pen because I'm a neatnik. Graphite smears. Pastels leave colored dust on everything. Oil and acrylic need to be washed out of brushes. Drawing directly with a pen helps me be more direct and decisive. When signing a document, we don't fussily correct our signatures, and a drawing can be as personal and direct as signing your name.

The workhorse of my technique is the easy-to-find and inexpensive Uni-ball Vision pen. I buy them in bulk at office supply stores. They can even be found in some drug and convenience stores. I use the "fine" (0.7mm) point for contours and the "micro" (0.5mm) point for smaller details and hatching. The ink is completely waterproof and quick drying, which is essential for applying washes and watercolor layers over the ink lines. If you try other pens, choose carefully! There are many "waterproof" pens that are merely water resistant. Test them before committing to a long sketch by drawing a few lines and then brushing clean water across them (or just trying to smear the ink with a wet finger).

An advantage of the Uni-ball Vision pen is that the line width is uniform and consistent. A disadvantage of the pen is that the line width is uniform and consistent! Pressing harder or softer will not vary the line width, so it is not as expressive as a brush pen or dip pen with a flexible nib. However, there are ways to achieve an expressive and varied line width, which we'll go over in later chapters.

Many of my sketching friends love Micron pens, which come in many widths and colors. I find the Micron has to be held perpendicular to the page, much like a technical pen, which is not my natural grip. I suggest you try them out for yourself.

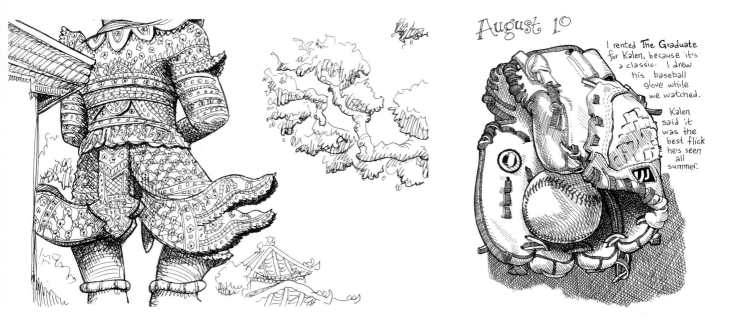

August 1º

I rented *The Graduate* for Kalen, because it's a classic. I drew his baseball glove while we watched.

Kalen said it was the best flick he's seen all summer.

TOP, LEFT *Thai Guardian*

During a brief lunch break with Urban Sketchers in Bangkok, I rested in the shade of this giant statue and quickly sketched it with a Uni-ball fine (0.7) point pen.

TOP, RIGHT *Kalen's Glove*

When my son Kalen was younger, I often sat beside him sketching while he was occupied with a book, the computer, or television. Doing a simple line drawing with only a pen allowed me to be close without juggling cumbersome materials.

RIGHT *Airport Again*

A search through the posted sketches of other Urban Sketchers reveals how much of our time is spent flying or waiting for flights.

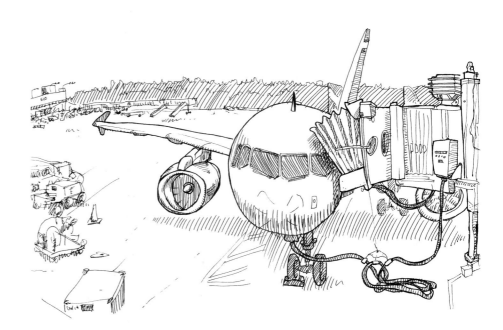

India Ink

The most important criteria for your ink is that it be completely waterproof. As with pens, many inks claim to be waterproof but are merely water resistant. You will be applying several layers of ink wash, and potentially several more layers of watercolor. If the ink is not permanent, your lines will smear and bleed.

You also want an ink that is opaque and flat black. We'll be working with two different solutions of diluted ink wash, a light wash and a slightly darker wash. In my experience, Higgins and Noodler's inks are too transparent and require too many drops of ink before you reach a mid-gray tone that's good for ink washes. My favorite inks are made by Koh-I-Noor, Staedtler (Mars), and Rapidograph.

I use ink that comes in rectangular plastic bottles with built-in eyedropper-style openings that permit you to release the ink one drop at a time, such as the India inks made for technical pens. Once you settle on a ratio of ink to water, you'll want to be able to re-create that blend quickly and consistently. Some inks come in glass jars with eyedroppers built into the caps, but these add an extra step with more potential for drips and messy spills.

Ink Wash Containers

I carry pre-mixed ink wash solutions in one-ounce glass jars with screw-on lids. You can find these online and sometimes in kitchen-supply stores, where they are sold as spice contain-ers. Plastic jars can serve in a pinch, but they tend to scratch and turn milky, and being lightweight, they are more prone to tipping over. Whichever you use, carry them inside a sealable plastic bag for extra protection. A satchel full of spilled ink is no fun!

Watercolor Brushes

I've used the same brushes for years. And by "same brushes" I don't mean the brand, but the same four or five white sable brushes! They have traveled to China, Bangkok, Singapore, Mexico, Canada, and through fifteen different states. The ink washes and watercolor layers I apply are so diluted, with such little pigment, that there is no need to wash the brushes after completing a drawing. The same brushes can be used for both the ink washes and the watercolor applications and will last for years before you need to replace them. When I finally break down and buy new ones, it's because the bristles have splayed or bent from being shoved into my satchel.

I buy white sable or nylon brushes that are reasonably priced or on sale. I like the Snap! brand and comparably priced watercolor brushes. I keep on hand at all times #2, #4, #6, and #8 brushes. I start the washes with the largest brush to cover the most area and move to smaller brushes as I add details.

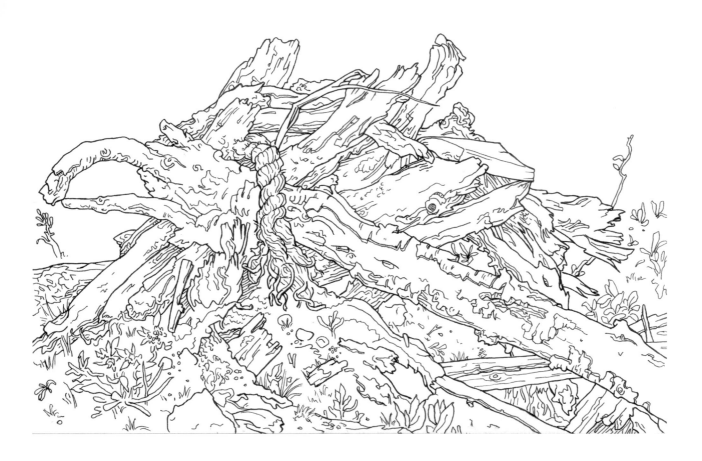

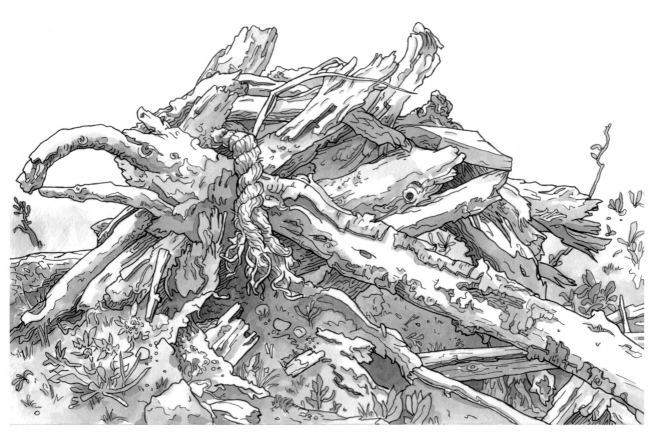

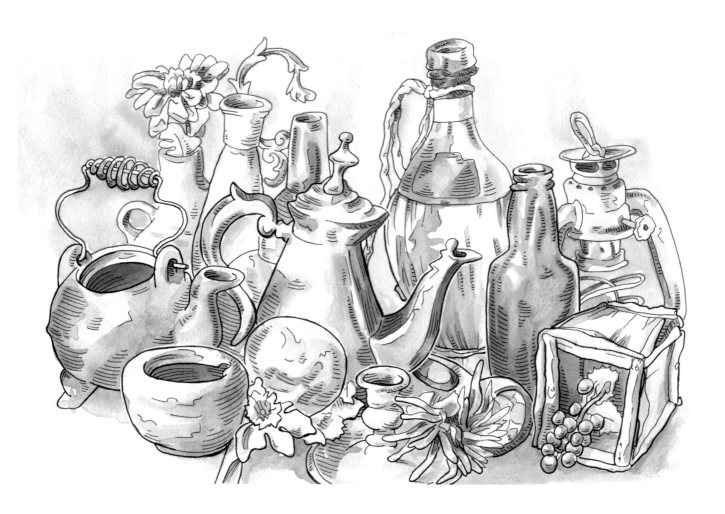

OPPOSITE, TOP *Driftwood Contour*

OPPOSITE, BOTTOM *Driftwood Wash*

Diluted India ink applied with a brush helps define the individual parts of this "found still life," a pile of driftwood found on a beach in West Seattle.

ABOVE

To help my students loosen up, I ink-washed this in-class demo entirely with my larger #8 brush. Letting the broad brushstrokes remain obvious can give your drawing a relaxed, painterly feel.

Waterbrushes

Another way to apply ink washes on location is with a Japanese waterbrush. Kuretake pens are filled by squeezing the plastic handle to create a vacuum that draws water into its tiny opening; Pentel brush pens have a wider opening. After filling the pen with water, you can squeeze in one or two drops of ink directly from your India ink bottle. Once on location, you simply brush the tones directly from the waterbrush.

While traditional brushes and jars offer finer control over blending, as well as the ability to smooth and "feather" the edges of your washes with pure water, the convenience of self-contained waterbrushes are sometimes worth the trade-off.

Brush Pens

For a more expressive line, I sometimes use a brush pen. As the name implies, the tip of this tool is a brush, which allows for a wide variety of beautifully expressive lines. Brush pens come in a variety of tones, tints, and colors. For black lines, I like the compact Pentel PocketBrush pens. I enjoy using them on careful drawings done on my desk in the studio. On location, however, with my sketchbook balanced on my lap or jostled in a moving vehicle, the line quality is more challenging to control.

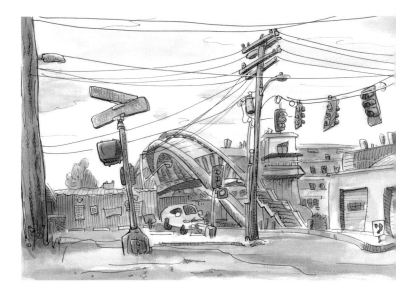

TOP *Amgen Bridge*

If you only have a few minutes, a waterbrush is a quick way to gesture in tones without messing with jars of ink.

ABOVE *Tashi Napping*

Having a solid table to rest my sketchbook on allowed me to carefully control the brushstrokes for this drawing of our cat on our unmade bed. The Pentel PocketBrush pen can make expressive lines with varying thicknesses, without the bother of dipping brushes into a jar of ink.

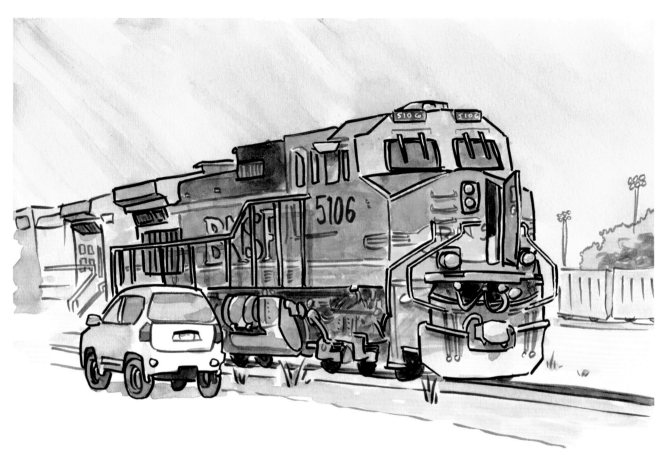

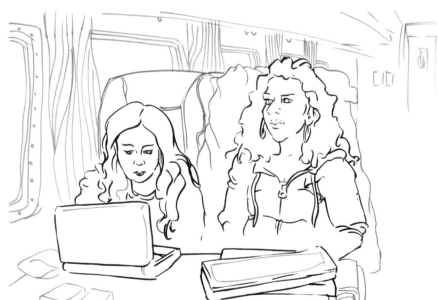

ABOVE *BNSF*

The outlines of this sitting engine were drawn with a brush pen.

LEFT *Friends on a Train*

On a train ride to Canada, I inked these contours with brush pens of different tints. Using a lighter shade of brush pen for the background suggests atmospheric perspective and keeps the focus on the mother and daughter in the foreground.

Watercolors

To stay portable, the only paint I carry is the Windsor & Newton travel set of twelve watercolors. Even these are too many, as I prefer to mix my colors from the three primaries: yellow, red, and blue. Don't ask me for specific hues. I'm so "right-brained" in my approach that I don't retain the names of the colors in my paint set. Like a musician who can't read sheet music, I "play it by ear." As certain colors run out, I use water-color sticks to replace only the colors I need. I cut off a piece the size of the empty cubical with an X-acto knife and smoosh it into place.

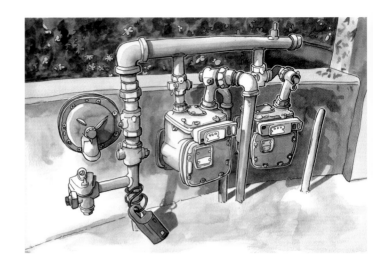

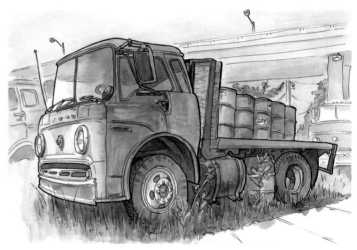

TOP, RIGHT *Plumbing Pipes*

Walking home from a day of teaching, the evening sun hit these pipes in a way that caught my eye. Another reason to keep your supplies always on hand: you never know what might present itself as a worthy subject.

CENTER *Truck Cemetery*

How realistically you apply the color will, of course, be determined by personal preference. Just as I'm not concerned with accuracy of proportion, I'm also not obsessive about accurate color. For fun, I've increased the color saturation in these neglected and rusty old trucks.

BOTTOM *House in Ballard*

This house was a commission for the homeowner by the long-time tenant. She liked the "cartoony" look she had seen in some of my drawings. That look can be determined by how much emphasis you give to black contours and saturated colors.

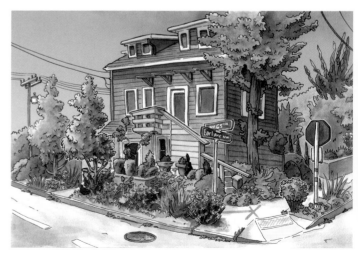

White Ink Pens

It's best to let the white of the paper show through your drawing to serve as highlights, reflections, and those rare pure white areas. Still, sometimes you'll want to sharpen a bright, shiny reflection or add white text to a dark chalkboard. In those cases, a white ink pen can be just the thing. I use white Gelly Roll pens, but be forewarned, they're temperamental and glitchy, and students are often frustrated by their inconsistent lines. Common reasons for problems include drawing on paper that is still damp, watercolor pigment buildup on the pen nib, and dried-out ink reservoirs. Pens with thicker and more opaque lines are available, but I find lines that are too obvious look gimmicky and distracting. Embrace the ephemeral nature of these pens. Ideally, the white Gelly Roll marks are integrated into the drawing so a viewer won't notice them. You'll learn to get what you need from them with practice. Better yet, let the white of the paper do the job. We'll discuss these pens more in later chapters.

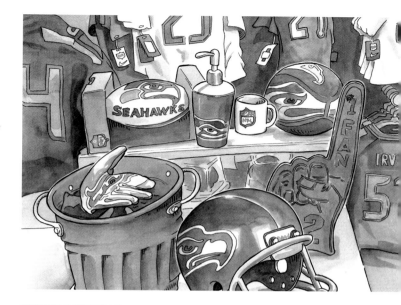

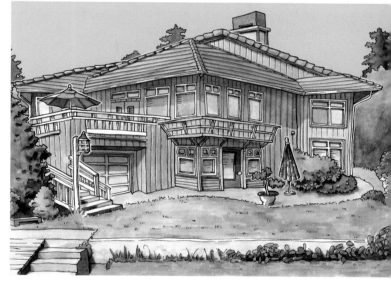

TOP *Commission for a Seahawks Fan*

Gelly Roll pens are helpful for applying or reinforcing small white details, such as the line around the Seahawks logo. They can also help separate objects from similarly toned or colored adjacent objects, as with this helmet.

BOTTOM *Lakeside House*

White gel pen highlights on the vertical slats of this house look like reflected sunlight and give this drawing some texture and architectural detail.

THE 5-STEP METHOD: GRAY DOES THE WORK, COLOR GETS THE CREDIT

*"It is equally fatal for the mind to have a system and to have none.
I will simply have to decide to combine the two."*

—KARL SCHLEGEL

My drawing method borrows from the oil painting technique of the "old masters" of the 1700s. Before applying color, entire paintings are completed in monotone, usually gray or sepia. The underpainting, or *grisaille* (French for "gray" and pronounced *greez-EYE*), lets artists model and sculpt subjects using only light and shadow. In the *grisaille* stage, one can assess the composition, balance, accuracy, and solidity of objects before dealing with color. After the monotone underpainting is complete, color is glazed on top in thin transparent layers that let the underpainting show through. I sometimes prefer the look and feel of the monotone underpainting and leave the drawing in black and white. Whether or not I take a painting to full color, all drawings pass through the fully rendered grisaille stage.

Once you've settled on a location and found a place to sit comfortably, take a minute to really look at your scene. You'll draw it in five clear, well-defined stages: quick pencil plan, contour, tone, color, and final details.

OPPOSITE *Georgetown Falafel*

Even though it was the sun shining on the bright yellow trailer that initially caught my eye, it's the contrast in the underlying grayscale drawing that makes the yellow pop.

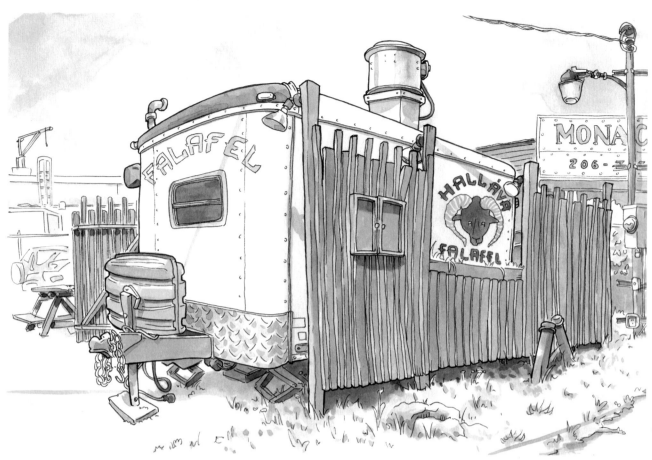

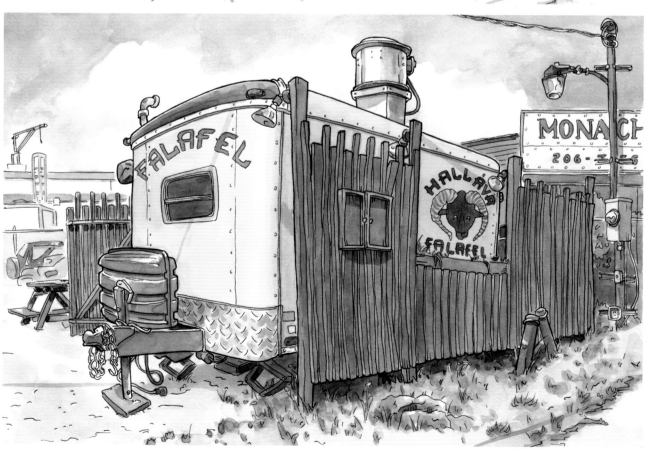

STAGE 1: QUICK PENCIL PLAN

Georgetown Falafel, pencil plan

This pencil plan for my Georgetown Falafel drawing (shown on the previous page), is a good example of seeing and penciling only the underlying geometry; most of the visible objects are boxes, cylinders, and cones. I've roughly framed each letter's location to make sure the words will fit.

Using a pencil, we start by quickly gesturing the simple geometry of only the main objects in your scene. Simplify! This is *not* a drawing. You are merely establishing the general placement of the main clusters of information. I reduce everything into generic solids: cubes, cones, cylinders and spheres. *No erasing!* There's nothing to erase because you are not, at this stage, making a drawing. You are simply noting how the sketch will fit on the page.

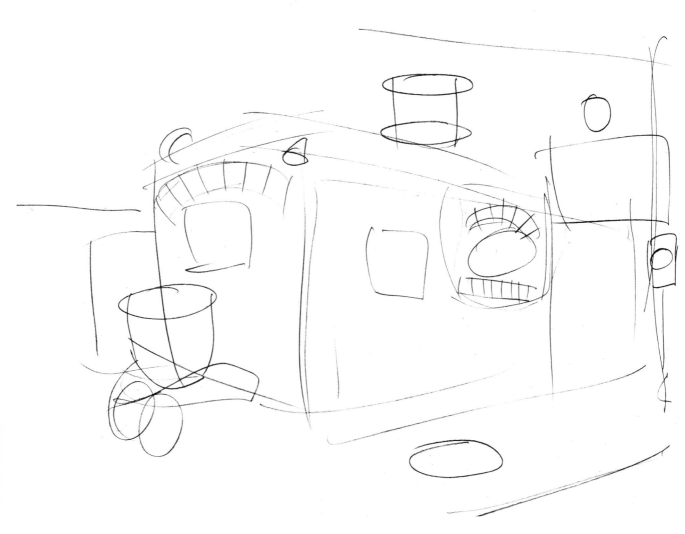

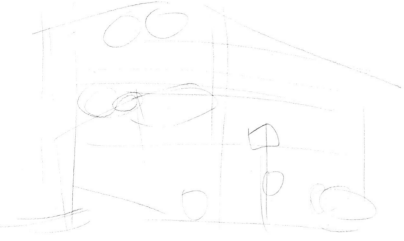

TOP *Tawon Thai*

CENTER *Tawon Thai, pencil plan*

BOTTOM *Tawon Thai Again*

In my first attempt to draw this Thai restaurant, begun without any pencil planning, the criss-crossing wires filled half the page, leaving little room for the building. This drawing is not "wrong" as it accurately reflects what caught my attention as I was drawing. For my second attempt, I spent less than thirty seconds loosely penciling (not "drawing") the major features of the scene (center). With the pencil lines as guides, it was easier to draw everything in place (bottom). I didn't trace any of the guidelines. They were simply reminders of approximately where features would be drawn.

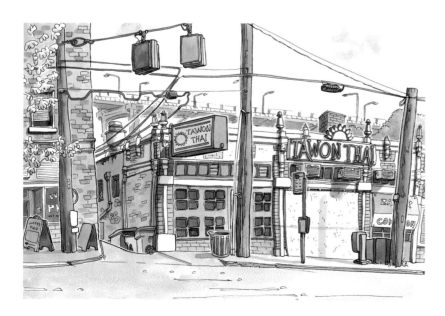

STAGE 2: CONTOUR

For our purposes, *contour lines* are the tangible, revealed edges of an object. The most obvious contour is the profile. If you place something before a white wall and project a strong light on it, the borders of the cast shadow are contour lines. Often there are interior contours as well, but be careful. It's easy to confuse the lines of surface decorations, painted designs, wood grain, and shadow edges for contours. When in doubt whether you are seeing a true contour, ask yourself if you can hide your pen tip behind it. If so, it's a contour. If not, it isn't.

I often begin by drawing contours directly in pen, not pencil, starting with foreground objects and working my way through the

BELOW, LEFT

The most obvious contour of any object is the outer profile. In this example, the opening inside the handle of the cup would be another. But what about the cup's hollow interior? You may be tempted to draw a closed ellipse near the top of the cup, as in the first example. But dip a pen into the center of the cup. Your pen tip disappears behind the rim of the cup revealing a contour edge. However, this edge is not a complete ellipse. You cannot hide your pen behind the far inner "edge" of your cup. You can hide your pen behind the cup entirely, but that only reveals the outer contour we've already drawn.

BELOW, RIGHT *Acapulco Beach Contour*

If you draw only legitimate contours, even complex features like sand, grass, and bark are reduced to a few helpful details. In this drawing, the rough bark of the trees was peeling away, creating contour edges you could literally reach inside. But in general, avoid the temptation to depict every detail with contour lines. Trust the process. The tone and color stages will help clarify what things are.

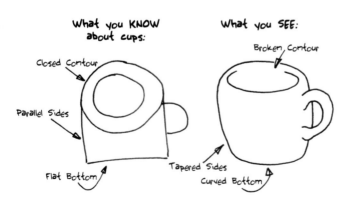

middle ground and then background. Without the ability to erase, every mark is a commitment. Erasing and redrawing lines will kill the spontaneity and joy of sketching, robbing you of the expressive lines that only happen when drawing directly from observation. If you start the sketch by being tight and fussy, it will feel like work. And when drawing feels like work, you do less drawing. Naturally, distortions and inaccuracies will appear that can't be corrected. If these deviations from photorealism bother you, it's a good indication that you're being too goal oriented.

Keep in mind that drawing is primarily observation and spend more time with your eyes on your subject and less time looking down at your drawing. The information, after all, is out there in the real world before you, not on your paper. I like to let a sketch develop on its own, without a lot of micromanaging. The more conscious input I give a drawing, the less surprising it is. It's fun to get out of the way and watch it unfold.

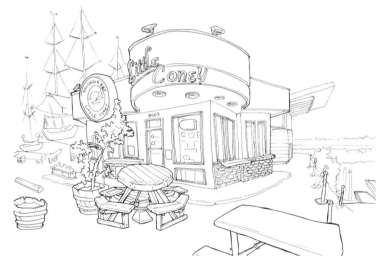

TOP *Baltimore Harbor*

Eager to explore the city, I didn't want to invest a lot of time on one drawing. This quick, wobbly ink sketch served a purpose. In just a few minutes I knew the harbor better than I would have after snapping a photo.

BOTTOM *Coney Café*

I was biking on a rare sunny day in Seattle. When we stopped for ice cream, I quickly inked this contour drawing without using a pencil. It was a fun challenge to draw the round table without being able to erase.

STAGE 3: TONE

"Black and white does the work, but color gets the credit." I first heard this phrase from a painting instructor whose work I admire. It's such an important concept that I repeat it often in my own classes. The grisaille underpainting is the key to creating the illusion of depth and solidity. The finished grisaille stage is often so satisfying that many of my drawings remain grayscale.

I use watercolor brushes to apply thin layers of diluted India ink in three discreet passes. The first wash is approximately 20 percent black and is applied with a #6 or #8 round brush everywhere that is not pure white. The goal of the first wash is not to paint shadows, but to expose the highlights. For any reflections or visible light sources to appear white or high-lighted, the rest of the drawing needs to have relatively darker tone.

The second layer of ink wash, still using the 20 percent gray, defines the objects' solidity, their core shadows, and the cast shadows around the objects in the scene. This second layer is more specific, and is applied only within the bounds of the first ink wash to darken the shadows.

The third and final ink wash is applied within the bounds of the second wash, using a slightly darker wash. The goal is to darken the recesses and concavities and increase the contrast in the drawing.

Try to give equal representation to all five gray tones from the grayscale shown above. Approximately 20 percent of your drawing

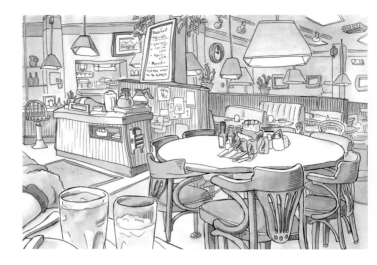

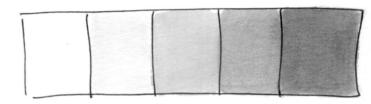

TOP *Vera's Diner*

Drawn after breakfast one Sunday morning. You can just see my partner's elbow on the far left. She was drawing me as I drew the room.

ABOVE *Grayscale*

Practice using ink washes by creating a grayscale of five tones: 0 percent black (the white of the paper), 20 percent black, 40 percent black, 60 percent black, and 80 percent black. I don't use 100 percent black ink in the gri-saille. My approach is linear: the contours and hatching are integral features of the drawing, and large areas of solid black would overwhelm the finer lines.

OPPOSITE *King Street Station*

A complete range and balance of gray tones can create depth, mood, and visual balance.

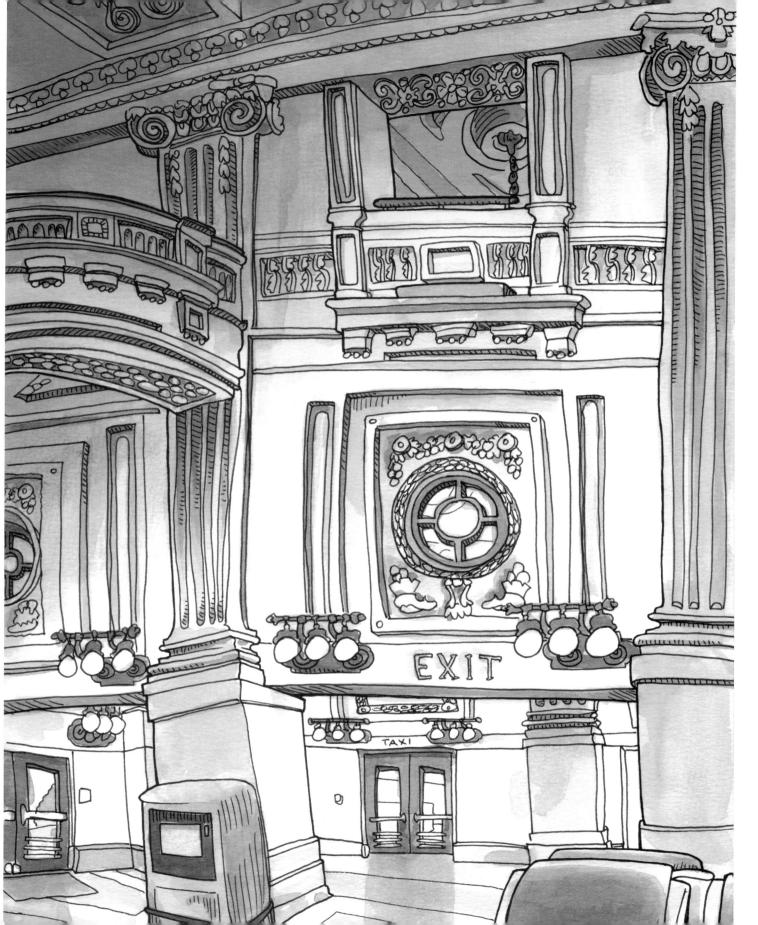

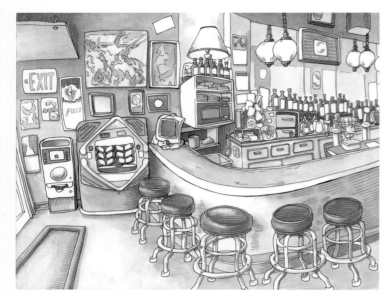

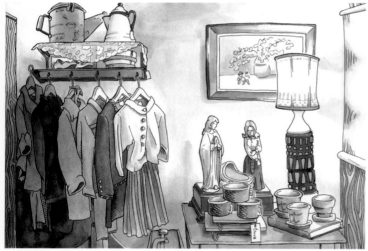

should be left white (the white of the paper), 20 percent light gray, 20 percent mid-gray, 20 percent dark gray, and 20 percent very dark (created by hatching, which we'll discuss on page 62). Watercolor layers tend to mute the contrast in a drawing, so if you're going to glaze color on top of your grisaille, it's even more crucial to have a rich range of grays and high contrast.

If you're afraid the ink will dull the watercolor layers, don't be. I've found the opposite to be true. What makes an object appear solid and three-dimensional, crisp and shiny, is the contrast between the darkest shadows and the highlights. Shiny surfaces like silverware, glass and bottles, chrome, and copper appear shiny because they have almost black areas adjacent to white (or almost white) areas. Sometimes we think we're drawn to a painting's use of vibrant and realistic hues, when what we're actually attracted to is a confident use of tone.

You can practice applying ink washes by drawing the four geometric solids—sphere, cube, cone, and cylinder—with different lighting effects. Imagine a light source from the right, with shadows falling to the left. Then draw the solids again, this time with your imaginary light source directly above. Then again with it down low, like a setting sun. How would the different light direction affect the shadows? Try shadows with hard edges as if in strong sunlight, and again with soft edges as if the sky is overcast. As with a pianist practicing scales, this is an exercise that you can't do too many times. Familiarity shading these simple solids will inform your still-life drawings, especially when the lighting is complex and you must simplify the scene to make it "readable."

TOP *Al's Tavern*

The owner's partner commissioned this drawing as a gift. The hanging lights and metal stools only look shiny in contrast to the darkened room.

ABOVE *Vintage Store Lamp*

For this lamp to appear bright, it was necessary to make the rest of the drawing fairly dark. I've darkened the lower left corner and the base of the lamp to provide contrast with the brightly lit lampshade. I also over-darkened the bottom left corner to help make the lamplight appear brighter.

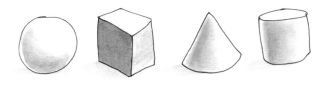

TOP

These four geometric solids are the building blocks of everything I draw. Practice drawing and shading these shapes to help you visually deconstruct and simplify the everyday things in your drawings.

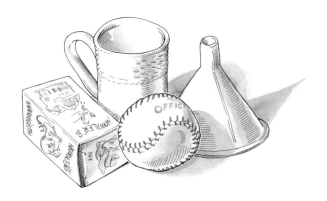

CENTER *Household Geometry*

Practice shading the four solids with a still life of real objects. These objects were found in my home. I chose white things to make the shadows clearly visible. Set up a desk lamp and sketch the effects of moving the light source.

BOTTOM *Coffee Roaster*

A complex scene is easier to understand and draw when viewed as a collection of simple geometric shapes. Note the cones, cubes, and cylindrical shapes throughout this machine.

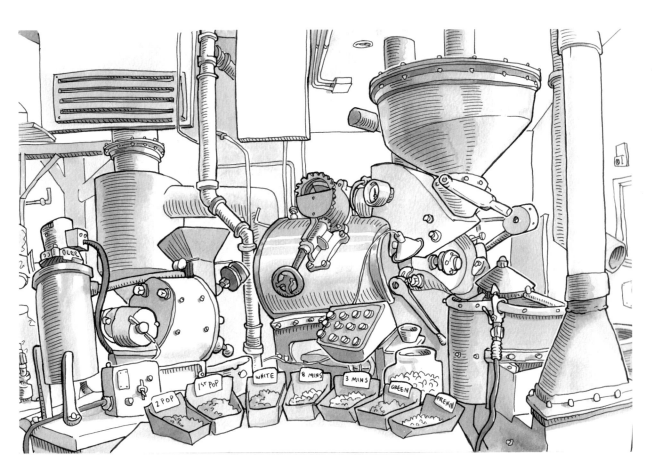

STAGE 4: COLOR

One of the great advantages to drawing on location with Urban Sketchers is the constant practice of drawing quickly with a minimum of materials. With only a couple of hours, at most, to complete a drawing, it helps to have an organized and systematic technique. I apply color in three discreet stages, just as I do the ink washes, building up from light hues (yellow) to reds, and finally to dark hues (blues and greens).

If you have completed a convincing grisaille underpainting, the colors can be glazed on top in thin diluted colors fairly quickly without overly concerning yourself with color accuracy. It can be fun to stylize the color for effect: limiting the palette for a cohesive, unifying effect, or accentuating certain colors for emphasis. We'll cover more specific examples of applying color in the next chapter and throughout the book.

BELOW *Cabin Clutter Still Life*
To keep the focus on the still-life objects, I left the background abstract and low contrast, with muted colors. I also changed any blue objects to green or red-brown to limit the colors and avoid "rainbowing" the painting with too many competing hues.

OPPOSITE *Metal Press*
This machine, made of the geometric solids mentioned earlier, was a gun-metal gray. Having supplied enough specific detail in the grisaille underpainting, I could have made the machine any color I chose without sacrificing its "machine-ness."

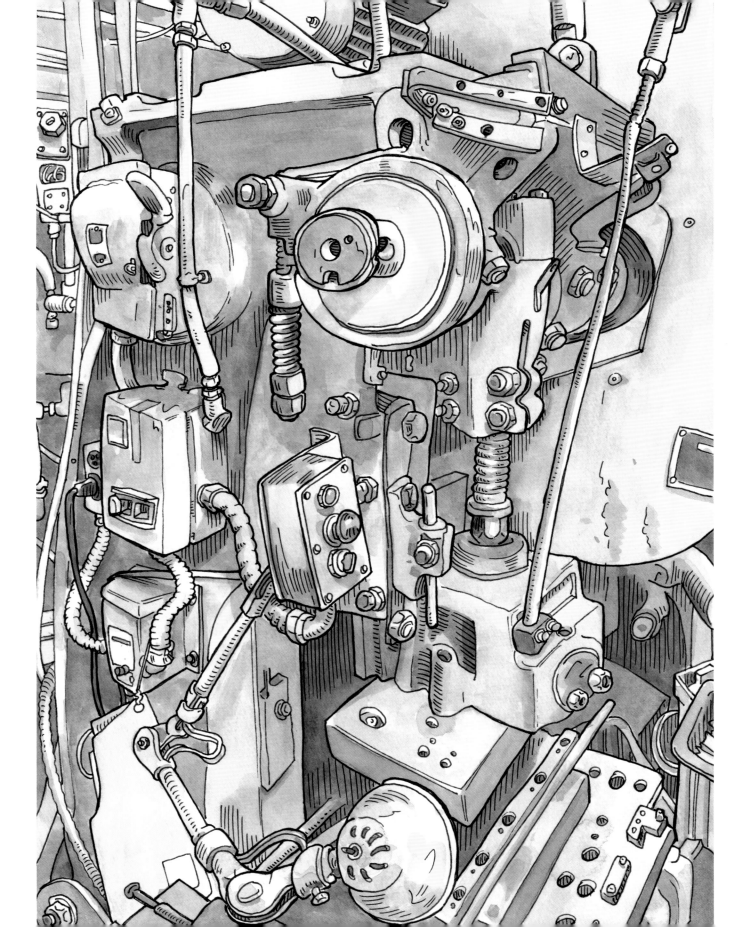

STAGE 5: FINAL DETAILS

The last stage is adding final details, including hatching and highlights.

Hatch lines are applied over a finished drawing to increase contrast, to give a surface detail and texture, and to reinforce the "direction" of an object's surface. To use writing as a metaphor, hatching is like adding punctuation to clarify our sketched description. We can write sentences without capitalization, commas, periods, and even proper spelling and still get our meaning across—but it creates more work for the reader. Hatching can clarify where objects overlap, show the bulge of a curved surface, or deepen a concavity. When hatching, the thin parallel lines should be so consistently drawn that they blend into a tone that suggests a shade. Hatching is less realistic than shading with ink. However, hatch lines should appear to

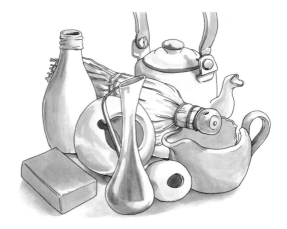

ABOVE

For clarity, here is a simplified grisaille without (top) and with (bottom) hatching. Hatching can give a drawing more contrast, emphasize deep shadows, and help clarify where an object overlaps another object.

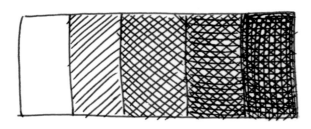

LEFT *Cross-hatch Grayscale*

Copy this grayscale to practice hatching in clear, controlled passes, just as we did when applying ink washes to our grayscale.

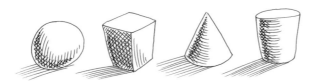

BOTTOM *Hatching Solids*

Practice hatching the four basic solids to help you hatch more detailed drawings of complex shapes.

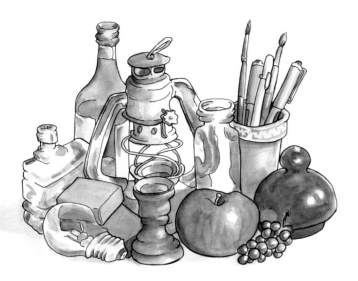 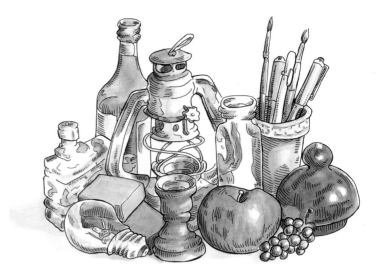

lie on an object's surface to help bring out its shape. If your object is curved, your hatch lines should also be curved.

Entire drawings can be completed using only hatch lines, and sketching this way is great practice for sharpening your observations of contour, shape, volume, and tone. It's a bit unusual to apply hatching over a completed watercolor drawing. For many, the marrying of these two different styles can be jarring. It is, of course, completely optional if you find hatch lines difficult or clumsy. However, I find that when used judiciously, they give a drawing the finishing detail, contrast, and playfulness that makes this approach unique.

To get started with hatching, gather some white objects, such as bones, sneakers, or coffee cups. Squint until you see only lights and darks. Then make short, smooth, parallel lines where you see shade. Remember to consider the curvature and surface "direction" of the objects. The curved hatch lines on a cup, for

example, should mimic the contours of the top and bottom of the cup. You'll find that your fingers and wrist will more naturally draw curved lines in certain directions, so feel free to rotate your paper as needed. Once you get the hang of it, hatch lines are just plain fun to draw. I find the repetitive action of drawing hatch lines meditative and relaxing.

Another final detail, though less common than hatching, is white gel pen highlights. White gel pens can be helpful when you want to reinforce a shiny highlight, embellish a reflection, or add a subtle glow to an object's edge to help separate it from an adjacent object of a similar hue or tone. Note that drawing white lines *outside* the black contours will give your drawing a graphic, stylized look.

Hatching Demonstration

Notice how the hatch lines in the second example (above, right) curve to reinforce the curve of the objects they rest upon. It may be helpful to think of hatching as another layer of dark gray, but applied with a pen rather than a brush.

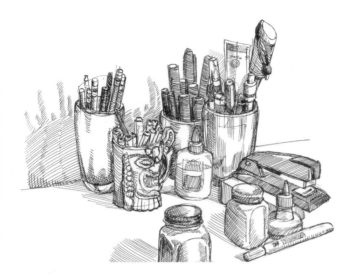

For a more natural look, draw them *inside* the contours, as if the white is reflected light on the objects themselves.

A word of caution about both hatching and highlights: Both of these are graphic devices that can look unnatural. Use them sparingly. Like special effects in movies, they should blend in and go unnoticed. It can take practice to draw the parallel hatch lines or Gelly Roll whites without them being too stark or gimmicky. Subtlety, restraint, and practice are key.

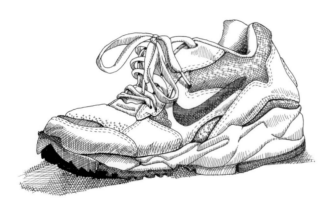

TOP *3am Desk Supplies*

Hatching is a simple and quick way to sketch a scene without the fuss of ink washes or watercolor. Unable to sleep one night, I got up and hatched the objects on my desk.

CENTER *Cross-hatch Shoe*

As the name implies, "cross-hatching" is when hatching lines overlap. Cross-hatching is helpful for creating different tones in a line drawing, such as this one. In grisaille and watercolor drawings, however, I use only one layer of hatching (no cross-hatching) as the grisaille does the bulk of the work.

BOTTOM *Cross-hatch Skulls*

Practice hatching on a white object, such as this seagull skull I found on a beach in Mexico.

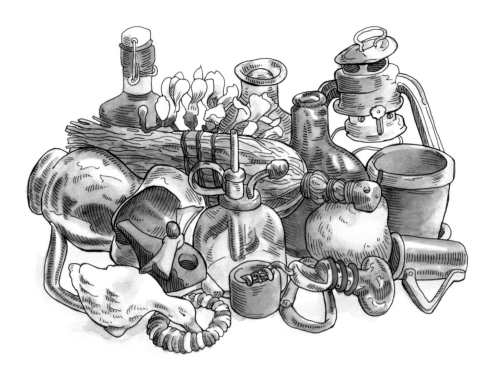

TOP *Still Life without White Gel Pen Lines*

BOTTOM *Still Life with White Gel Pen Lines*

The objects in the center of this still life have similar tones and color. In the bottom version, I used a white Gelly Roll pen to add thin white reflections just inside the contour lines of the bottle, pear, and corkscrew to subtly highlight the edges and help separate them from adjacent objects.

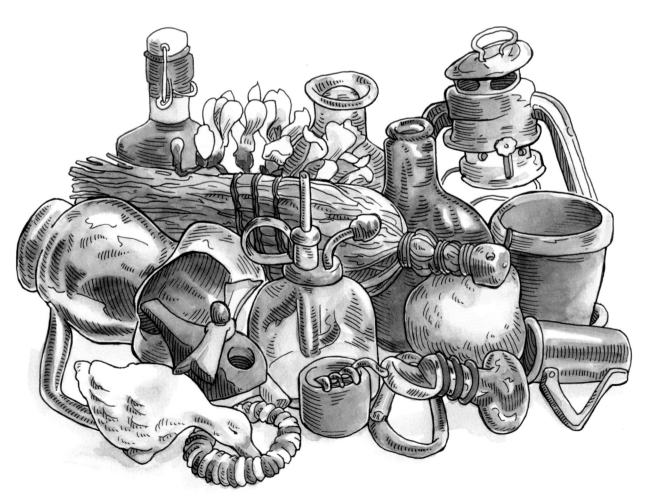

DEMONSTRATION:

STILL LIFE WITH LIGHTBULB

The following still life uses the kind of everyday objects you might find in your house. After reading through the demonstration, gather a half-dozen objects of various sizes and shapes and try it for yourself. All of the examples in this book follow the same steps, whether still lifes, urban exteriors, or crowded coffee shops. This is a simple, no-pressure invitation to dive in and get drawing. Here we go!

Step 1: Quick pencil layout

Use a soft pencil to lightly indicate placement of the major "chunks" in your scene. *This is not a drawing!* I cannot emphasize this enough. In my classes and workshops I have been known to pluck pencils away from students who spend time "drafting." Don't pencil anything recognizable. You are merely giving yourself parameters, establishing the major pieces of info within which to place the details. If you spend a lot of time erasing, correcting, and fussing, you'll deaden and polish away the little variations and serendipitous anomalies that make your drawing *your* drawing. Like scratching the boundaries of a volleyball game in the sand, the pencil lines let you know if you're going too far out of bounds to keep the real drawing on the page.

Step 2: Contours

Using your pencil lines as a general guide, start in the foreground with your Uni-ball fine (0.7)

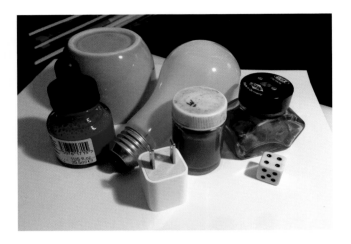

The setup for our demo

Quickly sketch in pencil guides.

Start with the contours in the foreground.

point pen and draw carefully observed contours. Because you're working in pen, you must draw the foreground objects first and work your way toward the back. Take your time but don't "sketch" with scratchy, hairy, tentative lines. Start at the beginning of a contour, continue until you come to the end, and then stop, just as you would write your signature.

Try not to prejudge your drawing at this stage. Wobbly lines, distortions, and wonky proportions will tempt you to start over. Don't. Your lines cannot help but have your personal stylistic stamp. When you fill the page with the kind of lines that only you can make, the consistency of your style will unify the drawing. As they say in jazz music, "If you make a mistake, make it three times." Don't try to correct or redraw wonky lines. Commit to a line, draw it once in ink, and move on. Leave them be. They're *perfect*. Excellent. Beautiful. Next line. Move on. When your contours are finished, use a kneaded eraser to remove all pencil lines. If you find it difficult to completely erase any pencil marks, then you probably drew too many or pressed too hard.

Step 3: Ink wash

Squint at your scene to observe only darks and lights. Apply one smooth layer of light (20 percent) ink wash to isolate the highlights and bright whites. Use a fairly large brush, #6 or #8, to cover everywhere that is *not* white. (This will include most of your drawing unless you are painting a polar bear in a snowstorm.) Use as little liquid as possible by swabbing off the brush inside the rim of your jar. If your paper is already buckling, you're using too much water or your paper is not robust enough. Don't scrub or fuss. Hit it and quit it and let it dry.

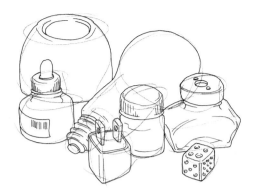

Continue drawing the contours, working your way toward the back.

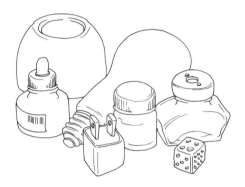

Erase the pencil lines for the finished contour drawing.

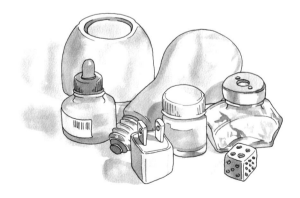

The first ink wash isolates the highlights and bright whites.

After the first layer dries completely, squint again at your subject and brush on another layer of the same light ink wash to darken the shadow areas. *Don't apply ink anywhere you left white.* Those areas are highlights. That's why you left them white, right? Only put the second ink layer inside the perimeter of your first wash. This is a good reason to use a fairly dry brush; otherwise, your paper will get soggy and warped and yucky. Let it dry. (Yes, you have to wait. Stand up and stretch. Move around. Go clean the cat box.)

Finally, apply your third and final layer of wash to really deepen those nooks and crannies. You can apply another layer of the same wash, but to speed things along and really increase the contrast, I use a different, darker ink solution or add a drop or two of ink to the one I've been using.

Step 4: Watercolor layers

Just as we built up three increasingly saturated layers of gray tone, we'll build up color in three passes. As in four-color process printing, where color images are made from yellow, magenta, cyan, and black we will also be applying color in three general passes, from lightest to darkest: yellows, reds, then blues.

I apply very diluted washes of color so the grisaille layer beneath remains visible. Remember my mantra: "Black and white does the work; color gets the credit." You can always add more saturation, but you can't remove color, so sneak up on it gradually.

While applying a color, remember to preserve the highlights you isolated in the ink wash stages. Also, look carefully for other objects that share that color. Here, the red ink bottle is reflecting onto the green bowl, and the orange pencil sharpener reflects onto the glass jar.

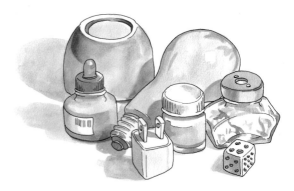

Apply a second ink wash to darken the shadow areas.

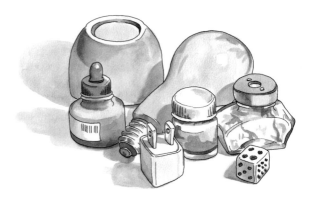

After the third and final ink wash

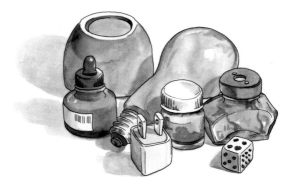

After a wash of light color

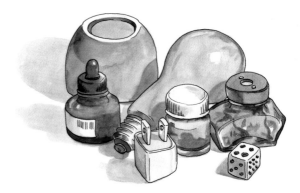

Continue to build up color, especially in the shaded areas to increase contrast.

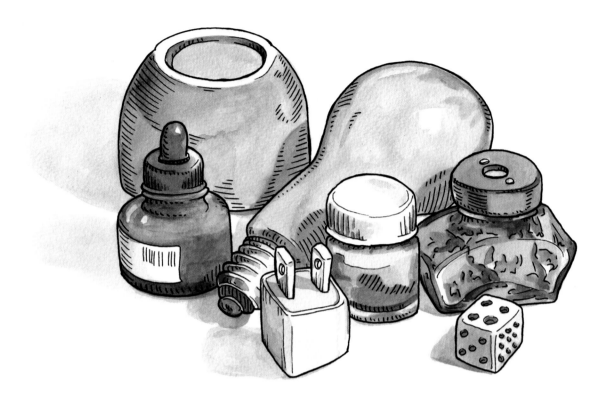

Step 5: Final details

Looks good, yes? Now let's add the hatching. It takes practice. Use your thinnest Uni-ball (the 0.5 micro point) and hatch little parallel lines where you want your super-duper blacks. I also hatch to indicate surface "direction" and to add surface details like wood grain, fur, design elements, and so on. This is your last chance to add details that you rightfully didn't draw yet because they weren't *contours*. (With your 0.7 pen you only drew actual contours, right?)

Finally, decide if you need to add any gel pen highlights. Whenever possible, it's best to let the white of the paper represent reflected light, as on the red ink bottle above. Sometimes you may forget to preserve the highlights or accidently cover them with ink wash or paint. In those cases, use a white pen to draw them back in. We'll look at specific examples and other uses for white ink in upcoming demonstrations.

Sign and date it. It's beautiful. It's perfect. *You're* perfect. Congratulations. Now do another one.

Then do another.

And another...

ABOVE *Still Life with Lightbulb*

The final drawing, with hatching lines added. Highlights on the red ink bottle were created by leaving the white of the paper untouched.

STILL LIFES: DRAW WHAT YOU SEE, NOT WHAT YOU KNOW

"I just happen to like ordinary things. When I paint them, I don't try to make them extraordinary. I just try to paint them ordinary-ordinary."

—ANDY WARHOL

With a still life, you can practice applying formal art principles such as balance, pattern, and rhythm, regardless of the objects in your drawing. You can control the lighting, scale, and complexity and take as long as you need, even re-drawing the same setup from different angles or with different lighting.

I've collected dozens of props for creating still-life arrangements. I visit thrift stores to pick up knickknacks of different colors, textures, shapes, and sizes. What the objects are or what they were for is not important. I've drawn them so often I no longer see them as kitchenware, tools, or tchotchkes. They are only resources for colors and textures. They are made of lines (curved, straight, intersecting, parallel) and shapes (cubes, spheres, cylinders, and cones). They provide an infinite range of tones and hues. Everything around you is a kaleidoscopic grab bag of retinal delights, interesting without regard to how it's used or what it's called.

OPPOSITE *Duo Eamon CD Cover*

A still life commissioned by a folk music duo for their new album release and web page banner.

GETTING STARTED

Working from a collection of inanimate objects has many advantages. Models get tired. Inclement weather can make drawing outdoors impractical. Drawing a still life allows for control of the lighting and the option to study specific shapes, textures, and surfaces.

A still life can be made with anything on hand. Overlooked piles of junk and clutter make good subjects as "found" still lifes. Don't overthink the specific objects or arrangement. Quickly gather some junk and dive in. Unless you're drawing something specific for an assignment or a commission, the objects in your drawing can be anything.

Drawing has a lot in common with meditating and a still life can be like the candle you use to focus your attention. It takes commitment, sustained focus, and a desire to quiet your mind and deal with the present. Don't confuse the *objects* in a drawing for the *subject* of the drawing. Whether you draw the contents of your fridge, the interior of a coffee shop, or junk found at a garage sale, the subject of your drawing is your experience of that location and moment in time.

Concavities
Here is a collection of objects deliberately chosen with a visual theme: things with holes or concavities.

TOP *Still Life with Red Flower*

Drawn as a demo while teaching, this still life is made of inexpensive objects found at my local Goodwill store.

BOTTOM *Custodian's Supplies*

A still life made of objects found in the school's broom closet.

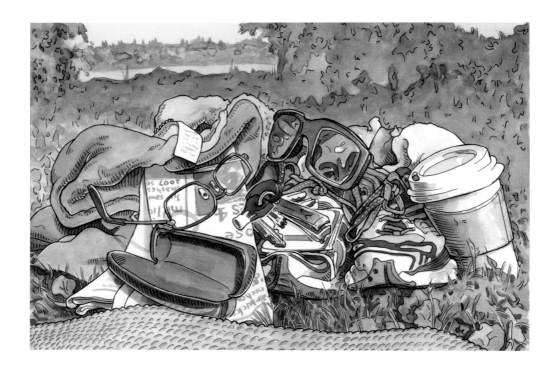

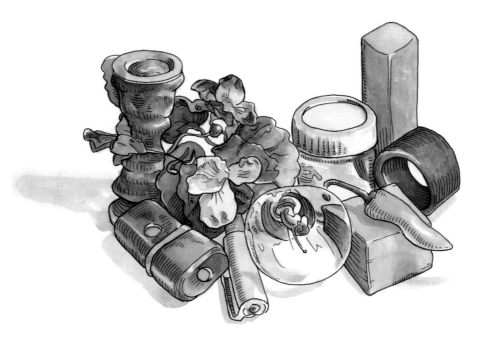

TOP *Yoga Debris*

While doing yoga in the park, I saw my pile of clutter as a still life. The next morning I brought my sketchbook and captured it after my workout.

BOTTOM *Micro Still Life*

For this in-class demo, I chose the smallest objects on hand. The entire arrangement was only a few inches wide.

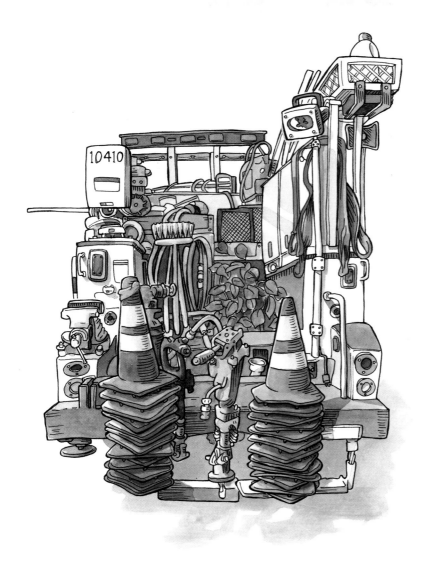

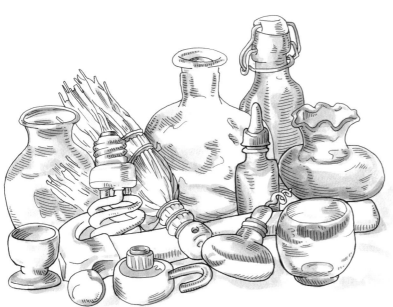

TOP *Maintenance Truck*

An "urban still life" on a macro scale, still made of cones, cubes, and cylinders. No matter the size, the principles are the same.

BOTTOM *Still Life with Broom and Hammer*

When arranging the objects in your still life, avoid separating everything like a lineup of criminal suspects. You may think it will be easier to draw if you can see each object clearly, but I find the opposite is true. The denser the setup, the better. If a cup or bottle (like the one in the back) is partly obscured, you need not worry about drawing it symmetrically. The same goes for long narrow objects, such as the handle of this hammer. Glimpsing objects piecemeal through gaps frees you from worrying about symmetry or drawing long straight lines.

DEMONSTRATION:
STILL LIFE WITH
ICE CREAM SCOOP

Here is another step-by-step demonstration, once again applying my five-step process to a group of objects.

Step 1: Quick pencil plan

Using a pencil, lightly sketch placeholders for the main elements. With a detailed setup like this one, you might be tempted to render everything with a pencil so you can erase and redraw your lines, over-working the initial planning stage and dulling the life out of your drawing. Resist!

Take a breath. Begin by looking at your objects. In your mind's eye, reduce each object to one of four simple geometric solids: cone, cube, cylinder, or sphere. In this example, the two lower-left vessels and the upper-right cup are quickly roughed in as spheres. Of the four solids, the clutch purse at lower right most closely resembles a flattened cube. The bottles can be seen as single cylinders or, at most, a narrow cylinder atop a wider one. Indicate only the general placement of the objects.

Step 2: Contours

Using a black Uni-ball Vision fine (0.7) point pen, begin with the foreground objects and draw their contours, working front to back. Try not to prejudge a drawing in the initial stages. A wobbly line or skewed proportion won't make or break a sketch. Still to come are three layers of ink wash and several layers of watercolor. You'll embellish

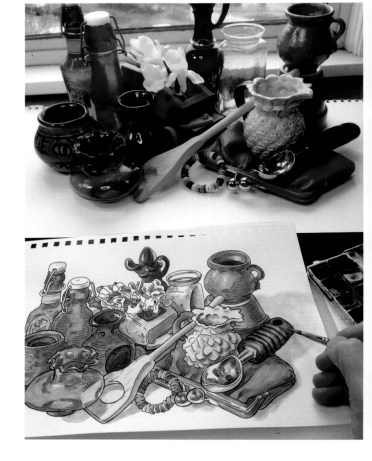

The setup

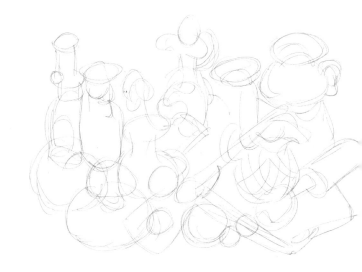

Even odd shapes like the bracelet and spatula should be only quickly indicated using one or a combination of the four solids: cube, cone, cylinder, or sphere.

contours and add hatch lines and gel-pen high-lights. If a drawing is completed with the same attitude consistently throughout, whether tight, loose, whimsical, or naturalistic, the idiosyncrasies will become part of its charm.

When drawing contours, draw only the edges you could feel if you touched them. Ignore painted decorations, printed text, differences in wood grain, and shadows. Put your pen at the beginning of the line, draw to its end, then move on. Don't scratch your way around a profile with a tentative, stuttering line as if feeling your way through a dark maze. A confident egg-shaped sphere has more character than a perfectly round circle that looks like it's covered in dog fur.

When in doubt whether you are seeing a true contour, ask yourself if you can hide your pen tip behind it. If so, it's a contour. If not, it isn't; don't draw it! When you've drawn the contours, erase your pencil lines.

Step 3: Ink wash

Squint to simplify the scene to lights and darks. Using a large brush (#6 or #8 round), apply a light wash (about 20 percent black) to any area that is not pure white, including "white" objects that are in shadow. Remember, the goal of the first ink wash is to isolate the highlights. Ignore color at this stage. White objects, like the flower petals, are often very dark when seen only in terms of tone.

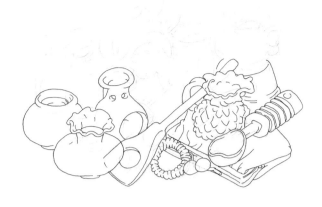

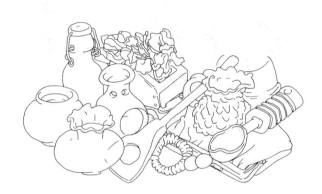

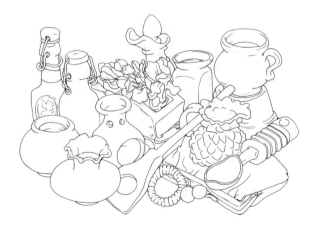

Start your contours in the foreground and work your way back.

After the first wash dries, use a #4 or #6 round to apply a second wash (still using the 20 percent black) to create midtones, staying within the bounds of the first wash. Remember to preserve white areas, including highlights and reflections.

Finally, use a #4 round brush to apply a third, darker wash within the bounds of the second wash.

When you're finished, you should have a complete grisaille with defined and recognizable objects. Notice I did not say "realistic" or "perfectly drawn." Rather than judging the drawing on the rendering, determine if there is a balance of gray tones. Your drawing should include four tones so far:

- white (the areas where we left the paper white for highlights and reflections)
- light gray
- mid-gray (the second wash, which doubled the pigment on the paper)
- dark gray (the final dark wash)

In step 5, you'll add a fifth tone: the darkest gray of the hatch lines.

Are the tones equally represented? Is approximately one quarter of your drawing the white of the paper? Is the rest of the painting equally covered in the various gray tones? If your grisaille appears too light or washed out, you have been overly conservative in your application of ink, or your ink solutions are not dark enough. (Remember, you will still be adding hatching, which is a final opportunity to increase the contrast in your darkest areas.)

Step 4: Watercolor layers

Just as we began the three ink layers with a very light wash over most of the drawing, start the color stage by applying a de-saturated yellow to all areas

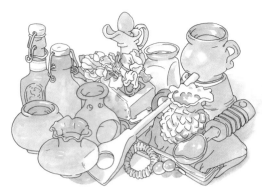

The first ink wash

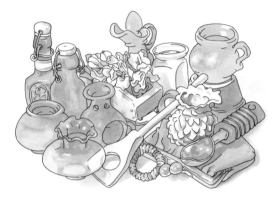

The second wash

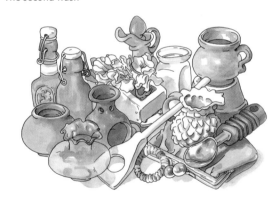

The third, darkest wash

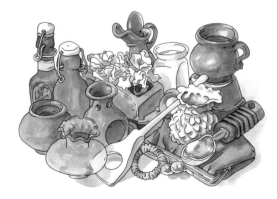

A first glaze of de-saturated yellow

that contain yellow (including orange and green, since these colors also contain yellow).

Rarely does the color in the store-bought palette match the color of my objects. Pre-made colors are usually too saturated and intense. I dull all hues with their complements (the hue opposite on the color wheel) to keep them from being too pure and garish. To knock the yellow back a bit, just enough to look more natural, I mix in violet (made by mixing a touch of red with a dab of blue). Remember, we're not overly concerned with photorealism here. The name of the yellow I'm using, or exactly which yellow I see in the still life, is a "left-brain" function. I trust my eyes. When mixing my color, if I add too much red, I add more yellow and blue. Like an experienced chef, I'm not measuring but mixing "to taste."

Gradually, add red to the yellow and apply where needed. Continue applying colors and finish with greens and blues, increasing saturation. Work all over the painting, applying the current color everywhere you see it or the objects will start to look isolated from one another. Look for ways to unify the drawing by sharing colors between objects. With careful observation you'll see that color reflects onto adjacent objects, as here with the green on the wooden spatula and the blues in the scoop.

Step 5: Final details

With a Uni-ball Vision micro (0.5) point, carefully hatch to help clarify the sketch. I've applied hatching to the insides of openings to emphasize their concavity, as on the blue vase. I've hatched surfaces that need defining, as on the wavy flute of the green vase at lower left. And finally, I used thin marks to suggest surface detail, as on the textured glass of the far left bottle.

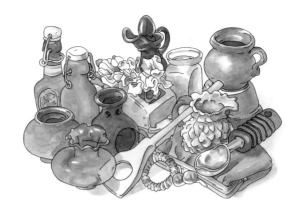

A middle stage of adding more color

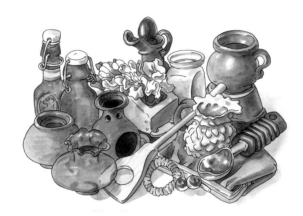

With more saturated color. The flower petals in the still life were white, but I added some tan and green to tie them to the rest of the painting.

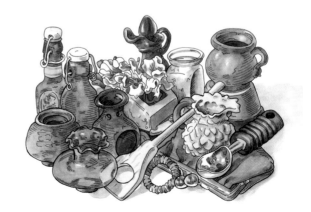

Still Life with Ice Cream
The final drawing, with hatching

TIPS AND INSIGHTS

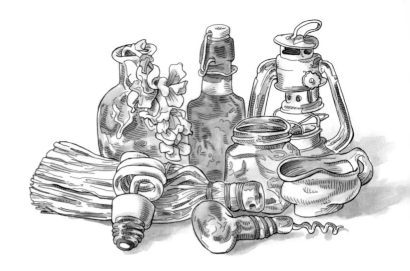

Working from a still life is a terrific way to explore specific drawing challenges. Choose objects with reflective surfaces, for example, such as glass or silver, or objects with challenging textures and surface features, such as wood grain or wool. Or, create a "portrait" of a friend or family member by drawing a still life of their favorite possessions. Even if the still life is not your ultimate goal, the steps are the same, and working from home will give you practice and confidence before you head outside to draw on location.

TOP *Still Life with Broom and Corkscrew*

When faced with a repetitious pattern of tiny details, such as on this broom, less really is more. Don't attempt to draw every bristle. Squint at your object and draw only the most obvious, highly contrasting details. The viewer will complete the picture, much as we "see" ordered constellations in random scatterings of stars.

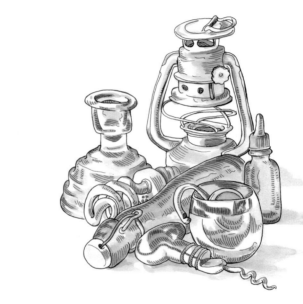

CENTER *Still Life with Lantern*

When drawing contours of thin, stringy objects, like the wires in this lantern, a single line will not suffice. Give yourself enough width to shade inside the contour lines of even the thinnest objects.

BOTTOM *Still Life with Spoon and Grapes*

Interiors often have more than one light source, which creates multiple highlights and conflicting cast shadows—especially if the light sources are not visible in the drawing to explain what is happening. As evidenced from the many highlights on the dark teapot, this still life was lit by several overhead lights. Depending on how much time you want to invest in a sketch, it can be helpful to simplify the lighting in your drawing. Practice drawing and shading the four basic solids: cones, cubes, cylinders, and spheres, and apply that practice to make your drawing easier for viewers to "read."

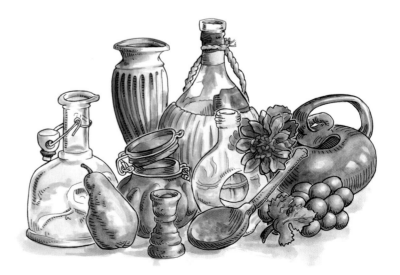

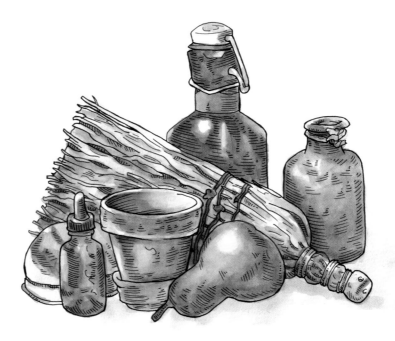

TOP *Still Life with Pear*

Reading text is a different cognitive activity than observing a drawing. Rendering a specific font is difficult and written words can "bump" the viewer out of the drawing while trying to read them. If small words appear on a label, as they did on this bottle's neckband, I leave them out.

CENTER *Still Life with Eggbeater*

Look at the distorted bend in the eggbeater, the asymmetrical vessels, the wonky trophy. As long as the entire sketch is done in the same style, *your* style, it will cohere into a fun and whimsical drawing.

BOTTOM *Still Life with Candelabra*

The three posts of the candelabra in the back of this sketch were equidistant apart, but that's not how I drew them. Does it matter? Not to me. Students sometimes ask me how to fix a "mistake" like this. You don't. You just do another drawing.

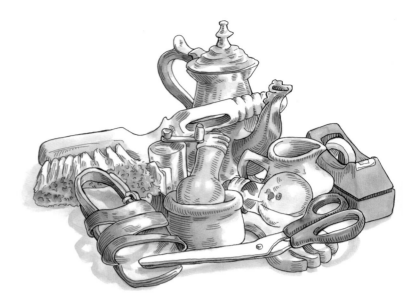

ABOVE, LEFT *Still Life with Tiki*

Look for an even dispersal of your darkest darks and lightest lights. I avoid obvious symmetry, but a sense of balance can ground your composition.

ABOVE, RIGHT *Still Life with Scissors*

Cast shadows are never outlined with contour lines or darkened with hatching. If you make cast shadows too dark or specific, they will look like objects and advance visually to compete with the real objects above them. I lightly brush on cast shadows during the first ink wash layer and leave them be.

RIGHT *Still Life with Green Bottle*

A common mistake is to draw objects seen through glass without allowing for refractions and distortions. The far edge of the wagon seen through the green bottle is not straight, though we know it is. Remember to look closely and draw what you see rather than what you know.

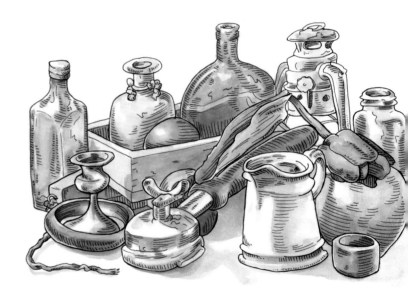

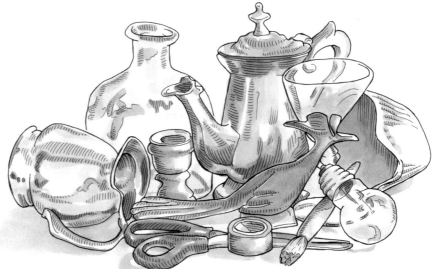

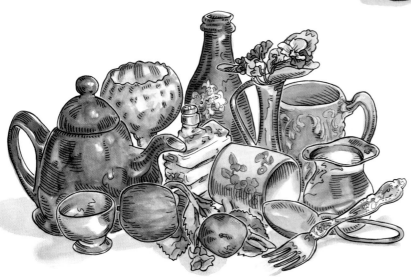

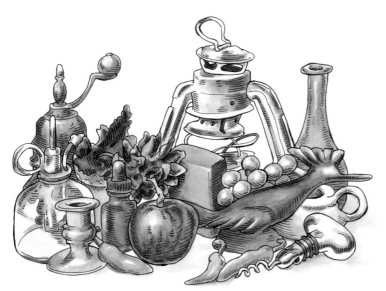

TOP *Still Life with Roadrunner*

A thin layer of white near the edges of a glass object will suggest that the thicker, turning edge is too opaque to see through, blocking the visibility of the objects behind.

CENTER *Still Life with Fork*

Chrome, silver, and glass look shiny due to the high contrast between areas of pure white and adjacent very dark tones. They also share the reflected color of nearby objects, as in the greenish glow on the far-right creamer.

BOTTOM *Still Life with Yellow Peppers*

You can exaggerate shared color to unify the objects in your sketch. The yellow from the lower-left pepper is liberally reflected onto the brass candleholder, bottle, and red apple. Notice also the variety of colors reflected onto the lantern, which was a dull flat gray in actuality.

TOP *Still Life with Baseball*

Using too many colors in a single drawing creates a "rainbow" palette that can make a sketch look naive and candy-colored. I often omit entire colors, replacing them with a select few to unify a sketch and keep the focus on the solidity of the objects. This drawing pushes the variety of colors as far as I care to go. Though I've limited the bright yellows and violets, it's still a tad garish for my taste.

CENTER *Still Life with Elephant*

By limiting the dominant hues to reds and yellows (with just a touch of green), the color range in this drawing is more satisfying for me. The central vase in the back was a rich cyan that I dulled deliberately to keep it in the background.

BOTTOM *Still Life with Large Red Teapot*

In a color drawing, gray and black objects look unfinished if left without any color on them. I avoid black watercolor—even for black and gray objects—as I find it muddy and dulling. Instead, use a neutral, unidentifiable hue made by combining the three primaries and lightly apply this over the grisaille of gray or black objects.

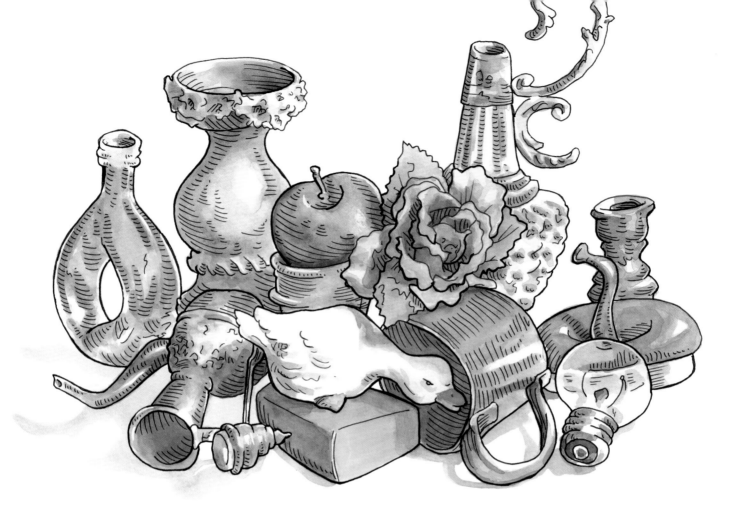

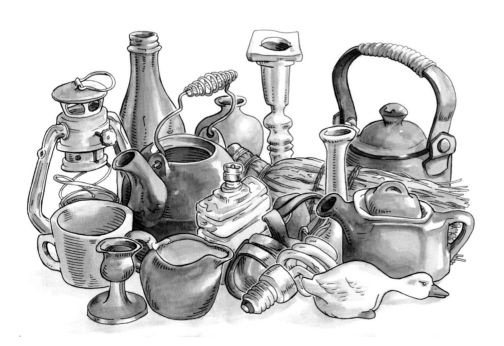

ABOVE *Still Life with Goose 2*

White gel pen outlines help define and
separate these closely grouped items.
Note how in the first example, I drew
white lines outside the black contours
of the goose's tail and coils of the
lightbulb, giving the drawing a graphic,
stylized look. In the second example,
the white lines are *inside* the black con-
tours of the lightbulb and green stem
just behind it, creating a more natural
look, as if the white is reflected light on
the objects themselves.

LEFT *Still Life with Goose*

INTERIORS: DRAWING IN PUBLIC

"Photography is an immediate reaction, drawing is a meditation."

—HENRI CARTIER-BRESSON

After practicing with manageable still lifes in controlled environments, we're ready to take our show on the road and apply the same approach to large, cluttered environments.

Learning to draw on location can change your life. It changed mine. It has heightened my awareness of the city in which I live and inspired me to travel around the world sketching the details of my adventures. Travel sketching has introduced me to artists and locations I never would have seen were it not for the global network of location sketchers.

There's nothing wrong with sitting at your desk drawing from photos. In the studio, I test new pens and inking techniques. I draw portraits of inspirational artists, writers, and musicians (shown on pages 150–151). I draw from images found on the Internet. I keep a daily journal of diary comics based on memories, plans, and dreams. It's a relaxing, private, introspective activity that I've kept up for forty years. But come down from the ivory tower and mix with the masses and it's a different experience. Observe the world on location. Draw from observation. Be part of the action. Let the real world intrude and jostle your elbow and let the marks be a record of your experience.

OPPOSITE *Irwin's Bakery*

The best options for interesting detail and clutter are often the workspaces you aren't supposed to notice. This is the kitchen of a local coffee shop and bakery near my house.

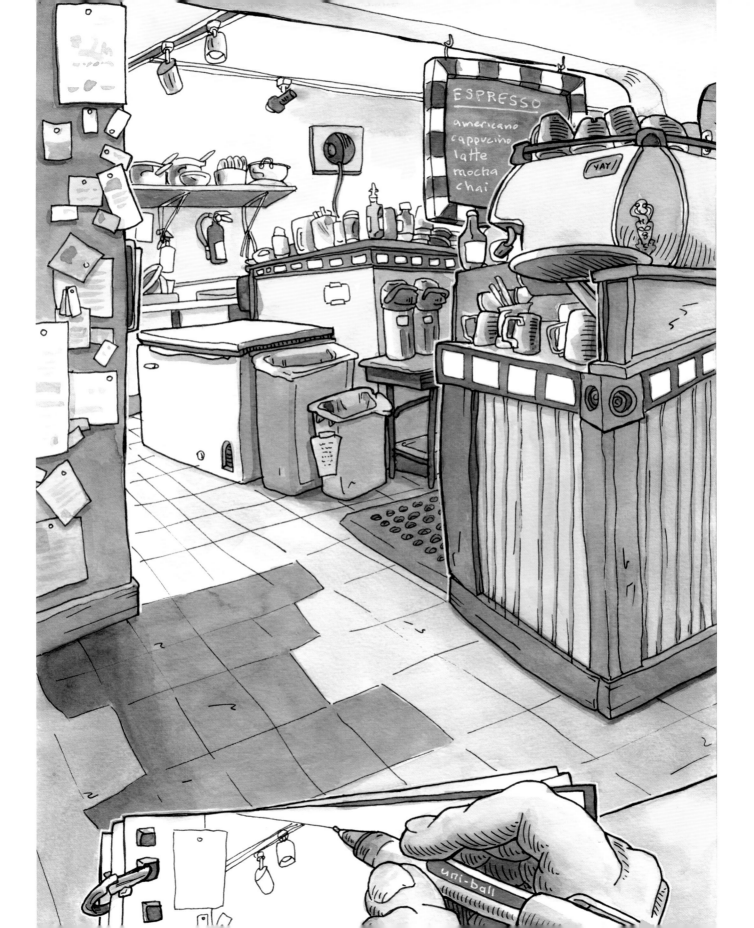

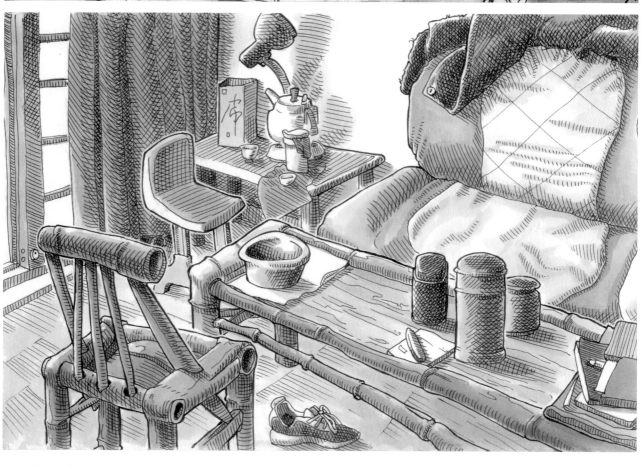

GETTING COMFORTABLE

If you have yet to venture out, drawing on location can be intimidating. You may be nervous about being observed in case your drawing goes poorly. But once you get used to it, you'll find your fears are mostly unfounded. Here are some strategies I've used at different times:

- *Start slowly*. Getting out of the comfort zone of your own home can be as simple as drawing at a friend's house.
- *Draw around supportive friends and family*. Draw your parents in their living room, your partner at a café, or your best friend in a booth at your favorite restaurant.
- *Draw with a friend*. Find a friend who also wants to start drawing on location, and when you're ready to venture out, go together. There's safety in numbers!
- *Wear earphones*. People are less likely to interrupt if you appear off in your own private Idaho. Sketching is the perfect opportunity to catch up on audiobooks and podcasts.
- *Sit with your back to a wall*. Indoors or out, it can be one less distraction to know that no one is looking over your shoulder.
- *Join a crowd*. If you sit in a popular café with pen in hand, you're just another student doing homework or studying. People will be too busy doing their own thing to notice you sketching in the corner.

It's hard to justify a day without drawing if you have access to a café or diner. With a little time and a few dollars, you can get a cup of coffee or slice of pie and draw whatever is in front of you without worrying about the weather or attracting attention. Restaurants and cafés have so much clutter and detail that you can draw in the same place several times and not repeat a drawing.

OPPOSITE, TOP *Donna's Place*

The first time my partner Donna had me over for dinner, I stood in her living room and sketched as she cooked.

OPPOSITE, BOTTOM *Olga's Apartment*

Olga was an English-speaking Spanish student studying calligraphy in China, where I taught for a year. She had me over for dinner when I was missing speaking in my native language. I drew her place while we chatted.

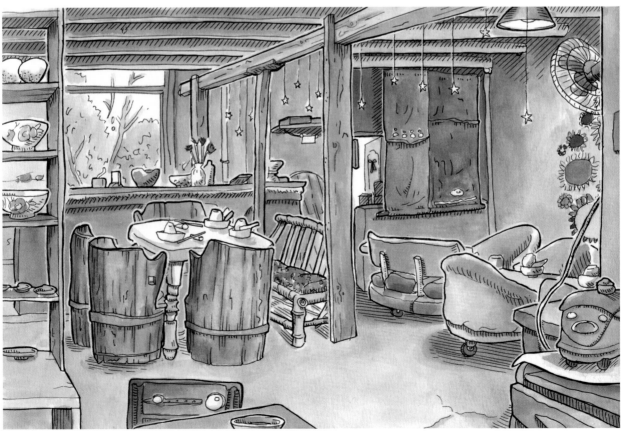

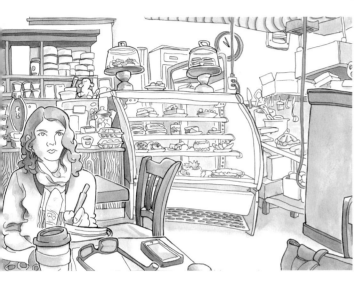

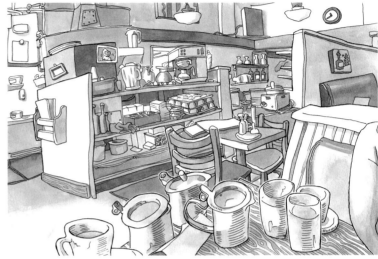

OPPOSITE, TOP *My Parents' Trailer*

When my son was little, we spent our summers camping. After roasting hot dogs and s'mores one night over the campfire, we sat in my parents' trailer and watched the movie *72 Hours*. In this sketch, you can see the condiments on the table and the video in the background.

OPPOSITE, BOTTOM *Korean Restaurant*

Before settling into your drawing, make sure you won't be in anyone's way. Avoid sitting on stairs or in aisles or narrow hallways. You don't want to be halfway into a drawing and be asked to move. Also, it's only fair that if you're going to occupy a table for any length of time, you order something to eat or drink. When the owners of this Korean restaurant in China saw me sketching, they comped my meal! I returned the next day and gave them a print of the sketch.

ABOVE, LEFT *Donna Sketching*

My partner Donna and I often sit across from each other sketching over coffee. Sometimes we include each other in our drawings, sometimes not.

ABOVE, RIGHT *Sunrise Café*

If you carry a small sketchbook—such as a 3- x 5-inch Moleskine sketchbook, which fits in your pocket—you can draw surreptitiously and quickly do a sketch before anybody notices. I did this drawing during a lunch break, when I was inspired by the cylinders and cubes clustered all around us. Sitting in a booth gave us privacy to draw unobserved. You only glimpse Donna's arm on the right side of the drawing.

CHOOSING YOUR VIEW

A drawing can take between twenty minutes and two hours. It can save you time and frustration if you're deliberate about where you choose to draw. Where can you sit for the best composition? Steven Spielberg once said the secret to a great shot is simply knowing where to place the camera. Is there a more interesting vantage point? I've drawn from the roof of my car, high up on fire escapes, and while floating in an inner tube on a river. Is the scene better if you move a little to one side? View your scene through a store-bought viewfinder, use your thumbs and fingers to form a frame, or look through a rectangular hole cut in paper.

Try not to face a building head-on or everything in your drawing will be equidistant on the picture plane, which can result in a boring, flat facade. If your subject is flat, like a wall, position yourself closer to one side so some parts will appear larger and the far side will recede.

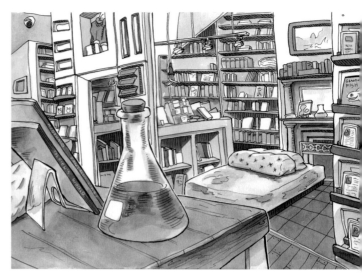

TOP *Ada's Technical Bookstore*

Drawing directly in ink, without a detailed pencil drawing to guide me, freed me to put my own spin on this sketch of an interesting bookstore. However, everything in my drawing is based on what I carefully observed. Nothing is "made up."

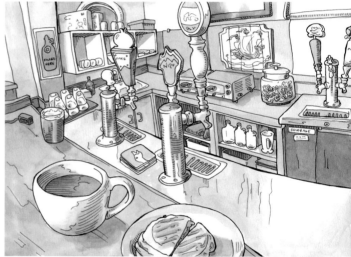

CENTER *The Bounty*

To create the illusion of depth, position yourself so there is a foreground, middle ground, and background. I often set something in front of me so I'll have large close-up objects to contrast with more distant ones. The back wall of this coffee shop had plenty of detail, but the foreground was lacking. Setting my lunch on the counter gave me just the foreground I needed.

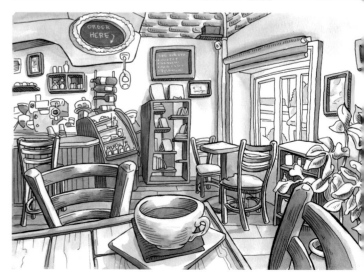

BOTTOM *Bookbar Café*

I chose a spot in this café that gave me a foreground (the table and chairs), a middle ground (the plant and bar), and a background (the far wall). I also created a closer foreground with my coffee cup.

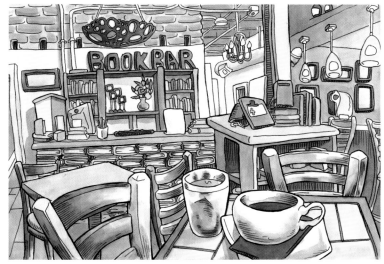

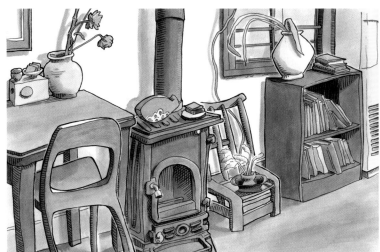

TOP *Bookbar Color*

For a second color drawing of the same café, as in the previous image, I had only to swivel to my left. I first ink washed the drawing as before, then applied watercolor on top. Though the actual scene had a full range of colors, I limited my palette to warm hues to unify the painting.

CENTER *Jingdezhen Café*

To give this scene a little more depth, I simply turned a bit to my right rather than face the wall directly.

BOTTOM *Planet Java Diner*

This scene probably would have been interesting enough had I sat facing the counter square-on, but by turning my shoulders slightly to one side I had a more dynamic composition.

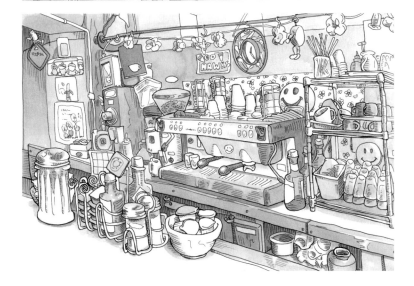

DEMONSTRATION:
PLANET JAVA DINER

Planet Java Diner is one of my favorite sketching locations. This downtown Seattle diner is playfully decorated in midcentury furnishings and lots of cartoon kitsch. I've drawn here several times with many more visits to come. Let's take a look at each of the steps I took to complete a fairly complex and detailed grayscale drawing.

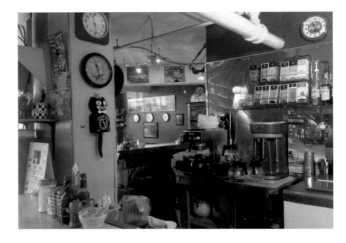

The original setup

Step 1: Quick pencil plan

Using a pencil, I made as few marks as possible to define the general composition. (These marks are very light. I've increased the contrast so you can see the lines better.) I've indicated that the foreground will be the counter and condiments on the bottom left. The middle ground is the kitchen counter at center right. The background is the dining area in the center distance. At this stage I'm not drawing, but merely noting major clusters of objects like clocks and support beams. This took about thirty seconds. Then I put the pencil away. I won't be needing it again.

My pencil plan for the sketch

Step 2: Contours

Using a Uni-ball Vision fine (0.7) point pen, I began with the foremost objects and inked their contours with clean lines. Don't try to correct or redraw wonky lines. Commit to a line, draw it once, and move on. Don't prejudge your drawing at this stage. When you fill the page with the kind of lines that only you can make, the consistency of your style will unify the drawing.

Do the same for the middle-ground objects. If some objects get crowded out while you draw, no one will notice. In my drawing, twelve boxes of tea became seven. Who cares?

Continue with the background, using everything you've already drawn as reference points for placing new details. A close look at my drawing reveals inaccuracies, faulty perspective, and omitted objects. Good! That's why we're drawing and not taking a photo.

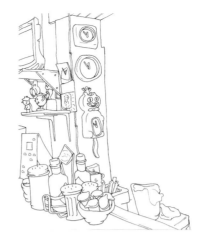

As mentioned, Uni-ball pen lines are very uniform. To give your lines some variety and expression, you can retrace some of them, as in the example on page 96. Be selective; darker lines will draw attention and appear to come forward, closer to the viewer. Choose prominent foreground objects and retrace their outer contours only. Since you will not be able to trace them exactly, the doubled lines will have a variety of widths where you slightly strayed from dead center of the line. Don't *try* to deviate or you will overdo it and miss the line completely. If you do stray so far that paper shows between your original line and the traced one, just fill it in with your pen. The line variations will add an expressive and dynamic touch to your contours.

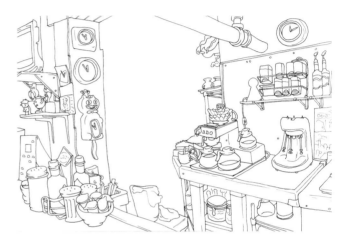

Step 3: Ink wash

Squint at your scene to observe only darks and lights. Apply one smooth layer of light (20 percent black) ink wash to isolate the highlights and bright whites. Use a fairly large brush, #6 or #8, to cover everywhere that is *not* white. Use as little liquid as possible by swabbing off the brush inside the rim of your diluted ink jar. If your paper is buckling, you're using too much water or your paper is not robust enough. Don't scrub or fuss. Hit it and quit it and let it dry.

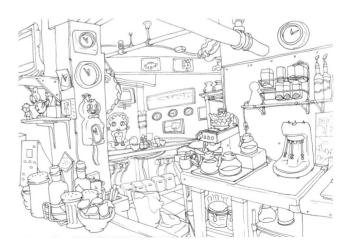

Start your contours in the foreground and work your way toward the back.

After the first layer dries completely, squint again at your subject and brush on a second layer of light ink wash to darken the shadow areas. Remember to leave your highlights white. Let it dry.

The final layer of darker wash should increase the contrast in your drawing. Since we're not applying solid blacks anywhere, it's important to assess the overall balance of tones. My beginning students tend to hold back, leaving the grisaille washed out. Remember the five tones from our grayscale (page 56) and check that you've included the entire range: the white of the paper, the three gray tones, and the darker hatching still to come.

Step 4: Final details

Finally, hatch wherever you want to further increase contrast and add details such as surface textures and two-dimensional decorations. If you inadvertently applied wash or color over the highlights, add them back in with a white gel pen.

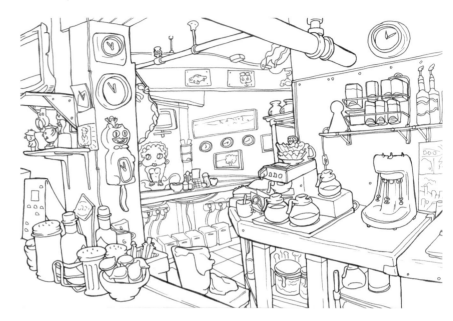

With some lines retraced to make them bolder

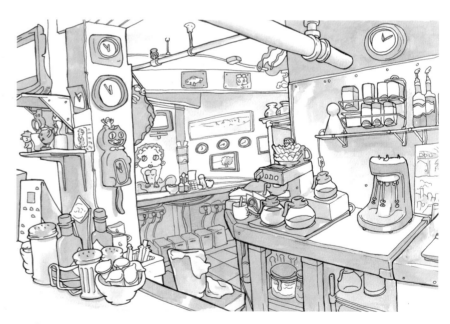

The first ink wash

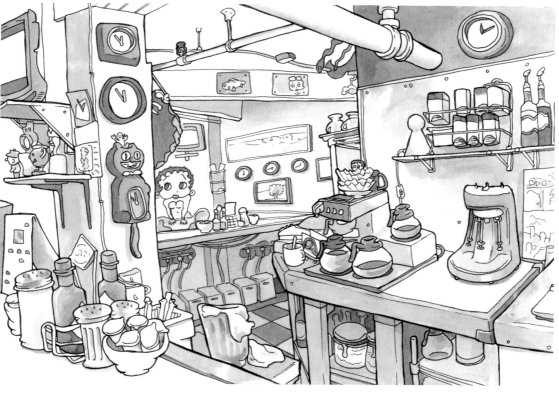

With the second and third ink washes applied

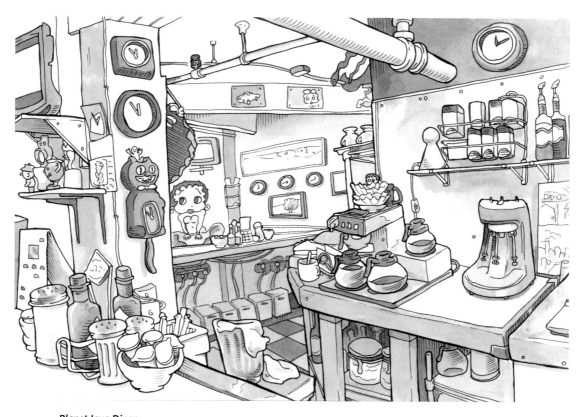

Planet Java Diner

The final drawing, with hatching

DEMONSTRATION:
IRWIN'S BAKERY

Let's walk through another interior sketch and this time, apply some color.

From my seat near the window of this bakery, the scene had a clear foreground: the nearby table and chairs; a middle ground: the deli case and archway; and a background: the far room and picture frames. I spent approximately seventy minutes on the drawing, during which time the woman in the drawing never noticed I was drawing her. I snapped the photo after I'd completed the drawing so I could include it here. It was only then that she glanced at me, probably wondering why I was taking her photo.

Step 1: Quick pencil plan

My minimal pencil guides are functional, not representational. With the major features indicated, the smaller details will take their place between them.

Step 2: Contours

I inked the foreground, ignoring surface details such as wood grain and strands of hair. At this point, I noticed that my pencil stage had squashed the square scene a bit to fit the horizontal format of my 9- by 12-inch sketchbook. So what?

I used the woman as a reference point for the detailed deli case behind her. Here is a good example of how the pencil guides serve the drawing. Notice how few objects in the deli case and

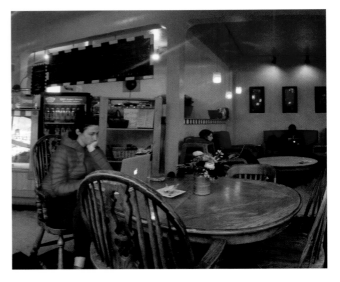
The view from my table

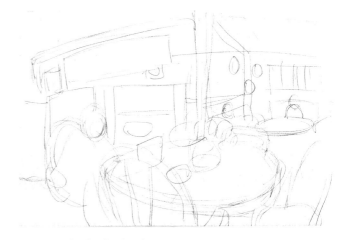
My pencil plan for the sketch

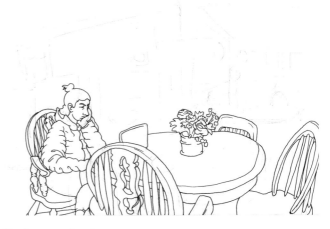
The foreground contours

shelves fit into the sketch. I didn't do this inten-
tionally. I simply ran out of space. Had I not drawn
boundaries I might have kept drawing bottles until
I hit the left edge of the paper. The guidelines told
me when to stop.

Next, I inked the distant objects, ignoring art-
work and other surface decorations that were not
contours. Then I retraced some of the foreground
contours to give them dominance and create
depth.

Step 3: Ink wash

The first ink wash covered most of the drawing,
as the room was dark and I wanted the few white
highlights to appear bright. I worked quickly with a
broad brush to create a flat gray.

The second pass, shown on page 100, darkened
areas already darkened in the previous pass.

The third and final pass, also shown on the next
page, deepened the darkest areas. If the drawing
was going to stay grayscale, now would be time
for hatching, as shown. This was a rare case where
I hatched before applying color. The hatch lines
emphasize overlapping objects, shelves, a bit of
wood grain on the table, and on the woman's legs
and furniture.

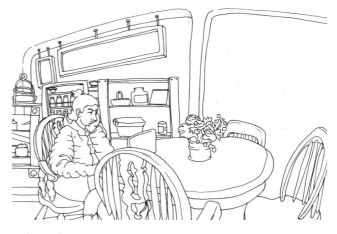

Midground contours

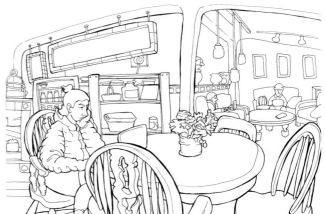

The finished contours

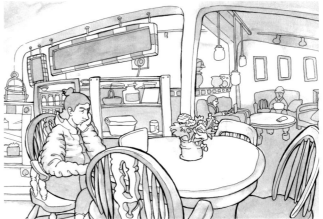

The first ink wash

Step 4: Watercolor layers

I began with a muted ochre made by adding a few drops of red and blue to the store-bought yellow in my palette. As you can see from the photo on page 98, the room was predominantly yellow, so I applied it liberally, looking for areas where varying the saturation would add detail, such as the wood grain and ceiling structure.

Then I gradually added magenta into the yellow, first subtly for the distant chairs, and then more for the flowers. Deciding how to limit the palette was easy in this case. I gave the woman's clothing some color and called it finished.

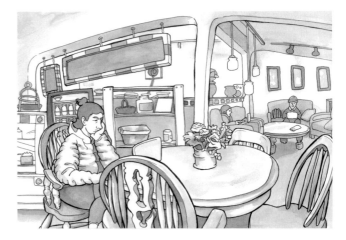

The second ink wash

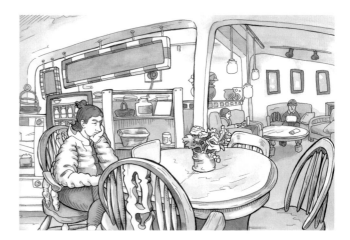

With a third ink wash and hatching added

After a wash of muted ochre

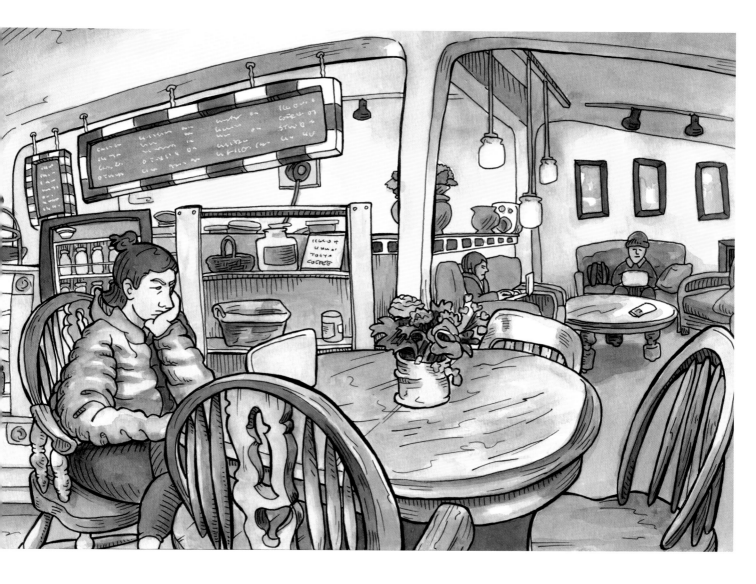

Irwin's Bakery

The final drawing, after selectively adding a magenta wash
and giving the clothing some color

EXTERIORS: LOCATION, LOCATION, LOCATION

"Amateurs look for inspiration; the rest of us just get up and go to work."

—CHUCK CLOSE

Whether you live in an apartment, condo, or house, your neighborhood has plenty of still-standing subjects for you to draw. Even if drawing houses is not your ultimate goal, they are perfect models for practicing your technique. Buildings will wait for a sunny day. They'll hold still. And they won't ask to see the drawing when you finish.

You might draw houses that catch your eye because they are unusual or easy to see from the street. I'm drawn to dense detail: bricks, stairs, shrubbery. Some are simply fun to draw. Hang drawings of your neighbors' houses in a local coffee shop. Imagine them coming in for their morning latté and being surprised to see their own homes hanging on the walls. I've done this several times and sold many drawings this way.

OPPOSITE *St. Spiridon Orthodox Cathedral*

I've drawn this church several times, once while sitting between the founder of Urban Sketchers, Gabi Campanario, and prolific New York sketcher Tommy Kane. It's interesting to see the progress in my own drawings as well as how the three of us differed in our interpretations of the same site.

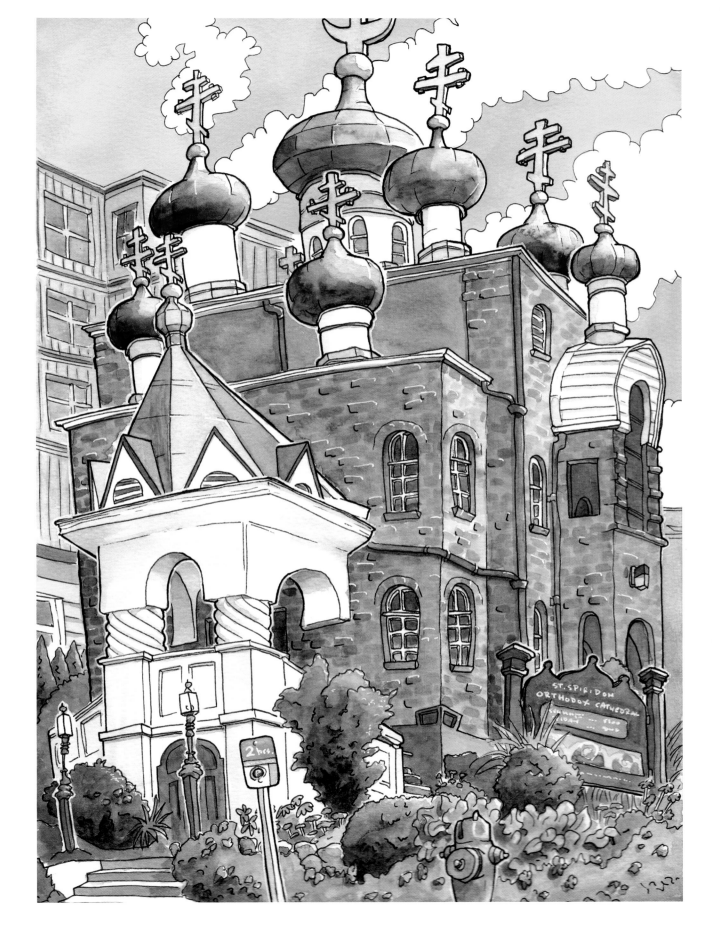

CHOOSING YOUR SUBJECT

Anywhere is a potential drawing. Just as a diarist might put pen to paper to discover what she thinks, I often discover the value in a location only after I begin drawing it. One of the benefits of drawing is the excuse to slow down and tune in to your surroundings. If you stand on a street corner doing nothing but staring at buildings for over an hour, you raise suspicions. Yet with a sketchbook on your lap, you can study a building or street corner for as long as you like. As you draw, overlooked details emerge: interesting architecture, damaged vehicles, odd landscaping.

Sometimes a house will be interesting in and of itself. Even better, draw a building that means something to you. Draw your childhood home, your friend's house, your grandparents' home. If it's a random house that caught your eye, think about why you noticed the house. The drawing is as much about you as it is about the object you're drawing.

TOP *Lego House*

This unusual house near the school where I teach caught my eye because of the contrast between the yellow bricks and large blueish planters. It looked like a design made of Legos.

RIGHT *Seattle Doorway*

Many historic buildings in Seattle are being replaced by boring, boxy condos. At least I can preserve them in my drawings. They don't make 'em like they used to.

While drawing a house, I alternate between intense focus on the subject at hand, and letting my mind wander. What drew me to this particular home? Who lives there? Did they have it built? Did they design it themselves? Is it occupied by a large family, a quiet couple, or a single bachelor? Is it an ostentatious display of wealth and privilege? Am I just jealous?

When it comes to choosing my own exterior subjects, I appreciate a skillfully done landscape or carefully observed floral but am more drawn to overlooked, ignored corners with a less staged look. I like random collections of barely recognizable clutter, using fresh eyes to look again at what we might ordinarily pass by without a second glance. I find it more inter-esting to draw scenes that are not generally recognized as "scenic." Decrepit buildings, dilapidated cars, pushed-aside mounds of scrap—all of these make good subjects for paintings. Houses and even whole neighborhoods you might not want to live in make better subjects than a new subdivision or a mall. When you're always on the lookout for things to draw, places you would have otherwise ignored look more interesting.

Draper House

The new owners of this historic home in Sidney, Iowa, came out to chat while I sketched from the sidewalk. When I finished, they invited me in for a tour. The idiosyncratic house has an interesting history and it was fun to hear how they acquired it, as well as their plans for opening a yoga studio.

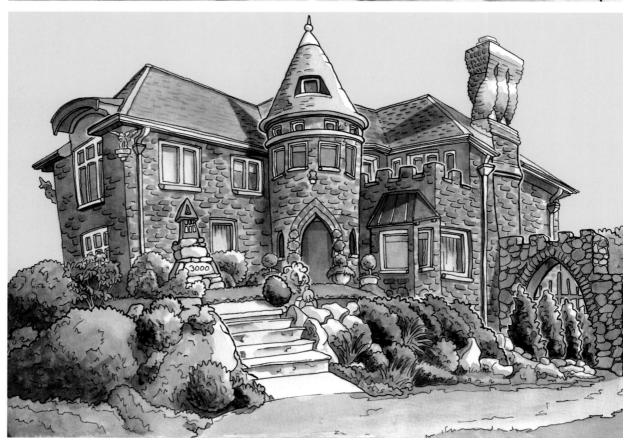

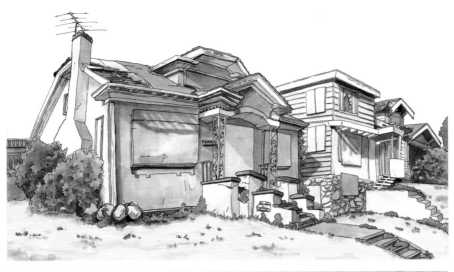

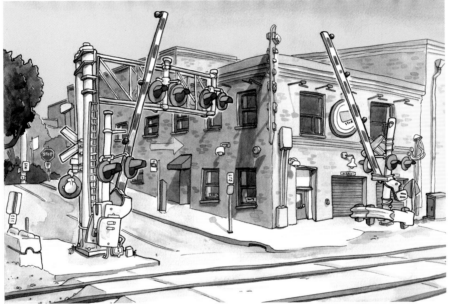

OPPOSITE, TOP *Haunted House*

Shortly after we moved into our current neighborhood, someone joked that a neglected house nearby was haunted. There was a comfy bench in the traffic circle out front, which made it especially inviting to draw. I waited for a clear day so I would have strong shadows to help define the house.

OPPOSITE, BOTTOM *Castle House*

They say a man's house is his castle. Sometimes this is literally true.

TOP *65th Street Demolition*

I live in one of the fastest-growing cities in the United States. Many iconic buildings and homes that I've drawn even in the last year are gone. It's something of a challenge to capture the more unique and historic places around Seattle before they're replaced with bland, boxy condos. When every corner in every city of the world is a Starbucks and a convenience store, what will be the point of traveling?

ABOVE *Vine Street Storage*

I drew this while sitting at a trolley stop downtown. Most people would turn to view the Puget Sound, but I drew the opposite view: a train crossing near a storage company.

OVERLEAF *50th Street Deli*

This colorful corner market was replaced with a generic furniture store the month after I drew it. I used this image as the cover of my first book, *Now Where Was I?: A Sketchbook Memoir.*

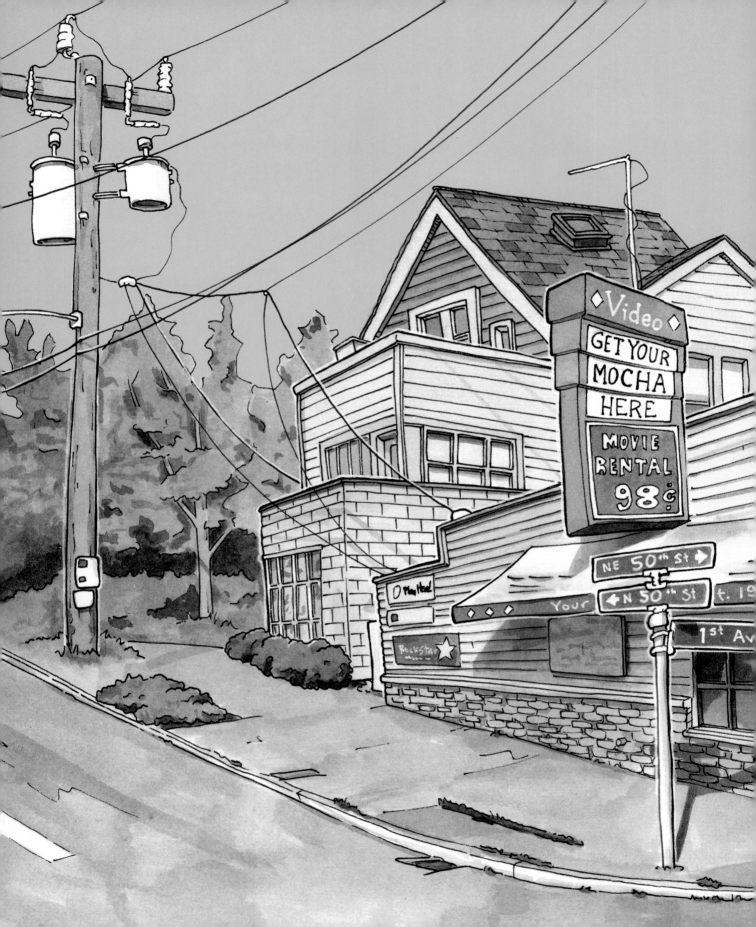

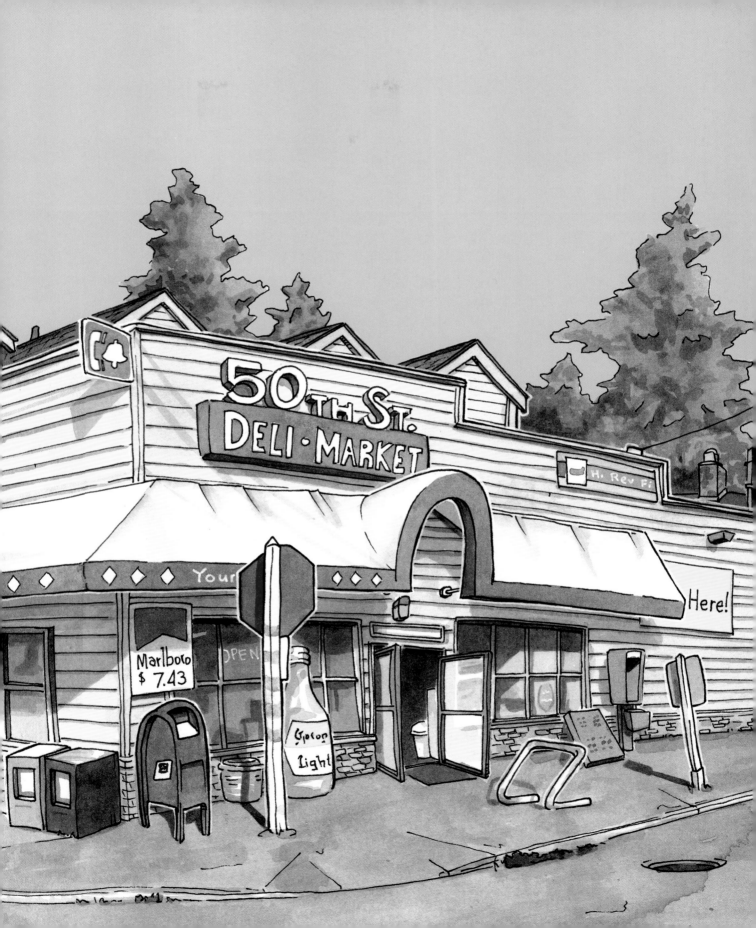

Just as the specific scenes you draw will reflect your personal interests and point of view, the long arc of your drawings will reflect the unique aspects of your city. Seattle is a city characterized by bodies of water, so it only makes sense that many of my location drawings reflect that.

TOP *Rick Miner's Houseboat*

I met Rick when he saw me sketching on the dock. Rick is a real estate agent who represents many of the floating homes on Lake Union, including the houseboat made famous by the film *Sleepless in Seattle*.

BOTTOM *Waiting for Fireworks II*

I found time to draw while waiting for the July 4th celebration with friends on the beach of Puget Sound.

OPPOSITE, TOP *1st and Pike*

Seattle's Pike Market, popular with tourists and locals alike, was too busy and crowded for me to draw comfortably, so I set up facing this intersection. Although it, too, was busy and crowded, I drew "around" the bustling people to capture a kind of ghost world intersection.

OPPOSITE, BOTTOM *Fremont Coffee Company Again*

The view from this café's comfortable porch offers fore-, mid-, and background layers, and the shady sitting area makes a nice dark frame for the drawing.

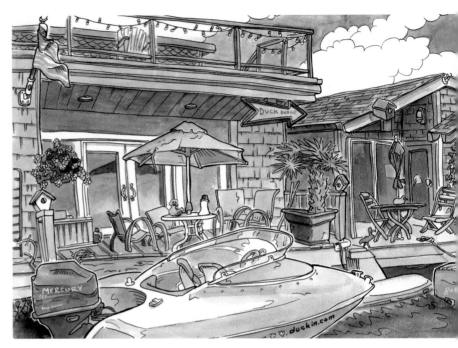

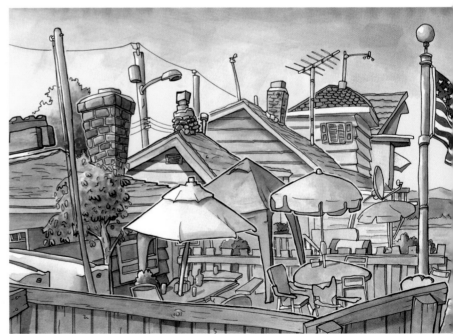

OPPOSITE, TOP *Sailing*

After a year traveling outside the United States, I drew this Puget Sound scene as a nod to how happy I was to be home.

OPPOSITE, BOTTOM *Interbay Terminal*

One advantage to choosing a scene with a lot of unrecognizable detail is that no one will know how much clutter you left out. Notice the obvious foreground (the dock on which I was sitting), middle ground (the boat), and background (the barely visible distant shore).

ABOVE, LEFT *Museum of History and Industry (MOHAI) Dock*

Drawing exteriors doesn't always mean drawing the big picture. Sometimes you don't have time, the scene is uninspiring, or your view is obstructed. In that case, narrow your field of vision and focus on what's right in front of you. In this quick sketch, depth is indicated by diminishing size, converging parallel lines, and keeping high-contrast details in the foreground.

ABOVE, RIGHT *MOHAI Ropes*

To avoid getting lost and confused by repetitive detail, such as this tangle of ropes, draw one visible section at a time, beginning with whatever is closest. And remember, if the drawing omits or repeats part of the scene, who will know?

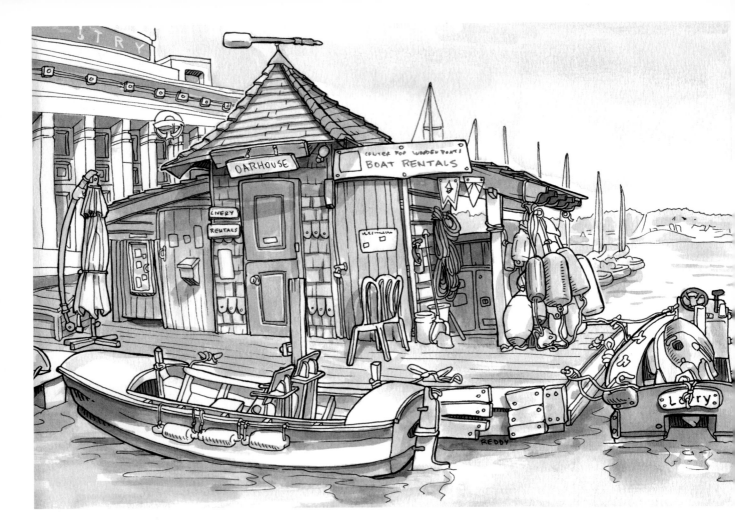

At some point after you develop a daily drawing habit, you might reach a point when you feel you're repeating yourself. You've drawn that subject, if not that exact building, before. But if you give it some thought, you'll realize you can't possibly have drawn everything there is to draw near you. Artists have been documenting the world since recorded history without running out of subjects. You won't run out in one lifetime. If you feel uninspired and bored, don't panic. It can be a good sign. From years of monitoring my own creative ebb and flow, I've learned that fallow periods usually come just before I'm about to launch into a new direction. Tired of drawing in my sketch-book, I recently took a little break and visited some galleries, went to a few art shows. Then I bought some larger sheets of 22- by 30-inch drawing paper and started a series of cluttered vintage malls. I soon had a successful art show of my own. When you feel stuck, what you are feeling is the seed of a new approach, the birth of a different way of working. You are about to explore a new technique. You're on the verge of stretching your vision.

Oar House

Hatching is used sparingly here to deepen the hollows of the boats and emphasize the curving surfaces of the boat motor and hanging bumpers. A white gel pen line helps define the panels on the Dutch doors.

ABOVE *The Evicted Fisherman*

A commitment to drawing every day, whether you feel like it or not, will force you to try something new whenever your go-to subjects, tools, or techniques are unavailable.

This simple drawing was a small breakthrough for me. I was set up on a cold November day at Fisherman's Terminal. It looked as if someone had been evicted from his storage unit and all this stuff was left outside. I didn't know what any of the stuff was; I saw it only as lines and shapes. All of my drawings up to then had been shaded with hatch lines, as in *Atlas Hatch* (right). But even with my gloves on, it grew too cold to finish all the hatch lines I would normally include. In a hurry to finish, I poured ink into my drinking water and quickly brushed in the shadows. The finished drawing didn't look like anything I'd done before. It was a "Eureka!" moment that changed the way I draw.

RIGHT *Atlas Hatch*

Nervous about attracting attention while sketching on location? Try drawing while standing in the narrow aisle of a busy vintage mall!

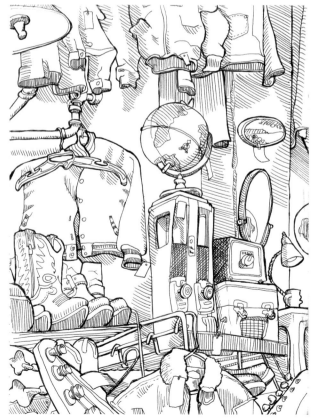

LIMITING YOUR COLOR PALETTE

Color is, of course, very subjective. You may enjoy bright, bold colors in your work. In that case, go to town. On the other hand, it can help your drawings feel unified and cohesive if you limit your color choices to a few dominant hues. Look at your scene and ask yourself which colors you can omit, or at least minimize. Experiment. Do some brightly colored drawings and others that are subtler, and see what feels more like you.

TOP *Mama's Mexican Kitchen*

I painted the brightly colored interior of Mama's Mexican Kitchen with saturated versions of the hues in the restaurant. With so many colors, there is less of a focal point and the colors compete for attention. The underlying tonal ink washes are obscured by the dominant colors.

Different scenes may call for different levels of color variety and saturation, or you may prefer more vibrant colors in general. Experiment by doing the same scene with a limited palette and again with many colors, and decide for yourself.

CENTER *Roosevelt Room*

This rental space contained every color, but I chose to paint the red and blue objects in versions of tan and brown so the finished scene would appear harmonious and unified.

BOTTOM *Trove Lamp*

I limited this scene to two dominant hues: pink and green. The colors aren't meant to be realistic, so a brown stool became green and a brown boot is now pink.

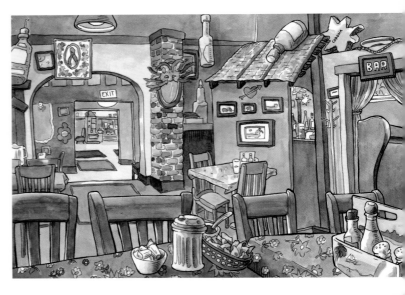

Queen Anne Condos

This was a commissioned drawing for a tenant of this high-school-turned-condo. I used the purest colors and highest contrast for the fountain shrubbery, pulling it forward to add depth to an otherwise flat subject.

DEMONSTRATION:
SARAH'S HOUSE

I was commissioned to draw this house north of Seattle as a gift for the owner, Sarah. The white balusters (the twenty or so vertical posts along the porch) were missing from the actual house, stored in the garage. Sarah brought one out so I could see the style. I posed it in several places along the rail to see how the light would hit it in each spot, then I faked the rest. I was tempted to draw the missing finial on the stair rail, but I liked the asymmetry and drew it the way I saw it.

My pencil plan for the sketch

Step 1: Quick pencil plan

Since this was a commission, I wanted the proportions of the house to be fairly accurate. I put more-than-usual thought into the pencil plan, while still keeping it loose and outlining only the placement of major features. Facing the house straight on would have shown more of the building, but positioning myself far to the left made for a more dynamic composition.

Step 2: Contours

The finished contours

With the porch the main focus, I created depth by having a clear foreground and background. Outlining all the leaves on the left took time but was worth it. I left the distant trees as mere silhouettes to keep them from competing with the house.

Step 3: Ink wash

Because it can take two hours or more to draw a house, the light will change and shadows will morph, stretch, or shrink. When I drew the contours, the house was completely in shadow. By the time I was ready to apply the ink washes, the sun had crept over the roof to give my scene dynamic shadows.

Step 4: Watercolor layers

Limit your color palette to unify the different parts of the drawing and retain the linear aspect of this technique. If you use too many colors, the contours and fine details will be lost. Even though the house was white, I introduced blue and tans to ground the building in its surroundings.

Step 5: Final details

I used a white gel pen to emphasize and bring forward the nearest stair rail and the porch posts, and to add little highlights to many of the leaves. I didn't add hatching on this drawing because the leaves and siding were clearly defined.

With the ink washes completed

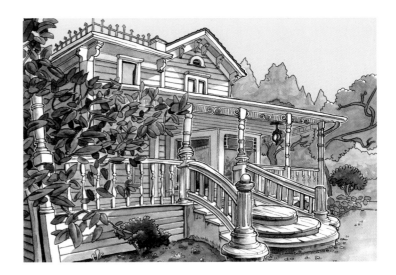

Sarah's House
With the watercolor layers and final details complete

CLUTTER: EMBRACING COMPLEXITY

"How vain is painting, which is admired for reproducing the likeness
of things whose originals are not admired."

—BLAISE PASCAL

A common obstacle for students in beginning drawing classes is learning to draw what they see, not what they know. When seeing directly, there's no difference between drawing a vehicle and a cat. Both are composed of edges, volume, tone, and—if you choose to go there—color. Even the densest and most detailed scenes can be apprehended as a collection of simple geometric shapes: cubes, cones, cylinders, and spheres. They are simply arrangements of mass and space, lines and shadows, geometric solids stacked and arranged in different configurations.

Knowing this is helpful when tackling a subject that at first glance may seem daunting in its complexity. Don't shy away from intricate scenes of detail and disarray. Anything can be drawn. Spend less time wondering if something will make a "good" subject or not. Just sit down and get on with it.

OPPOSITE *Plumes*

Even a complex scene like this vintage store display can be drawn as a collection of simple solids, differentiated by colors and fine details.

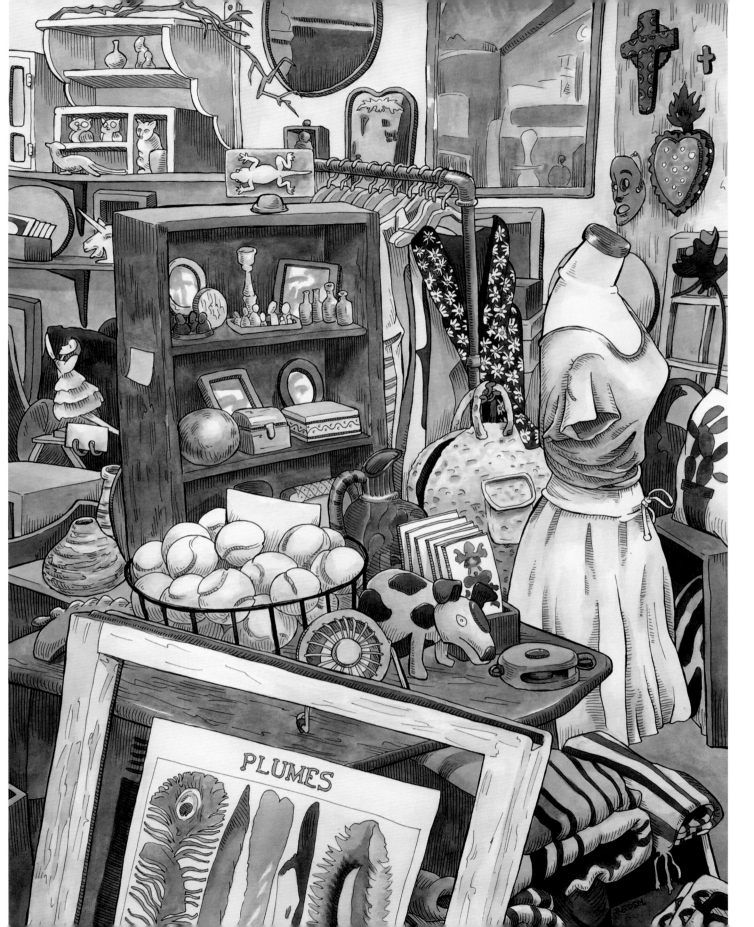

SEEING BEYOND THE CLUTTER

As we navigate the world, we "chunk" repetitive information to save time and preserve cognitive energy for learning new things. After learning that an object is an "apple" and that another object, which bears only a categorical resemblance, is also an "apple," we create a construct for "apple" that looks like neither of the actual apples. Then, when we attempt to draw an apple, we rely on the construct and draw our time-saving symbol: a red circle with a stem. The symbol is a useful shortcut when communicating that we are hungry, but is a distraction when trying to draw any one specific apple.

I wonder if toddlers learn the names of things at the cost of dulling their senses? Where before there was the immediate and direct apprehension of the vibrant and pulsing everything, there follows a filtering screen of vocabulary and distancing verbiage. Better to forget, or ignore, what you think the object is. Better to not think at all, but to see the apple as a baby would, without understanding anything about it. With that mind-set, it doesn't make sense to say, as I often hear, "I can't draw people," or, "Trees are hard." Some drawing exercises, such as turning a reference photo upside down, or drawing only the negative spaces of a scene, are designed to help us see around the symbols.

When drawing a cluttered scene—or any scene—forget labels and simply see things as themselves, without the distracting and bent telescope of categories and utility. Look at the thing, whatever it is, without "knowing" or recalling anything about it, and record your observations as if seeing it for the first time, as a collection of lines of relative lengths and various levels of hue and saturation. If you draw what you see and not what you know (or think you know), you'll produce a drawing that looks more like the object before you.

Chair

When drawing, we can see an object called a "chair," but naming it makes it harder to see that this particular object—this "chair"—actually has squat legs, an uneven seat, and a reclining back.

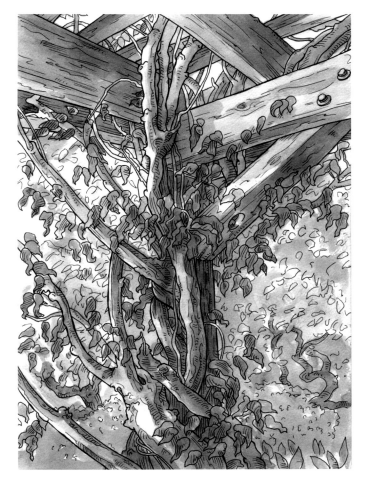

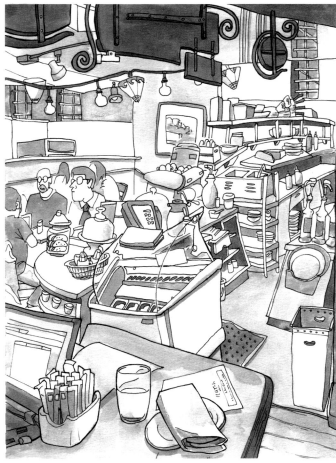

ABOVE, LEFT *Park Tree*

Although this is clearly a drawing of a tree, it wouldn't have served me to think, "I'm drawing a tree" while I was drawing it. If you close your eyes and picture a typical tree, does it look anything like this one? I doubt it. Better to just observe the lines. They intersect, run parallel, diverge, overlap, end. When applying the washes, I squinted and built up darks where I saw them, regardless of what they were. Mid-drawing, you may wonder how the pieces will add up to something recognizable. But when the two-hour Urban Sketchers meet-up ended, there it was: a tree.

ABOVE, RIGHT *Vios Restaurant*

When you approach a cluttered scene, try not to over-think it. Focus less on *what* you are drawing and just record the lines, shapes, and tones as they appear to you. I drew no guides of any kind, and it shows. Parallel lines taper off drunkenly, right angles are crazily obtuse and acute, horizontal planes tilt as if made of rubber. I wasn't obsessively concerned about the "rules," making this bustling, noisy, living café a joy to draw.

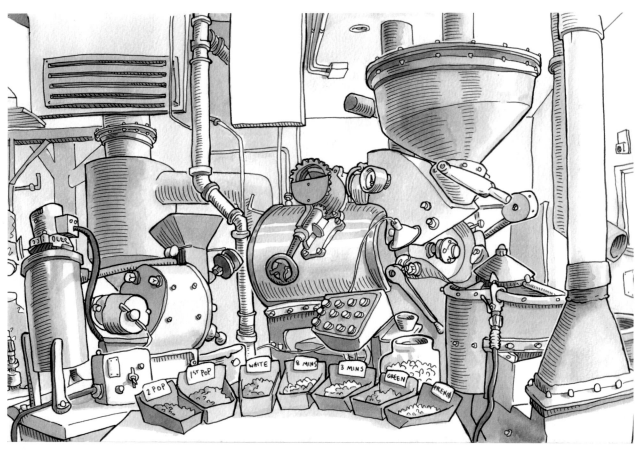

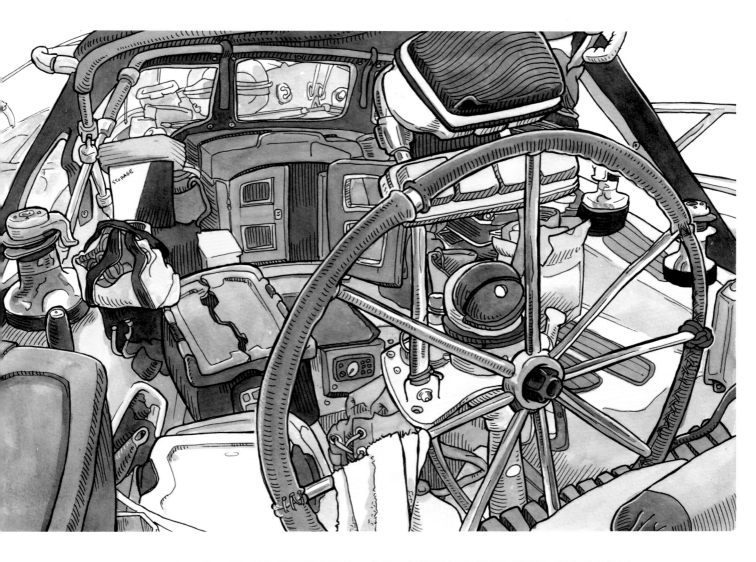

OPPOSITE, TOP *Caffe Appassionnatto Roaster*

A cluttered scene will be easier to draw if, in your mind's eye, you can see it as a collection of the four geometric solids (cube, cone, cylinder, and sphere). The manager of this coffee shop contacted me to suggest I might like to draw this big beautiful collection of geometry, and even served me a free mocha while I did so.

OPPOSITE, BOTTOM *Georgetown Bricks*

Be open-minded about what will serve as an interesting subject. The Georgetown neighborhood in Seattle holds an annual garden walk and the Seattle Sketchers met to draw the colorful residential gardens. While walking to our meet-up point, I saw this cluttered "urban still life" and couldn't resist setting up my portable stool in the cluttered alley.

ABOVE *Sailboat Clutter*

My friends Heidi and Kirk live full time on this little sailboat, blogging about their adventures as they freely wander the globe. I drew this scene as they prepared for another around-the-world journey.

EMBRACING THE CHALLENGE

When faced with a particularly complex scene, you might be tempted to take photos and refer to them later to finesse your drawing and "fix" inconsistencies, or even just draw from them entirely instead of from life. Though of course photos are sometimes necessary, I encourage you to draw from direct observation whenever possible, no matter how intimidating your scene.

One of the many disadvantages of working from photos of a cluttered scene is that you can't move closer to analyze objects or relationships that are obscured or confusing. For example, had I been on location when drawing the objects reflected in the large mirror in *Aging Fancies* (page 130), I would have walked over to see what they were. As it was, I could only re-create what I saw in the photograph.

Yes, it is more challenging to draw from life. The scene you draw on location is living and dynamic. Lighting changes as the sun and its shadows lengthen and slither over your subjects. People shift around even while sitting still. Wind blows and trees wave. Even if the world were to freeze for you, like a disciplined life model, *you* continue to move. Your head tilts, your gaze shifts, your shoulders get tired and sag, your leg goes to sleep so you shift positions. With each blink your pupils expand and contract, changing the contrast and brightness. These challenges are features, not bugs. Letting real life influence your drawing will animate the finished piece in a way photos won't.

Working from photos—or being overly concerned with realism—will deaden your drawings. If you relax and draw what you see, your drawing will have an interesting quality of being alive, which, of course, it is. It's natural that the objects in your drawing will seem fluid and shifting. The scene you began drawing is not the same scene you see at the end.

If you do find that you have no choice but to draw from photos, avoid the temptation to tighten up and draw careful pencil layouts. I consciously treat the photo as if I'm on site and use the pencil for only minimal guidelines.

OPPOSITE, TOP *Trove Vintage Boutique Color*

For a show of large drawings (30 by 22 inches), I had to work from photographs because setting up with paper that large in many shops wasn't practical. In this case, I took several photos inside the shop and used two of them for references, combining the two scenes into one. When drawing from photos in my studio, I take the same approach as when drawing on location: very few pencil guidelines and then drawing directly in ink with my Uni-ball pen.

OPPOSITE, BOTTOM *Mort's Cabin Again*

Mort's Cabin is a densely packed little shop of Northwest-themed furnishings and accent items. The narrow aisles barely accommodate a single shopper, let alone a sketcher with a stool and a sketchbook on his lap. The owner told me not to worry and even offered me tea while I worked.

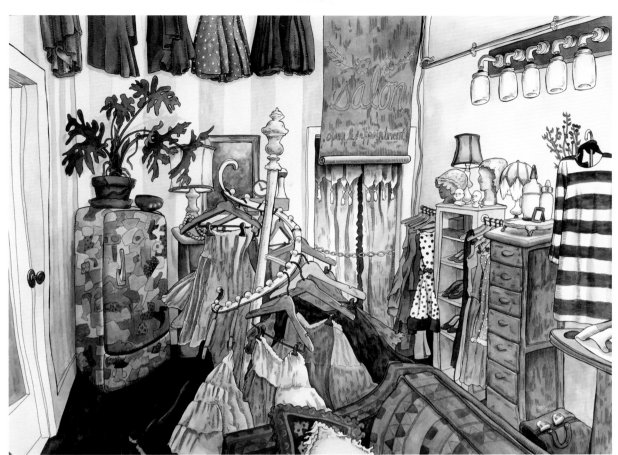

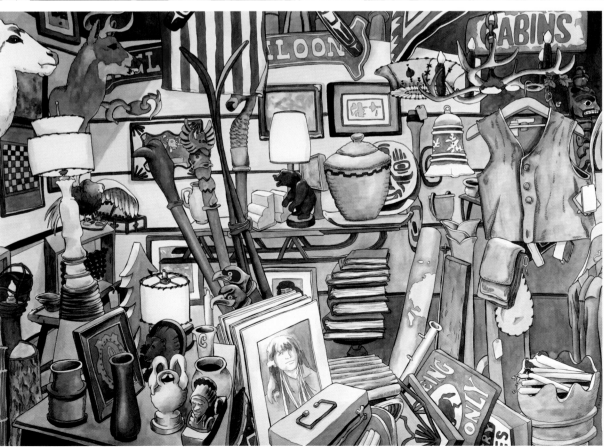

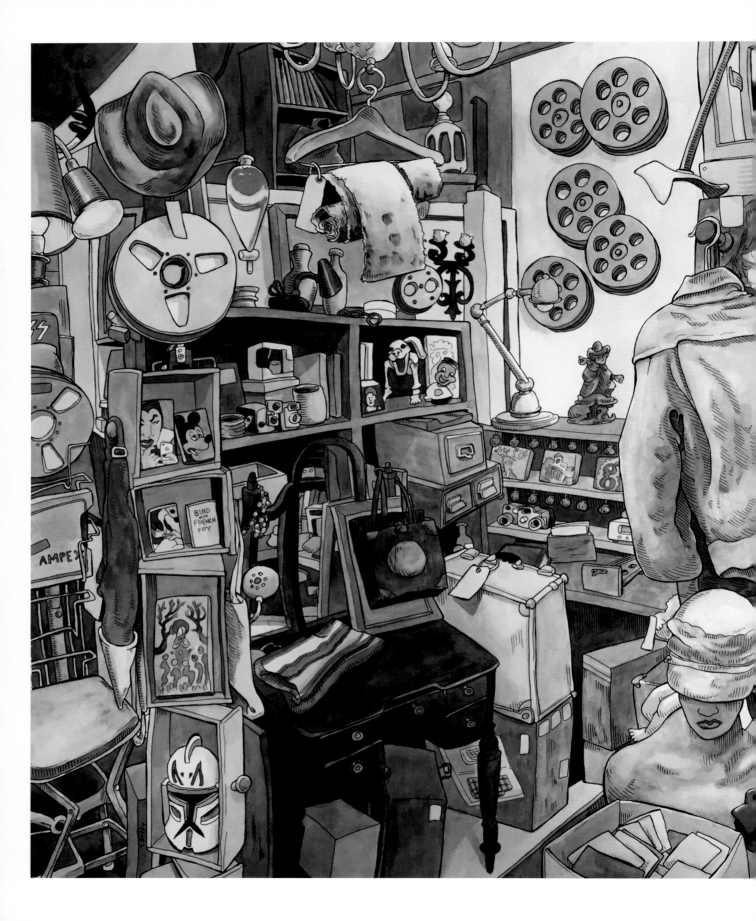

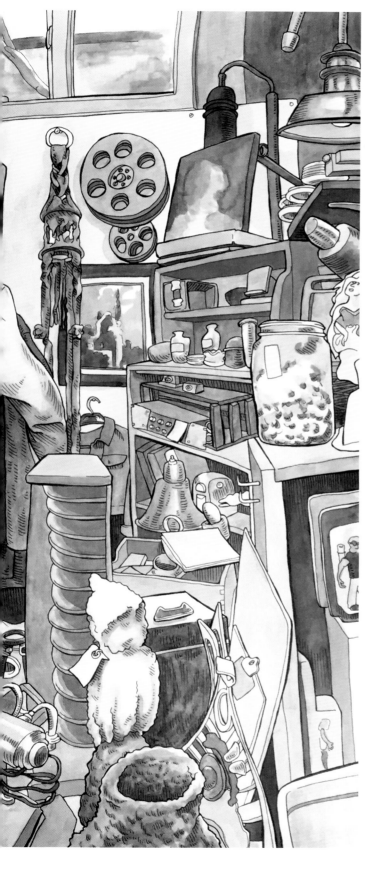

Atlas Reels

Vintage malls and antique stores are like giant, complicated still lifes. From tiny, crowded rooms in the owner's home to vast consignment malls with numbered stalls, it's easy to find interesting displays to draw. This is only one stall in a large antique mall where I've sketched dozens of drawings. I come often and never run out of gorgeous still lifes because everything changes as items are sold and restocked.

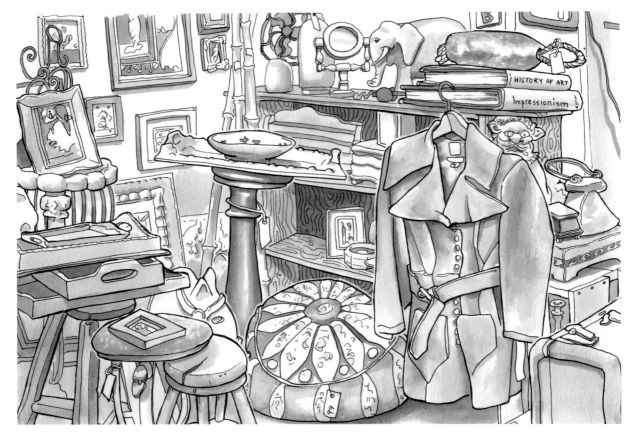

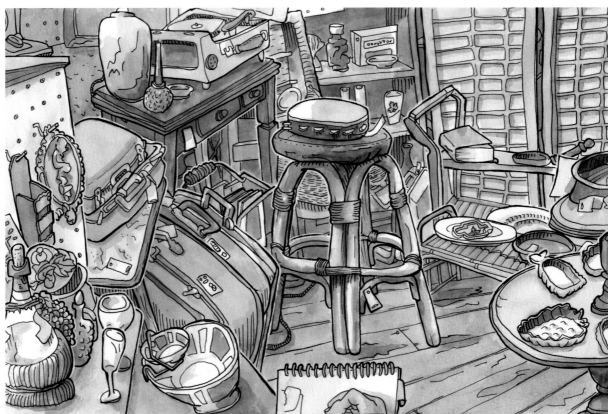

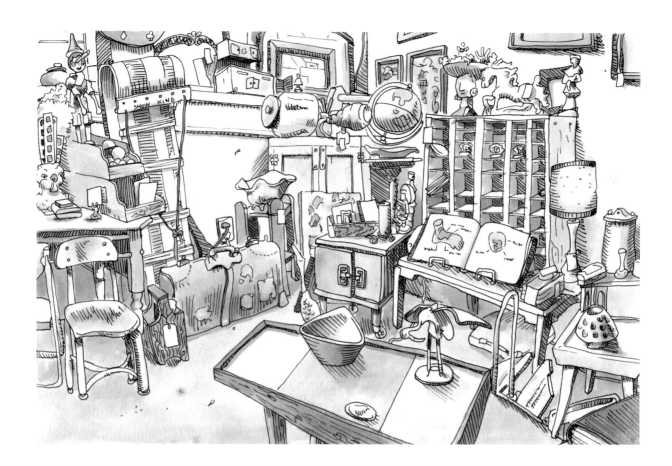

OPPOSITE, TOP *Atlas Vintage Mall Jacket*

I love drawing in this mall and return often. The merchandise changes so often, the store never looks the same twice and offers an endless choice of page-filling still lifes. This drawing is a rare case in which I applied no hatching.

OPPOSITE, BOTTOM *Atlas Tamborine*

I began by drawing my own hand and sketchbook, then moved clockwise to the bowl, the wine glasses, the bottle in the wicker cozy and its cork, and so on around the picture. Whenever I drew something too large, such as the suitcases, I omitted something else to compensate. Who's to know? The same went for the slats on the floor and the number of books on the shelf. Without counting, I just focused on one thing at a time, teasing out the scene, selecting whatever seemed most interesting at the time. I made my way around the perimeter, making sure to draw the foreground objects first. It's fun to watch how the pieces of the puzzle fit together.

ABOVE *Atlas Table*

Another favorite of mine, this drawing was done very quickly. Perhaps because of that, it has a looser style (maybe only noticeable to me) that surprised me.

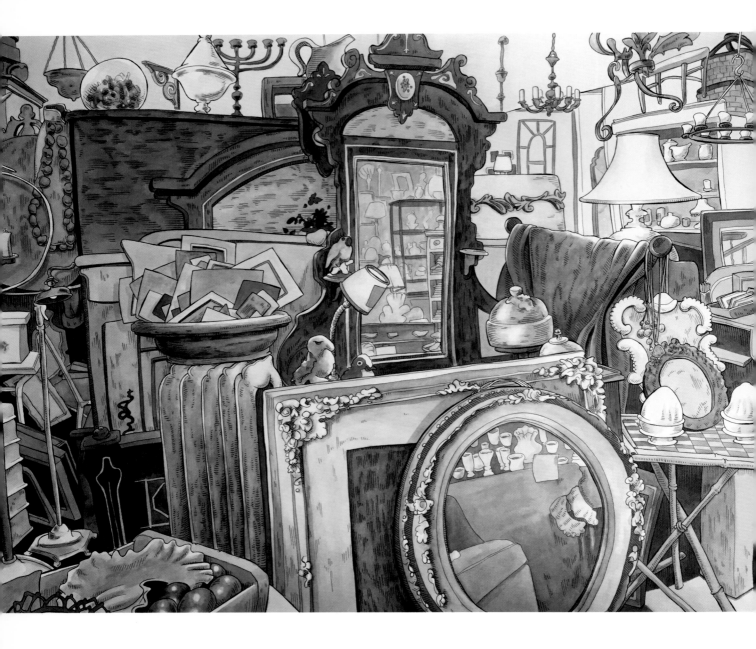

ABOVE *Aging Fancies*

I made this large, 22- by 30-inch drawing from photo references I took in an antique shop.

OPPOSITE, TOP *Mort's Cabin Totem*

This corner of Mort's crowded vintage store is the perfect still life. It's also a rare instance in which I applied almost no hatching. To help differentiate the central totem pole from the surrounding clutter, I gave it a fine white "halo" using a Gelly Roll ball point pen.

OPPOSITE, BOTTOM *Old Bridge*

Drawing a pile of rocks and driftwood, as in the bottom of this sketch, can be as challenging as you want to make it. Use the visible rocks to inform your contour lines, and if you leave some out or inadvertently rearrange a few while drawing, who will know?

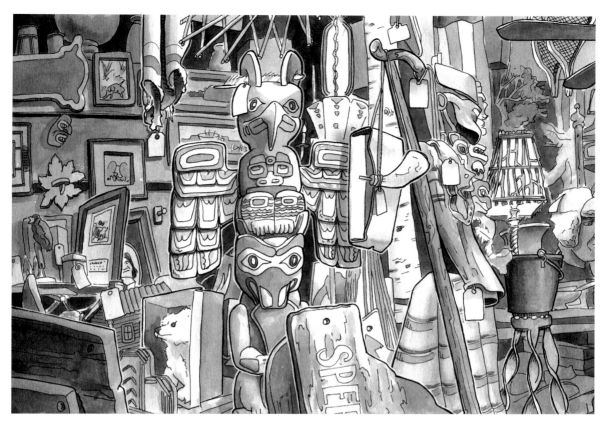

DEMONSTRATION:
SEATTLE SOUND REPAIR

An avid walker, I passed by this instrument repair shop and happened to glance in the window. I knew I had to draw it, and the owner, Marie, was kind enough to let me sit at her workbench one afternoon while she sat at another desk doing bookkeeping. If you look closely, you can see her in my final drawing.

Step 1: Quick pencil plan

Marie was kind enough to let me sit at her workbench while the shop was open, so I was determined to be quick as possible. My pencil plan is only detailed enough to show the general placement of the bench, her motorcycle helmet, the trash can, and a few of the sorting cubbies on the wall.

Step 2: Contours

Note the differences between the scene as photographed and my finished contours. The air compressor had an interesting geometry, so it emerged larger in the drawing. The drawer is noticeably narrower. Had I drawn from the photo, I would not have known there were storage containers under the main drawer. Also, note how I've simplified the tools hung on the backboard and the details below the helmet, yet the drawing still reads as plenty cluttered.

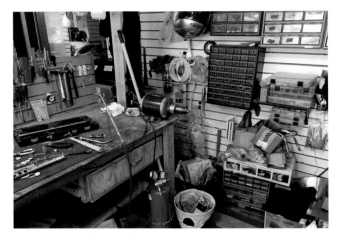

The workspace I chose to draw

My basic pencil plan

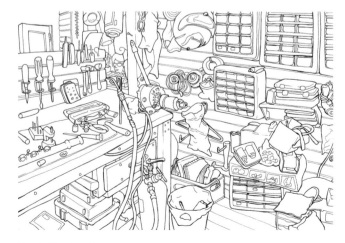

The finished contours

Step 3: Ink wash

There's very little in this room that is pure white, so I brushed on a light ink wash almost every-where. Remember, I'm not painting shadows, just isolating the white areas. To bump up the contrast in the foreground, I left the red wall white.

The second and third ink washes were applied within the areas covered by the first wash; only previously toned areas are darkened. Anywhere left white will stay white. Here, I was careful to leave the white of the paper untouched for the shiny hardware of the lathe, the compressor, and the cymbal on the floor so they would look metallic.

Step 4: Final details

I added hatch lines to the lathe and cymbal to increase the contrast and help give them a shine. I also drew lines to create wood grain on the bench and on the air compressor to clarify its cylindrical shape.

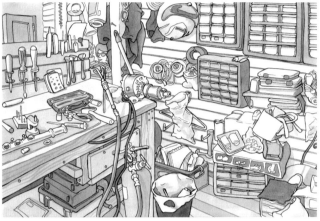

After the first ink wash (top), and the second and third ink washes (center).

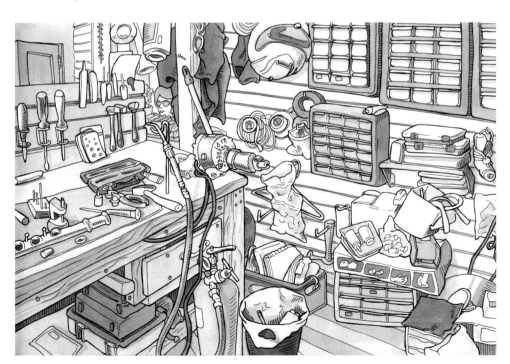

SEATTLE SOUND REPAIR

The final drawing with hatch lines added

PEOPLE: STEALTHY SKETCHING

"If you're drawing humans, it can be detrimental to be too naturalistic, which is like animating little corpses."

—HENRY SELICK

If you can draw people, you can draw anything—or so the thinking goes. It's harder for artists to get away with distorting humans than, say, trees, because we're instinctive judges of the appearance of humans. Being people ourselves, we know immediately when a drawing of a person is "off."

On the other hand, why should drawing people be any more stressful than drawing anything else? Try not to think about *what* you are drawing and simply enjoy the process of laying down line, tone, and color. I approach drawing people just as I tackle any other subject: drawing the details that catch my attention and allowing the sketch to reflect my interests. Isn't that the point? Your drawings are about how *you* relate to your surroundings, and that includes the other inhabitants.

OPPOSITE *Fuel Coffee*

It's helpful to have a friend with whom you can spend an hour or more over a meal or coffee, both of you contentedly working across the table from each other. Busy people who can work on a laptop or iPad while you sketch make great subjects, and it can be a comfortable, relaxing way to spend time together.

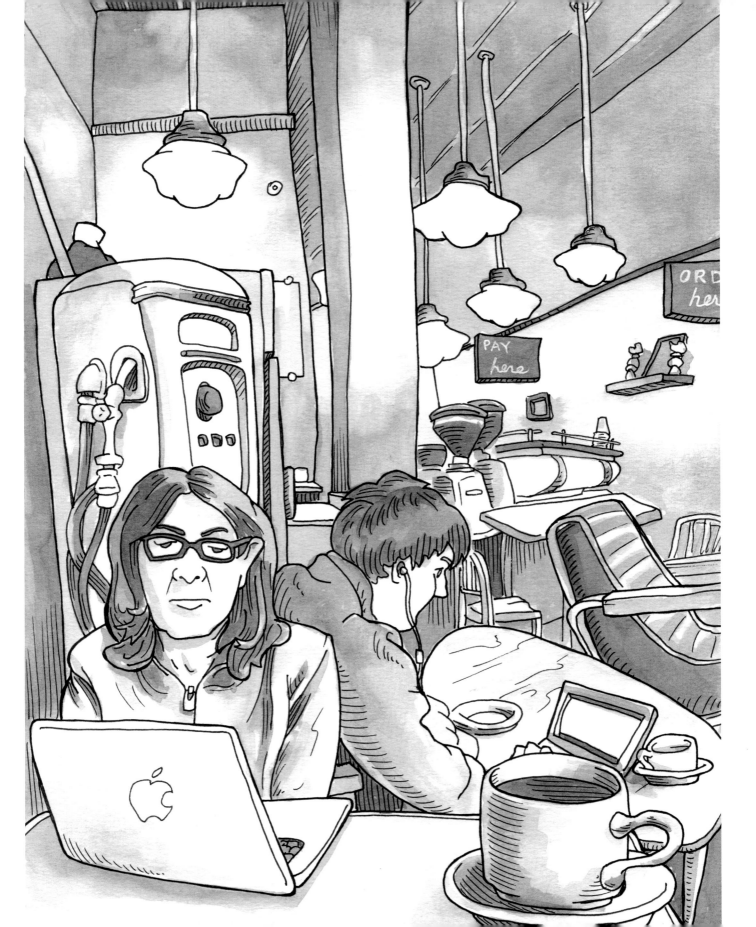

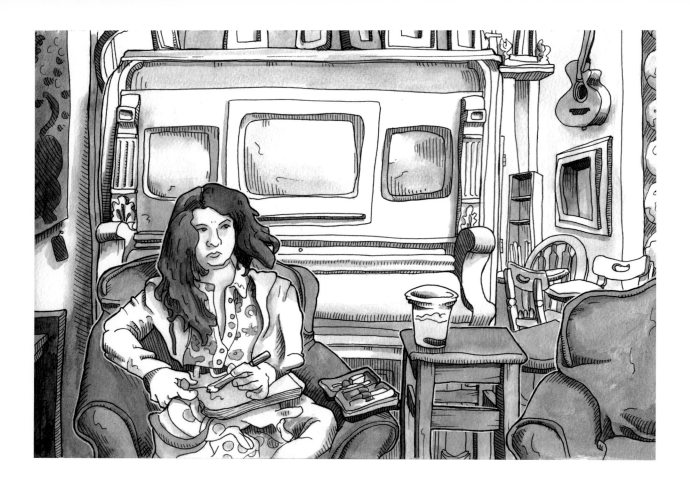

DRAWING FROM LIFE

People are endlessly fascinating to draw, and once you get in the habit of looking for subjects, you'll find them everywhere. Coffee shops, of course, but you can also find fairly stationary human models in libraries, waiting rooms, and on buses. I draw while sitting in audiences and during staff meetings. Colleagues and students have grown accustomed to seeing me sketch at work.

I try to be as unobtrusive as I can. I've never, to my knowledge, been caught sketching someone who didn't want to be sketched. People are consumed by their own work, lost in their earbuds, or too busy browsing the internet to

ABOVE *Donna Drawing*

If my partner Donna looks like a different person in many of the drawings of her throughout this book, it's because I rendered her with the same spontaneity as the inanimate objects in the scenes. Creating a faithful likeness would take much longer than I want to spend on any drawing.

OPPOSITE, TOP *Post-Surgery*

Keeping Donna company after her surgery was a good opportunity to draw a captive model. Here she is surrounded by exactly the kind of geometric clutter I love to draw.

OPPOSITE, BOTTOM *Donna Recuperating at Home*

I included the chocolates and flowers to create a foreground for this drawing, leaving the details outside the window vague and unfinished to imply depth.

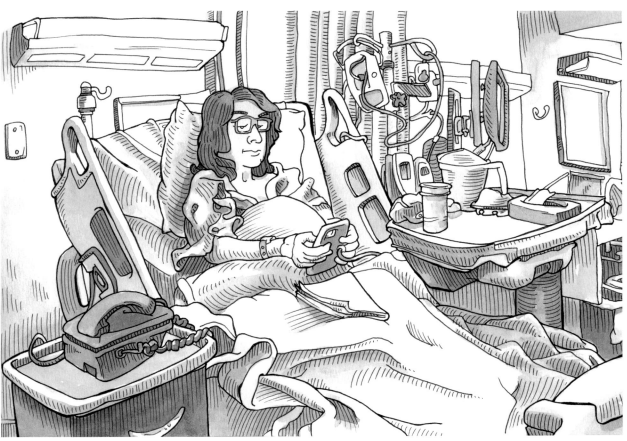

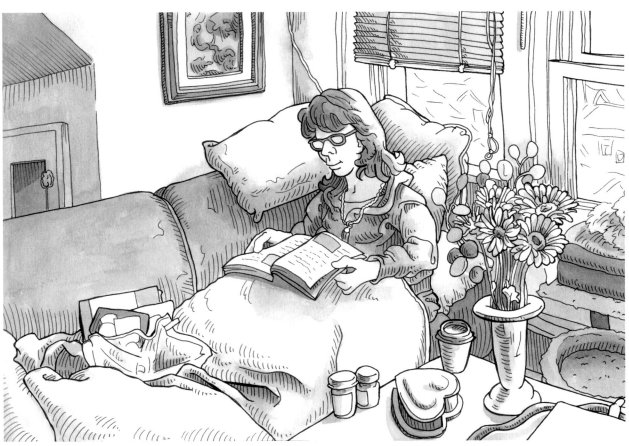

notice you drawing them, unless you call attention to yourself. Sit back with your sketchbook resting on your lap and propped against the table. Relax and avoid staring at your subject.

To make things a little easier, don't feel obligated to include every person in your field of vision. Kids—and parents with kids—are a challenge. Pick and choose who to include. If someone appears about to leave, omit them. I've drawn many scenes that were full of patrons and pedestrians but was selective about who I included.

When drawing quickly in ink, it also helps to relax your expectations about drawing faces and figures. Unlike the inanimate still life or cluttered coffee shop, people don't hold still unless they're paid to do so. Quickly drawn portraits will be asymmetrical. Anatomy will be wonky. Your human subjects may not be recognizable. And for these reasons, drawing people is an invaluable exercise.

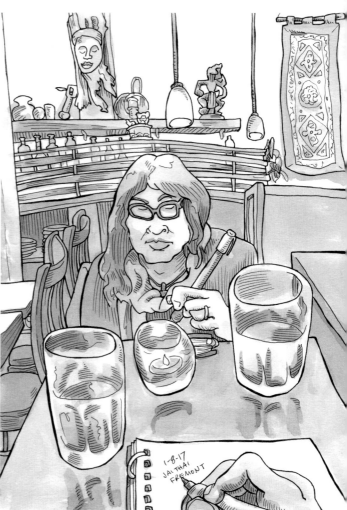

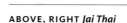

ABOVE, LEFT *El Diablo Coffee*

If you're intimidated about being caught sketching someone, or just want to draw without being observed, coffee shops provide plenty of subjects who are too engrossed in their laptops, phones, and books to notice you, especially if you sit behind them, as I did here. In the lower right I've placed my novel and lunch to create a foreground.

ABOVE, RIGHT *Jai Thai*

Like a batter warming up with two bats, drawing under less than ideal conditions is great practice. It was a challenge to draw in the dim candlelight of this Thai restaurant. I could barely see the page as I quickly drew the scene while we waited for our dinner.

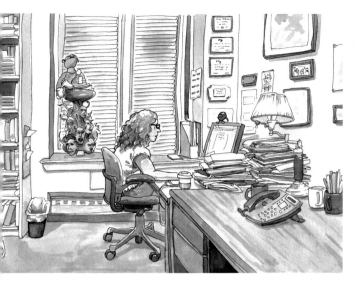

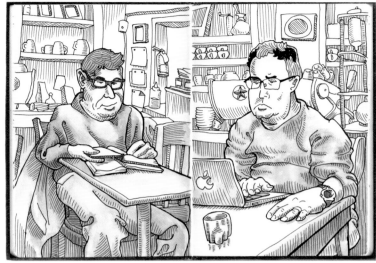

ABOVE, LEFT *Jackie at Work*

Waiting for my friend to finish up some work in her office at Seattle University.

ABOVE, RIGHT *Two Men at Zoka Coffee*

Neither of these guys were aware that I was sketching them in my little Moleskine book, though I was just a few feet away.

LEFT *Library Patron*

The library is filled with people too engrossed in reading to notice you drawing them.

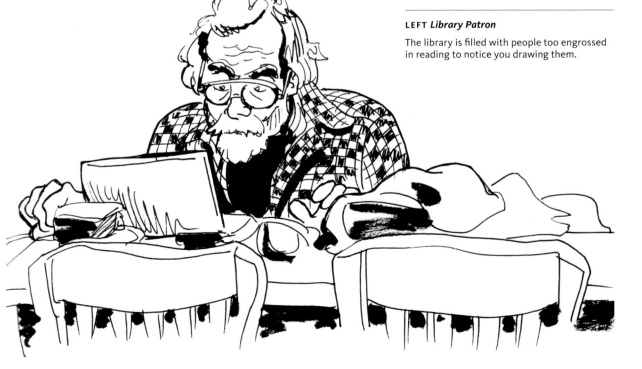

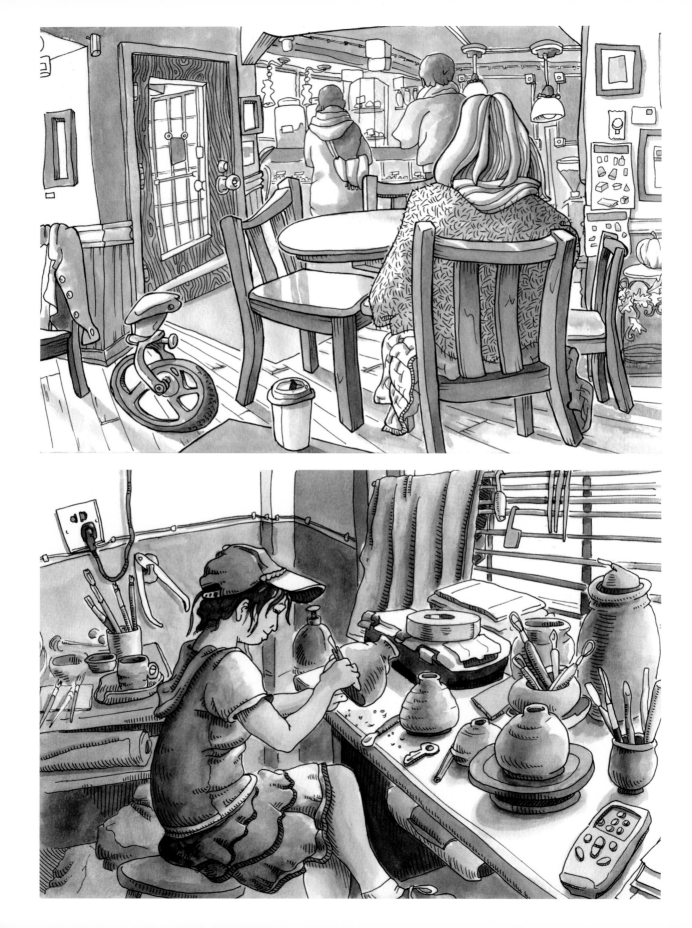

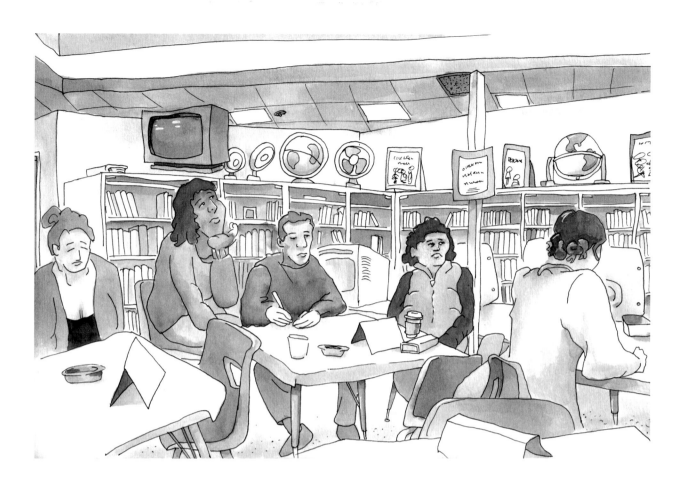

OPPOSITE, TOP *Lonely Wheel*

The odd, forlorn unicycle in the bottom left of this drawing was the front wheel of a stroller. The distortions are due to the mother constantly "rocking" the thing to lull her infant to sleep. Before I moved beyond this one detail, her coffee order came up and she left! Rather than be dismayed, this drawing serves as a more accurate reflection of the moment than had I finished the entire stroller.

OPPOSITE, BOTTOM *Gao Ling*

While teaching in China, Gao Ling was my translator, guide, and friend. She showed me how to find the things I needed, took me to interesting sketching locations, and gave me tours of local art studios and galleries. I drew her while she etched Chinese characters onto clay pots at the Ceramic Institute in Jingdezhen.

ABOVE *Staff Meeting*

My colleagues are accustomed to seeing me off to the side sketching during meetings, though some school principals are more open to it than others!

Another option—especially if you prefer more stationary models—is figure drawing classes, which are offered by most colleges. You might also find privately organized drop-in figure sessions. Check online or on the bulletin boards at art stores and coffee shops.

Anatomy Notebook
Random notes from an anatomy class.

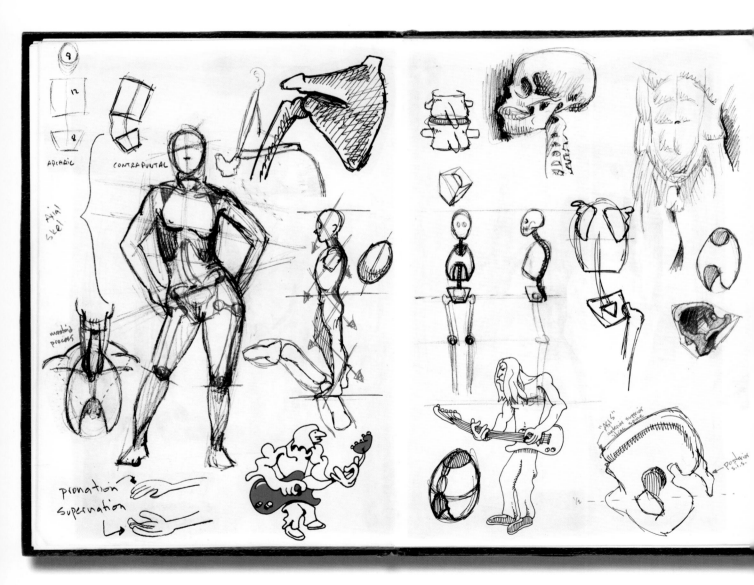

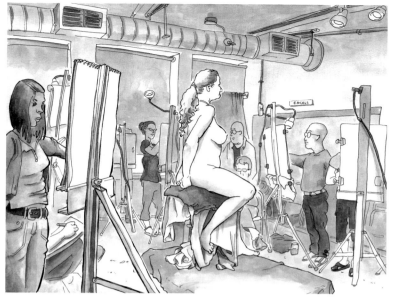

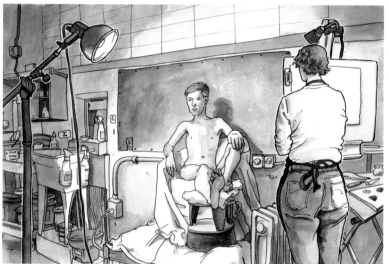

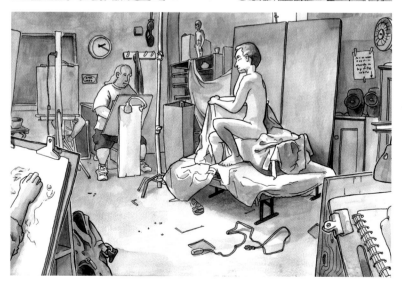

Live Model Sessions

Live figure sessions, such as these held by Gage Academy, are good places to practice: not only does the model hold still, but so does everyone in the room. I had to work quickly to take in the whole room, which reduced any impulse to get fussy.

DRAWING FROM PHOTOS
(IF YOU MUST)

Dustin

Dustin's mother is a fan of my work and had shared my online classes with her son. By coincidence, Dustin recognized me sketching at a coffee shop and asked me to draw him as a gift for his mother. Since the drawing would be in color and I wanted to take my time, I snapped some reference photos and completed the drawing at home.

As discussed in the last chapter, there are many reasons why I prefer drawing from life rather than from photos: engagement with the world, drawing with friends, learning to sketch quickly without fussiness and criticism, learning to capture essential information in short bursts, learning to trust your gestures and instincts. However, drawing from photos can be helpful for many reasons as well. When given a commission, I often work from photos because my subjects are not trained models and sitting for more than an hour can be a challenge. Even if willing, they may not have the time.

I also keep a comic book diary and often want to depict some thought, event, or conversation from earlier in the day. I draw these mostly for myself, the way others might keep a diary. If I'm lucky, I'll have taken reference photos during the day or, if the location is near my home, I can go back to shoot

Graying Hair

Sagging Jowls

Slouch

Receding Hairline

Failing Vision

Unfocused Hearing

Perpetual Scowl

TAKING INVENTORY

Varicose Vein

Softening Butt

Wonky Runner's Knee

references. If I don't have my own photos, a Google image search usually provides photos I can use. They won't be exactly what I saw, of course, but for a personal diary, they're close enough.

The newspaper is another daily source of reference photos. If you challenge yourself to draw from whatever photos appear in the paper, you'll be forced to draw people, places, and things that you might not otherwise gravitate toward. This practice will come in handy when you're drawing on location and need to draw people quickly and simply. It's also a good way to stay informed about current events!

ABOVE, LEFT *Pizza Maker*

Drawn from an article in *The Stranger*, a Seattle weekly newspaper.

ABOVE, RIGHT *Self-portrait*

I rarely draw myself, but I asked a passer-by to snap a photo reference so I could draw this selfie for my memoir, *This Is Then, That Was Now*.

TOP, LEFT *Family Photo in Gray*

TOP, RIGHT *Family Photo Hatched*

BOTTOM, LEFT *Family Photo with Black*

I sketched these three family photos found in a shoebox to practice different inking techniques: hatching, using solid blacks, and ink washes.

BOTTOM, RIGHT *Parisians*

I was moved by a photo on the front page of The Seattle Times showing French people mourning in the streets after a terrorist attack and turned it into a drawing.

OPPOSITE, TOP *Obituaries Grid*

Portraits drawn from newspaper obituary photos.

OPPOSITE, BOTTOM *Land of the Giants*

Sometimes I want to draw from my imagination, or to experiment for no other reason than to play. This strange drawing is collaged from family photos, Internet images, and stills from a play I was in.

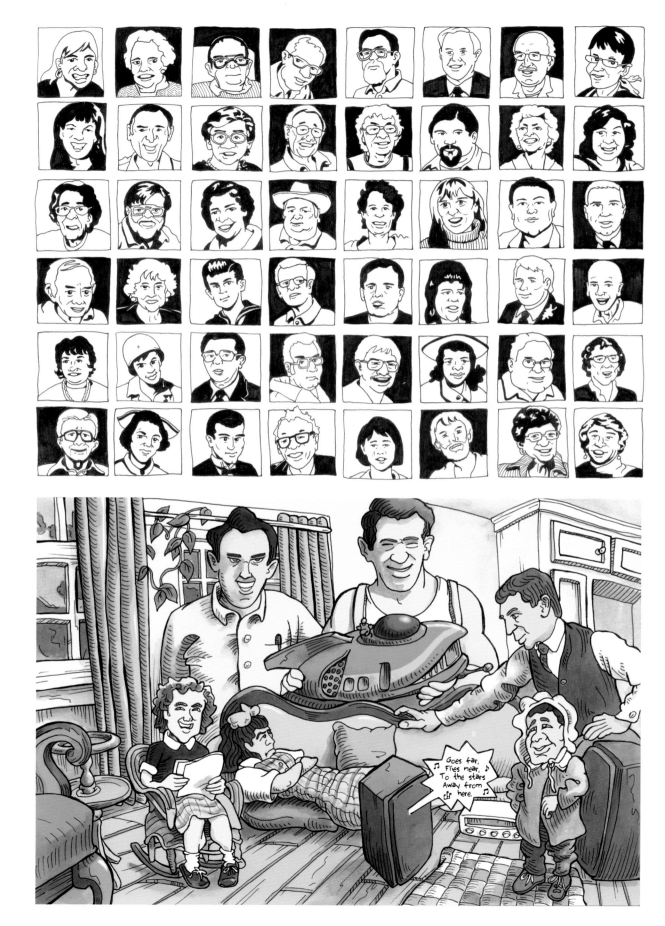

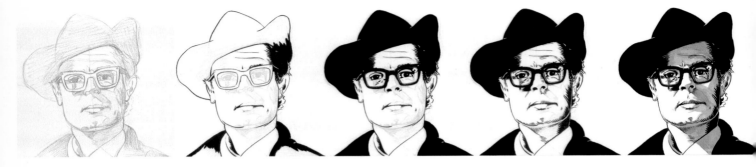

To expand my drawing technique and try out new and different materials, I also use photos to draw portraits of artists and authors who inspire me with their explorations of candid self-expression. I especially admire artists who are prolific and have a drive to create art that is personal. Drawing carefully observed portraits like these helps inform the more expressive drawings I do from life. Just as practicing with the four basic geometric solids can help you clarify objects in complicated scenes, using photos to practice drawing faces is helpful when drawing a quickly observed or moving person on location.

TOP *Marcello Mastroianni*

This portrait began with a careful drawing in blue pencil. The blue pencil is difficult to erase but can be easily deleted from a scan. After outlining the contours with a Uni-ball pen, I filled in the larger solid blacks with a Pentel pocket brush pen. I then completed the finer details with a Uni-ball micro (0.5) point pen before brushing on a final layer of diluted India ink wash.

ABOVE, RIGHT *Marc Maron*

I admire Marc's goal to be more open and candid on stage. Although he is a comedian, his intent is to be vulnerable and compelling. "Be sincere. The funny will come."

OPPOSITE, TOP LEFT *David Byrne*

David Byrne was a painting major when he started making music to entertain his friends. His song lyrics express his unique vision, and on stage his eccentric mannerisms make him fascinating to watch. Like me, he's also an avid bicycler.

OPPOSITE, TOP RIGHT *Jeff Bridges*

Take a look at Jeff Bridges's website and you'll see the issues, charities, and causes that he is passionate about. Besides, he's a super nice guy and a great actor.

OPPOSITE, BOTTOM LEFT *Robert Crumb*

R. Crumb is the legendary father of underground comics. He is known for his incredible hatching technique, as well as his bravery for exposing his most awkward thoughts and fantasies.

OPPOSITE, BOTTOM RIGHT *Montaigne*

Considered the first and foremost chronicler of introspection. Montaigne obsessively wrote down every thought he had on any subject. "I am loathe even to have thoughts which I cannot publish," he admitted.

DEMONSTRATION:
SEATED CUSTOMER

My neighborhood coffee shop is the perfect place to capture live models. Let me show you, step by step, how I approach drawing a customer who is sitting nearby.

Step 1: Quick pencil layout

A pencil drawing will take too long, robbing my sketch of its immediate, "live" character. I used the pencil with a very light touch to indicate the general placement of main objects. My pencil skimmed the paper to create a gesture sketch that is barely visible. (For the purposes of this demo, I increased the contrast to help you see the pencil lines.)

Step 2: Contours

As always, I began inking my contours in the foreground. I don't treat the figure differently than anything else in the scene. Notice how the carefully observed folds and wrinkles define his shirt and hat. My focus was on the man, so I only suggested what's behind him with a few distant contours.

Step 3: Ink wash

With my #8 round brush, I loosely applied a light wash everywhere that was not white. I wasn't concerned about staying in the lines; my focus was more on applying one even layer of tone.

For my second layer, I squinted at the scene to find the dark areas. Then I applied another layer of the same ink wash to increase the shadows, staying within the bounds of the first wash.

The subject of my drawing

My quick pencil layout

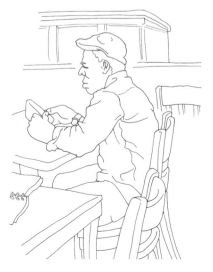

I inked only the contours, starting in the foreground.

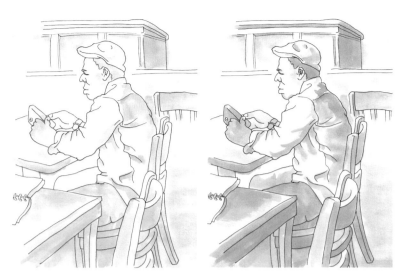

My first, second, and third ink washes

For the third and final wash, I used a smaller #4 brush and my jar of darker ink wash to deepen the darkest areas of his hair, the phone, his watchband, and parts of the tables and chairs.

At this stage, it would have been okay if the man had moved or left. I can retrace the main contour edges based solely on what I want to emphasize in the drawing. Black areas of high contrast will appear closer, so I gave the table and chairs nice fat contours, but added nothing to the more distant features so they would stay back.

Step 4: Final details

Now comes my reward. I switched to my 0.5 (micro) pen and "sculpted" the forms with hatching. I applied the lines for three purposes: to create a fourth, darker tone, as in the man's hair and the chair backs; to create volume, as on his leg and back; and to add surface details, such as the wood grain and clothing folds.

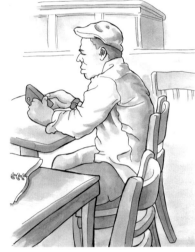

I retraced some of the contour edges to give them emphasis and make them appear closer

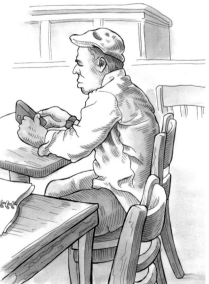

Seated Customer

With final hatch lines applied

TRAVEL JOURNALING: WHO NEEDS ANOTHER GIFT SHOP T-SHIRT?

"Own only what you can carry with you: know languages, know countries, know people. Let your memory be your travel bag."

—ALEKSANDR SOLZHENITSYN

When I travel, I'm not interested in the staged tourist experiences or whitewashed, prepackaged presentations designed to show the country in only the best light. My goal is to learn about the culture I'm visiting. Where do the locals eat? How do they spend their leisure time? What would it be like to live here?

It can be tempting to head out looking for the "perfect" scene or picturesque location, only to return home from a long quest empty-handed. Committing to draw whatever is in front of you can push you to try something new and will be a more accurate record of your journey. Once in the habit of drawing on location, you begin to take more interest in the details of your surroundings and places you visit. With an eye toward your next drawing, you won't be able to walk through a neighborhood or view an urban landscape without considering how you might record it.

OPPOSITE *Karaoke Street*

Wandering aimlessly through the streets of Jingdezhen, China, I came upon this colorful row of karaoke bars, though I didn't know what they were until I showed the drawing to my students.

When I returned from my year in Asia, I had no drawings of the Great Wall, the terra-cotta soldiers, or Tiananmen Square. Glimpsing a new country through the window of a tour bus or walking with a cluster of Americans wearing baseball caps and Nikes cannot compare with joining a table of non-English speakers to learn the card game Dou Dizhu (Fight the Landlord), or staying up all night singing karaoke with my students, or having a long, slow dinner with a local family.

TOP, LEFT *Alley*

While I lived in China, there were more unique scenes within walking distance of my dorm than I could draw in a year, though I drew every day. While inking this drawing, I realized—too late—that the stairs would not end where they should. That's quite a drop from the lowest step! That's the way it goes sometimes.

TOP, RIGHT *Chinese Water Closet*

This was one of the first drawings I did after arriving in China. For a Westerner on my first visit to the East, Asian-style bathrooms were a surprise. In the shower you have to watch your footing so you don't step in the hole and twist your ankle.

ABOVE, LEFT *Student's Gate*

In addition to teaching at the University, I privately tutored students preparing for English-language exams. This was the entry gate to the home of one of my students.

In my experience, Americans have large personal space bubbles and a sense of privacy that many other countries don't share. Drawing in central China, I often found myself in the center of a small crowd of people curious about what I was doing. Children would jostle one another and block my view, hoping to be included in the drawing. Adults talked at length about the drawings, pointing and laughing, even when I indicated that I didn't know what they were saying. I was rarely allowed to practice my Mandarin because the locals I met were eager to practice English. Taking the time to chat while I drew taught me a lot about Jingdezhen and the kind people who live there.

TOP *Haibo*

These giant mascots were salvaged from the 2008 World Expo in Shanghai. They guard a small gate that leads to a pond traversed by a suspension bridge to nowhere. In the distance are the ubiquitous cranes and scaffolds of construction sites.

BOTTOM *Park Bridge*

Gao Ling showed me her favorite little park and we came here often to do our schoolwork.

TOP *Institute Garden*

This little garden on campus was maintained by university students.

CENTER *West Virginia Student Work*

This drawing shows the left-behind ceramics work of exchange students from West Virginia.

BOTTOM *Student Sculptures*

I'd been warned not to discuss politics, religion, or sex, but as I drew this wall made of student ceramic discards, students gathered around, eager to discuss their feelings about all three, and to ask me about stereotypes of the United States.

In China, several students asked to join me on my sketch outings, and I was surprised by how talented they were. The ability to draw seemed taken for granted and my college students often gifted their finished sketches to me. Though they were adept at drawing on location, my students did not see it as a practical skill that would earn them much money and only came along as a way to spend time chatting with me about the West.

ABOVE, LEFT *Student Bathhouse*

In the time it took to sit and draw this scene of the student bathhouse, I learned that the deer were made by an early founder of the school and that the showers were heated by burning never-ending piles of reclaimed lumber, often still coated in paint. The smoke filled the air, drifting into open windows and onto the basketball courts.

ABOVE, RIGHT *Fruits Love Fruits*

In spite of the name, this restaurant sold no fruit. It was, however, my favorite place to get lunch. The owners came to know me and my order, politely smiling at my attempts to pronounce, "Chao shucai buyao hong lajiao" (stir-fry veggies without the spicy red peppers).

TOP *Ceramic Wall Contour*

CENTER *Ceramic Wall Grisaille*

BOTTOM *Ceramic Wall Color*

I positioned myself closer to one side of
this wall so I wouldn't be facing it head-on.
Even with all the variety and detail, facing
it square-on would have made a less
dynamic drawing with little depth. Since
objects farther away are perceived through
more air and look paler and less defined,
I left the far side of the wall low-contrast
and lighter, while darkening the tree to
bring it forward.

TOP, LEFT *Hutian Temple*

Mosquitoes had me for dinner as I drew this tiny temple hidden in the woods at Hutian, a state-preserved kiln site from 907 A.D.

TOP, RIGHT *The Master Ceramicist's Studio*

Students suggested I might like to tour and draw this building and the surrounding grounds.

LEFT *Urban Homes*

I passed these homes on my daily walk to the produce market. Revisiting this drawing reminds me how noisy the streets were, with modified car horns and blaring muzak pouring from every market. I eventually wore earplugs whenever I went out to spare my already damaged hearing.

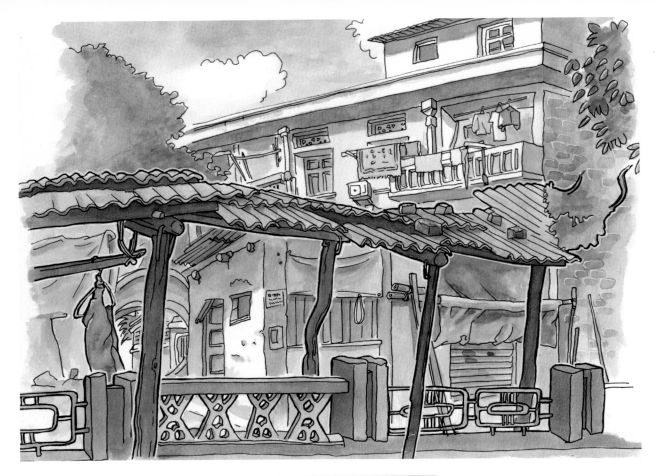

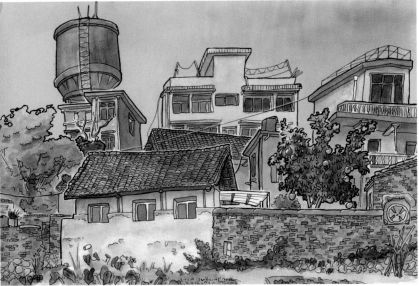

ABOVE *Neighbors*

I sketched in the shade of a public atrium as a dozen children gathered to clown and climb on the low walls, hoping to get into the drawing. When a woman hurried out to remove the row of drying laundry I was drawing, I muttered, "Oh, no." One of the young boys heard me and yelled in vain for her to leave it for my drawing. The reddish garment hanging on the left was all I captured before she carried her clothes inside.

LEFT *Riverside Houses*

As I drew these homes along the Nanhe River, a tributary of the Yangtze, an elderly woman watched me work. She spoke with enthusiasm, pointing at my drawing and then up to the houses. I apologized in Mandarin, "Duibuqi, wo bu dong." *Sorry, I don't understand.*

She continued, pointing at the building under the water tower. Finally, I understood the phrase, "Wo de jia." *My home.*

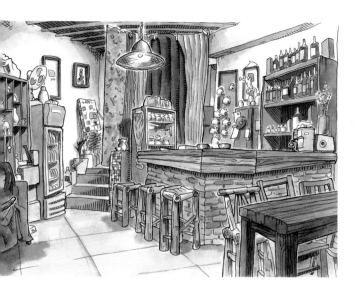

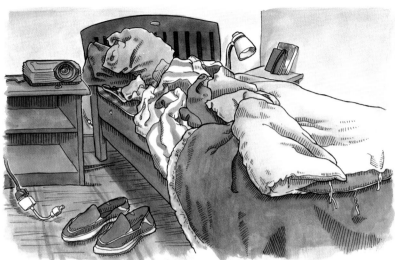

After a year away from home, I became a little depressed and lonely. My students were half my age and I missed conversing beyond surface niceties. Being single at my age was seen as very odd; one student suggested that I was either "broken or unlovable." The air quality made me leery of jogging outside and I began staying in my little room listening to music and reading. I still drew every day, but the drawings grew more introspective.

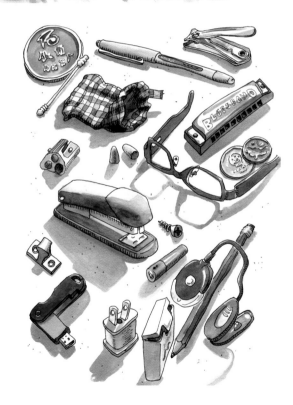

TOP, LEFT *You You Cafe Shu Bar*

This little book bar was the closest thing I could find to a Seattle-style coffee shop. I came here to grade student papers and write in my journal.

TOP, RIGHT *My Nest*

My bed, where I began to spend more time, projecting American movies on the bedroom wall as I huddled under the covers against the freezing cold and homesickness.

RIGHT *Junk Drawer Stuff*

A record of the random flotsam collected while living in China: earplugs for riding the bus, a book light for when the power would occasionally go out, lunch tokens for the school cafeteria.

By posting sketches to drawing websites, you will come to know—at least virtually—sketchers from around the world. On my way home from China, I caught a flight from Jingdezhen to Thailand. After a few days of exploring and sketching on my own, Asnee Tasna, a prolific Urban Sketcher, instructor, and all-around nice guy, helped organize an ad-hoc day of sketching the historic sites of Bangkok.

TOP, LEFT *Singapore Bay*

I rarely draw the more stereotypical tourist attractions, but the odd geometry of these famous buildings in Singapore attracted me. After I posted the drawing online, a company based in Singapore contacted me about using the image on their business cards.

ABOVE, RIGHT *Church*

The grounds of this Singapore church were closed to the public, but sometimes asking politely and showing those in charge your sketchbook will grant you special concessions. Be polite and explain that you love the location.

TOP, RIGHT *Chapel*

It was a challenge to fit this tall chapel in Singapore on a single page. Not obligated to draw it proportionately, I "squeezed" the building into a narrow composition. Although wildly inaccurate, all the details I chose to include are there.

RIGHT *Singapore Alley*

This was a stop along a sketch-crawl with the Singapore Urban Sketchers. To draw your eye into the alley, I emphasized the detail in the center of the drawing and left the bordering areas relatively simple.

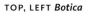

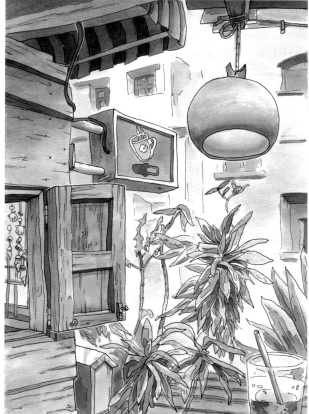

TOP, LEFT *Botica*

This drawing remains one of my favorites. I sketched it very loosely and quickly, yet it captures my impression of this little store in El Golfo, Mexico. Without giving it much thought, I tried something different with the sky. Whether or not the hatched sky would "work" didn't concern me. I just found myself hatching it, which pleasantly surprised me. It's these kind of experiments that sometimes lead to techniques that I can use again in later drawings.

ABOVE, LEFT *El Golfo Gas Station*

I drove into town and parked in the only shade I could find, under a torn tarp stretched between some four-by-fours in the sand. Across the street was a scene I might not have drawn, but it was all I could see from my place in the shade. I leaned back in my seat and looked at the chaos of shapes until I figured out how to see it as a U-shaped stack of cubes.

TOP, RIGHT *Bangkok Green Bar*

A short walk from my hotel, I found this little health food café and sat to draw and eavesdrop on some expats about their new lives in Thailand.

RIGHT *Bangkok Street*

Unable to read these signs, I treated their lettering as I would an abstract design. I'm sure anyone who can read the language would catch several mistakes and omitted letters.

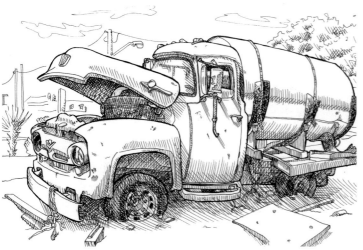

ABOVE, LEFT *Old Truck*

I saw this terrific-looking truck in the yard of a small house in El Golfo, Mexico, as I was exploring the town. The place looked deserted, so I parked beside it in the front yard. I was halfway finished drawing it when the residents came home. I wondered if they'd be disturbed to find me on their property, but after glancing at my sketch, they went into the house without a word.

ABOVE, RIGHT *Grand Mayan*

I mistakenly arrived at the Grand Mayan Hotel in Acapulco a day ahead of my reservation and had an hour to kill while they readied a room for me. Perfect! This was drawn while I waited in the open-air lobby.

LEFT *Mountaintop Lighthouse*

During spring break, this hill in El Golfo is covered in roaring dune buggies and pickup trucks. On a quiet morning I drove my quad to the top of the hill and sketched it with only the ocean breeze to listen to.

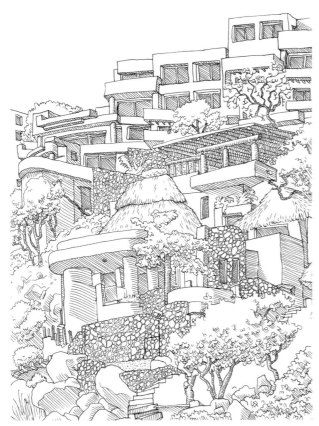

TOP, LEFT *Acapulco Hillside*

An armed guard said I couldn't draw these houses. "Propie-dad privada," he said.

"Por favor, Señor," I showed him my sketchbook. "Con su permision. Solomente una hora. Soy un artiste."

He adjusted his AR15 and looked up at the houses. He held up a finger. "Una hora," he said and sat in the shade of a nearby tree and closed his eyes.

When I finished an hour later, I called out, "Gracias!"

Without opening his eyes, he muttered, "De nada."

TOP, RIGHT *Cemetery*

I'm usually compelled to fill the entire page with dense detail, but sitting in this desert cemetery, I couldn't ignore the incongruity of the big beautiful blue sky over such a somber setting.

CENTER *Water Park*

I drew the kids' section of this pool in Aculpulco because of the clear geometry of cubes and cylinders.

BOTTOM *El Golfo Fire Station*

The emergency room of this makeshift fire station in the tiny fishing village of El Golfo is an ambulance without wheels. While I sat across the street sketching, the fire-fighters drove the larger truck to the local grocery store to pick up lunch.

CHALLENGES AND EXPERIMENTS: WHAT HAVE YOU GOT TO LOSE?

"A lot of what I do is just the mental illness of persistence."

—NICHOLSON BAKER

I can pinpoint the origins of my drawing technique in a series of serendipitous discoveries, experiments, and compromises. My emphasis on contours comes from a childhood spent watching cartoons. I first discovered hatching in a high school library book of Albrecht Dürer's etchings. Too cold and running out of time to finish hatching an outdoor drawing, I dumped ink into my drinking water and created my first ink wash drawing. Working without pencil came from a need for speed when drawing with Urban Sketchers. My choice of subject matter—the everyday objects, locations, and people who inhabit my life—comes from a desire to leave behind a personal footprint.

You have your own influential experiences and interests. Borrow tools, steal ideas, make mistakes. Then use what serves you and retire what doesn't, albeit temporarily—you never know when you might find a use for it again!

OPPOSITE *The News*
Each image in this drawing was inspired by a news story on NPR. I did the drawing as a "negative," making black dots for the stars and leaving the white of the paper for the blacks. Then I used Photoshop to reverse the drawing.

DRAWING FOR DRAWING'S SAKE

I draw every day as a record of my daily life. My sketchbooks are diaries and travel journals. They are a record of one specific life lived one drawing at a time. Whenever I've tried to make drawing my *job*, my love of drawing for drawing's sake becomes lost in the pressure to please others in order to make money. When drawing is about the end result, about fulfilling an assignment, the ability to lose myself in the joy of drawing is drowned out.

ABOVE *Twist-Warp Beast*

To help pay for college, I made cold calls to ad agencies looking for work. I illustrated ads for restaurants, lumber stores, real estate agencies, car dealerships, wine and spirit importers, and used furniture outlets. One client, Weyerhouser, asked for a drawing to convey that they had solved a "twist-warp" problem they'd been having with bowing plywood. This drawing also captures my frustration with drawing other people's ideas.

TOP, RIGHT *Mental Block*

I found commercial drawing unsettling. Trying to motivate people to buy things robbed drawing of the pleasure of drawing for its own sake. Yes, beautiful creative work is made by commercial artists, but it just wasn't for me. After a few months in advertising, drawing became the chore I needed a break *from*, not the escape I had previously turned *toward*. Drawing had become a product, not an activity; a noun, not a verb.

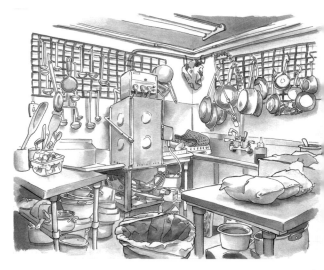

ABOVE *Catering Kitchen*

Turning any hobby into a job can have unintended consequences. To pursue her love of cooking, my friend opened a catering business. With a dedicated staff, commercial space, and regular clientele, she said the "business of running a business" was so time consuming, she had no time left for cooking!

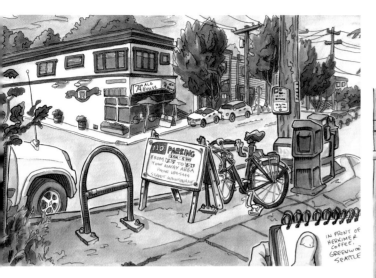

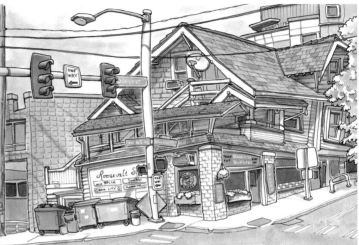

If you find yourself too concerned with pleasing others with your drawing, you might find yourself mystified at best, creatively handcuffed at worst. Which drawings will appeal to others is unpredictable. My favorite drawings get no love from others, while I sell multiple prints of drawings I consider forgettable. Students apologize for their drawings even as I enthuse over them. I know that I enjoy some of my own drawings because of the context or the events that happened around me as I drew. Perhaps I tried something different, or something about the drawing makes me laugh. Knowing this can free you up to take chances, play around, surprise yourself.

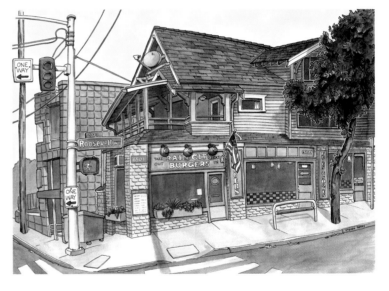

ABOVE, LEFT *Phinney Ridge*

The perspective in this drawing is wildly inaccurate. The street goes behind the utility pole and emerges lower on the right side. The bicycle is a mess. Nevertheless, I've sold several prints of this drawing—just another example of why judging our own drawings can be unproductive.

ABOVE *Rain City Burgers*

When I showed my first drawing of Rain City Burgers (top) to the owner, he commissioned me to do another drawing, larger and in color so he could frame it and hang it inside the restaurant. "One thing, though," he asked. "Can you draw it so it doesn't look like the whole building is falling apart?" The commissioned version (bottom) is understandably less wonky and chaotic—not how I experienced the building when I observed it for myself.

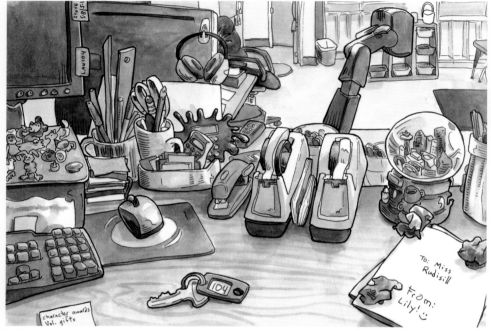

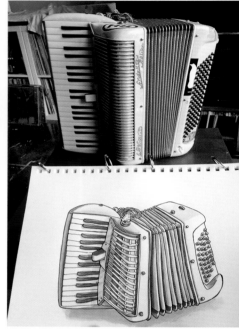

When I became a teacher, drawing resumed being a personal exploration: a journey and not a destination. At first, my daily drawings filled sketchbooks without an audience. Many years later, I discovered online sketching groups and found I wasn't alone in my obsession. Thanks to the internet, sketching can be shared by everyone—not only professional illustrators, but hobbyists, students, retirees. Most cities around the world have Urban Sketchers and other organized sketching clubs, which meet regularly to draw from life and share tips and techniques. Look online for one near you. These groups offer an opportunity to meet likeminded, encouraging sketchers, and to explore parts of your city you might never otherwise visit. Even professional architects and designers, who draw all week to fulfill job requirements, join beginning artists on weekend "sketch-crawls" to draw for more personal reasons.

ABOVE, LEFT *Rudisill's Desk*

I've given up my own classroom, but I miss the kids and still love teaching. I drew a friend's desk while I subbed for her class.

ABOVE, RIGHT *Anjl's Accordian*

I took many liberties with this accordion: I drew fewer keys and buttons than I saw, and I made the body chubbier and the rivets and folds more prominent. The drawing was based on observation, but counting the buttons and keys, measuring to find the center line—that's the sort of "left-brain" activity I find less fun than simply keeping the pen moving. By interpreting the instrument in a way that is fun for me, I've transformed my friend's accordion into *my* accordion.

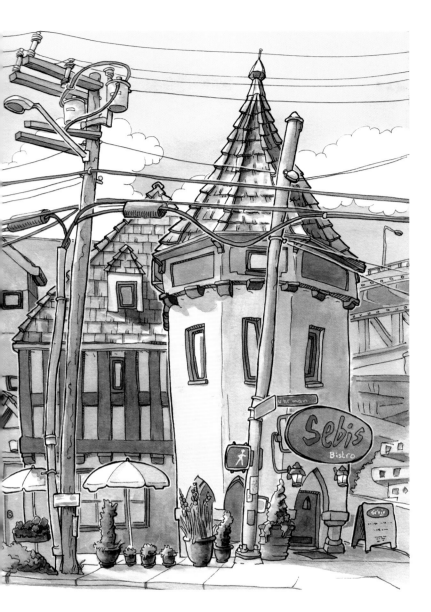

again! As for the unsatisfying marks in the finished piece? It was drawn by a human, and the human-like marks you made are like wormholes in fine leather, proof of its authenticity.

I choose a subject for various reasons: Is it visually interesting? Is there a clear foreground, middle ground, and background? Is it something I can commit to staring at for two or more hours? Is there a comfortable place to sit, out of the sun and away from distractions? What will I have to listen to while I draw?

Unless you invite them to, no one will conduct a side-by-side critique of how faithfully your drawing depicts reality. If it serves your composition, move things around. Would that painting look better on the other wall? Then draw it there! Is that car in your way? Don't draw it. Would that blue bowl look better green? Voilà, it's green.

As I draw, I hear myself saying things like: "Oh, what is that thing I hadn't noticed before?," "Now I see how that object is constructed," "So that's what this doohickey is for," "I see now those parts are connected this way," and so on. If, after finishing a drawing, you see how you would do things differently were you to draw the scene again, congratulations! Your powers of observation are improving. Draw the scene

Sebi's

When a foreground line conforms too perfectly with lines behind it, it creates "tangents": overlapping contours that obscure or conjoin separate objects. This scene had too many parallel vertical lines. The utility pole lined up exactly with the slats behind it and the metal pole blocked the central window on the turret. I prefer to shove things around to create clearer distinctions.

Another deliberate distortion is in the way I drew the top of the telephone pole. Had I insisted on accuracy, the fun, complicated bits of wire and streetlamp would have been much higher and out of the drawing altogether. So I shortened the pole and filled the top left corner of the drawing with a nice cluster of detail.

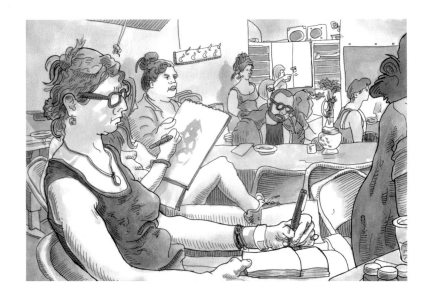

Sketching is communicating. It's your half of a dialogue with the eventual viewers of your drawing. It's also an exchange between you and the subject of your drawing. Conduct an interview with your surroundings. Ask the silverware drawer, "How are you organized?" and record the answer. Ask the abandoned bicycle, "How do you work?" Ask the messy alley, "How's your mood?" Then draw the answers.

There are no mistakes. The marks you make, you make intentionally. No puppet master controls your hand. Unless somebody bumps your elbow while you draw, that mark you made was the mark you meant to make. If you judge the success of your drawing solely based on how well it represents objective reality, you are negating the reason you, and

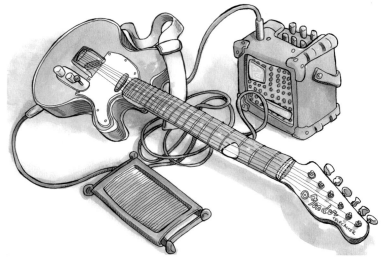

TOP *Gage Drink and Draw*

I never acquired a taste for beer or wine, but I had a beer or two at this fund-raiser for Gage Academy while drawing the other participants. At least, that's my excuse for the crazy proportions on these sketchers.

CENTER *Guitar*

My 1962 Fender Telecaster, bought as a birthday present to myself, is exactly the same age as I am.

BOTTOM *Guitar City*

My partner Donna also plays guitar. I sketched these electric guitars in the music shop while she browsed the acoustics.

not a camera, are making the drawing. If you learn to embrace the deviations from photorealism, than you'll see that what you draw is an accurate reflection of how you see the world.

For similar reasons, don't try to cultivate a style. Stylistic affectations are usually superficial and distracting. Draw what you see with the tools you're comfortable using. Even if you begin by emulating artists who inspire you, you can't help but include your own contributions. Your "style" is simply the difference between what you set out to draw, and what you drew. One of my favorite reviews called my drawings "chubby." I rarely distort my drawings on purpose. I'm trying to faithfully re-create the scene. This is how I see the world.

I encourage you to keep all your drawings, even those you consider failures. There's something to be learned from occasionally looking back at your older work, even if it's just to confirm that you are improving and growing as an artist. Looking back at an older drawing, you may also see a technique or an idea that was effective but that you had forgotten about.

LEFT *Anchored Ship*

The "chubbiness" of the wooden planks and water jug are exaggerated and simplified to make this utilitarian section of a coffee shop more playful and appealing.

TOP *Bike*

On a rainy day in Jingdezhen, I sketched this borrowed bike in the hallway of my dorm.

BOTTOM *Car Interior*

I bought a Prius and when I drove it home, I sat in the driveway long enough to capture the dashboard.

OPPOSITE TOP *Keys*

OPPOSITE, BOTTOM *8-Grain Roll*

These sketches of keys and muffins were drawn six years apart; in each case, the older sketch is on the left and the newer one on the right. The gray wash and hatching are applied with more control now, and I prefer the ink wash over the hatch lines to indicate cast shadows. But there's an energy in the earlier drawings that I don't want to lose. The paper bag in the earlier drawing reads more clearly as a paper bag than the later, more controlled rendering. And the fingernail clippers in the first version look shinier and more reflective, prompting a mental note to increase the contrast in future drawings of silver things.

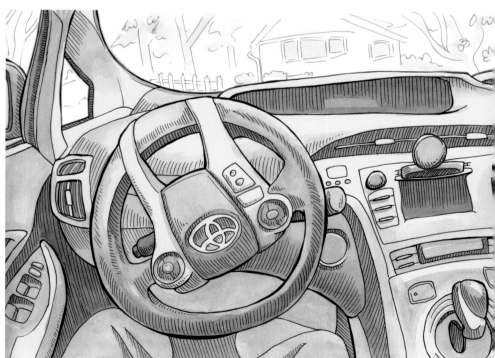

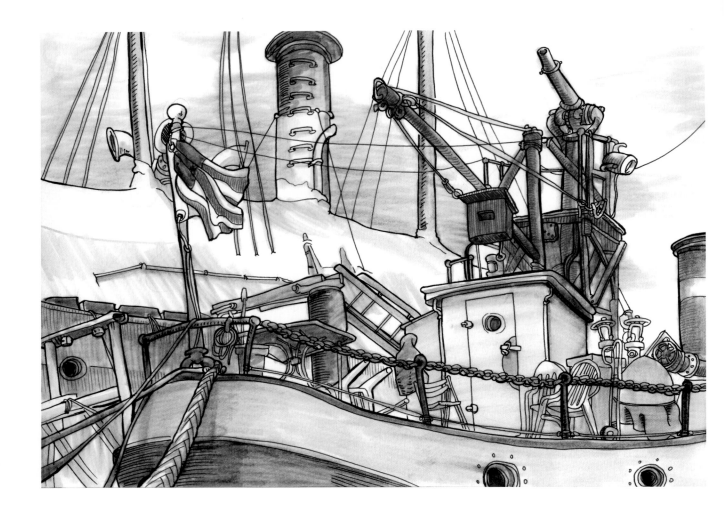

STAYING FLEXIBLE

Don't panic if you find yourself on location only to discover you've left your favorite pen at home. We all have our pet materials, but don't let forgotten supplies stop you from a productive outing. If you approach drawing as an exercise in observation, the tools you use to make your sketch become less paramount. Just as when you go to the gym or meditate, the goal is to *draw*, rather than to come away with a tangible artifact as proof of your efforts. I've borrowed pens and pencils from cashiers, drawn on the backs of outdated fliers pulled from bulletin boards, and even borrowed a pair of reading glasses from the lost and found so I could see my sketchbook.

ABOVE *Center for Wooden Boats*
The red in this drawing was hatched with a ballpoint pen.

OPPOSITE *Zeitgeist Coffee*
After riding the bus downtown, I found I'd left my Uni-ball pens at home. In my satchel I found a non-photo blue pencil and a red ballpoint pen and made do.

Urban Sketchers' 5-Day Challenge

Day 1:

ZEITGEIST

Pioneer Square, Seattle

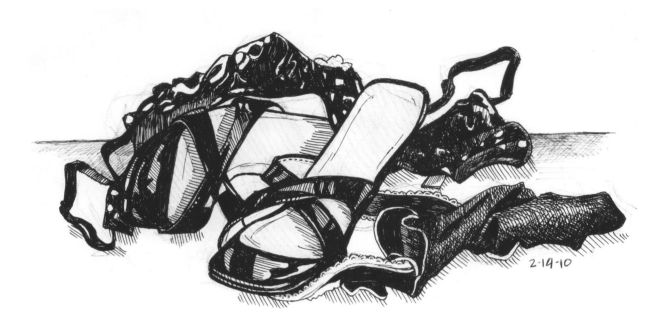

2-14-10

ABOVE *Valentine's Day*

On a date without my drawing supplies on hand, I used a generic red ballpoint pen to draw these shoes.

OPPOSITE, TOP *Grand Central Bakery*

I met with Seattle Urban Sketchers downtown to find I'd forgotten my sketchbook. I drew this in my lined writing journal instead.

OPPOSITE, BOTTOM *Art Room*

While subbing for a middle-school art teacher, I found myself with a few minutes to myself while the students were at lunch. I used a Sharpie found on the teacher's desk to capture the clutter on a nearby counter.

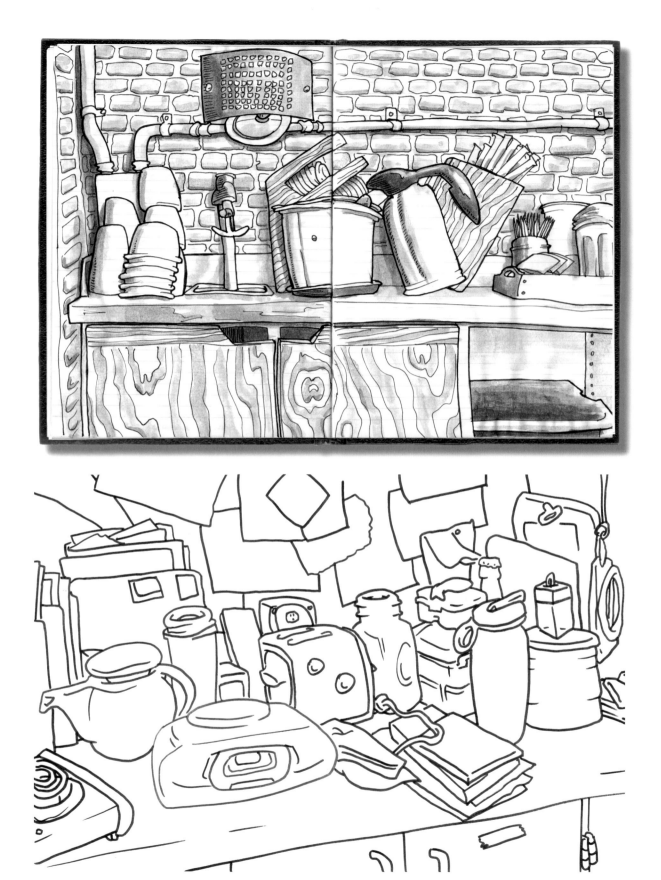

EMBRACE EXPERIMENTATION

If you find yourself unmotivated and unable to commit to drawing, create a challenge. Give yourself a narrow task to simplify things and help you focus. Decide to draw with a different tool, for example, or set a timer and speed through a drawing with no time to judge. Draw standing up or lying in bed. Sit with a friend and draw the exact same scene. Draw in the rain. Draw in an elevator or the backseat of a car on a bumpy dirt road. Draw during a movie or concert in a darkened theater, where you can barely see your paper. Draw the people at the next table in the restaurant without them catching you. Draw super big. Draw really tiny.

Often, having limited time or resources will work in your favor. Being rushed forces you to be spontaneous, uncritical, and immediate. Using different tools can lead you to discover or create techniques that may perfectly suit your needs. Even with your favorite tools at the ready, it can be fun and worthwhile to experiment. Draw with the wrong end of a paintbrush, spatter ink on the page by flicking a wet brush, try creating a grisaille with your coffee instead of ink.

ABOVE, LEFT *Charles Drives*

I'm lucky that I don't get motion sickness while bouncing around in the backseat of an SUV. This was drawn on the long drive to Joshua Tree National Park. Drawing accuracy went out the window as I did my best to capture the interior of the car.

ABOVE, RIGHT *Singapore Elevator*

Each time I left or returned to my hotel in Singapore, I sketched a tiny bit more of the elevator. After a dozen rides, I had a drawing that looks very different, I'm sure, than if I had been able to complete it all in one sitting.

For Day 2 of
the Urban Sketchers'
Five-Day Art Challenge
I'm sketching the

JAVA
BEAN

24th Ave, Ballard, Seattle.

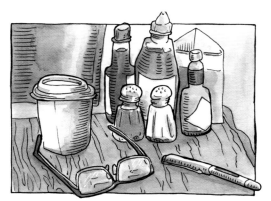

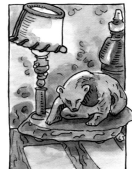

ABOVE, LEFT *Java Bean*

I was challenged by an Urban Sketcher to draw and post five complete drawings in five days. I was already drawing every day, so I increased the challenge by making each drawing a collection of views, arranged like a page in a comic.

ABOVE, RIGHT *Pagodas*

There were only two of these stone garden pagodas. I drew them in different styles just for the practice.

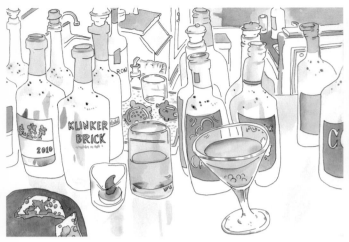

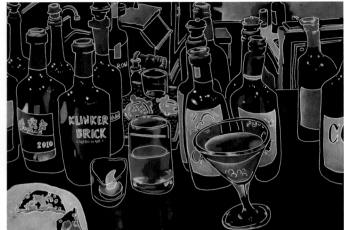

ABOVE, LEFT *Smash Wine Bar (Original)*

ABOVE, RIGHT *Smash*

This wine bar was very dark, speckled with reflections and tiny highlights. It occurred to me that I could draw the scene as a "negative," making black dots for the scarce whites and leaving the white of the paper for the blacks (shown above, left). I then scanned the drawing into Photoshop and reversed the image (above, right).

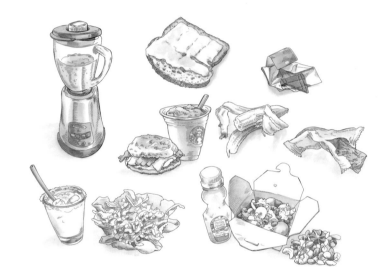

RIGHT *You Are What You Draw*

Sketches from my "You have to draw it before you eat it" diet. I thought if I had to sketch everything before I ate it, I would eat less. It lasted all of a week.

BELOW, RIGHT *My Living Room*

Don't feel like going out? Don't. Challenge yourself to sketch wherever you are right now.

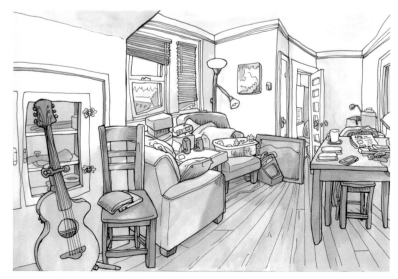

Discovery Park Run

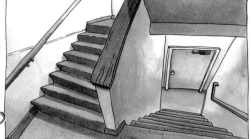

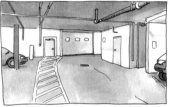

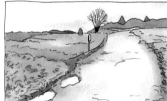

ABOVE *Park Run*

I trained for half-marathons by running through Discovery Park. One day I snapped photos along the way and drew this "comic" of my running route.

RIGHT *My Costume*

Stuck inside one rainy day in China, I drew my daily wardrobe.

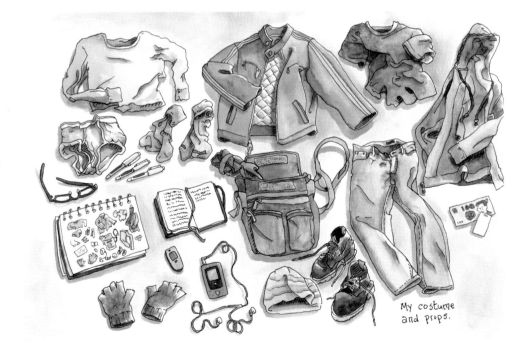

My costume and props.

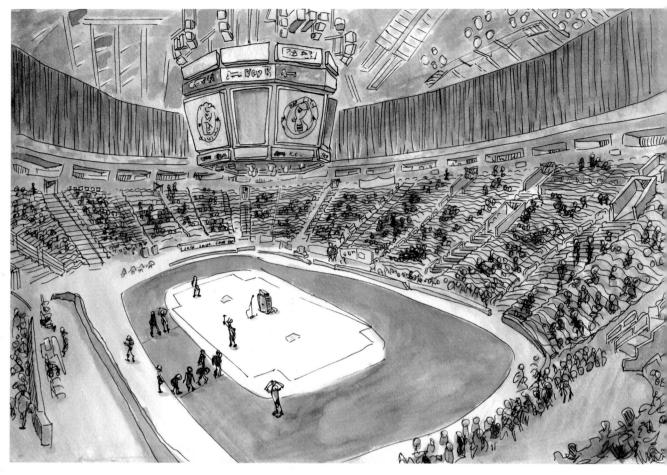

ABOVE *Roller Derby*

I'm in the habit of assessing every location as a possible drawing. In some cases I think, "How could I possibly draw all this detail, with all this distracting noise and commotion?" When the point is not the final drawing, but the challenge itself, it almost always pays off. You can be pleasantly surprised by how much you actually captured. Even if the results are not "frame-worthy," you learn tricks for simplifying, generalizing, and for conveying a lot of information with a few scribbled lines.

RIGHT *Sailboat Interior*

I was invited to sail across the Puget Sound in November. I gamely tried to ignore my chattering teeth and stiffening fingers, but after an hour or so the cold drove me below deck.

OPPOSITE *1620*

For this large (17- x 23-inch) drawing, I used Tombow and Copic markers. They are not waterproof and tend to bleed, but I like the softer effect and will continue to experiment with them.

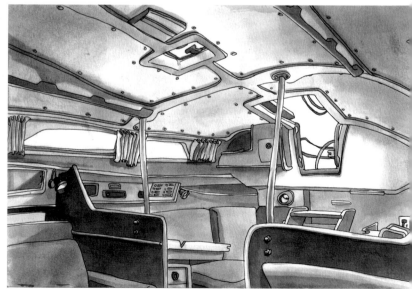

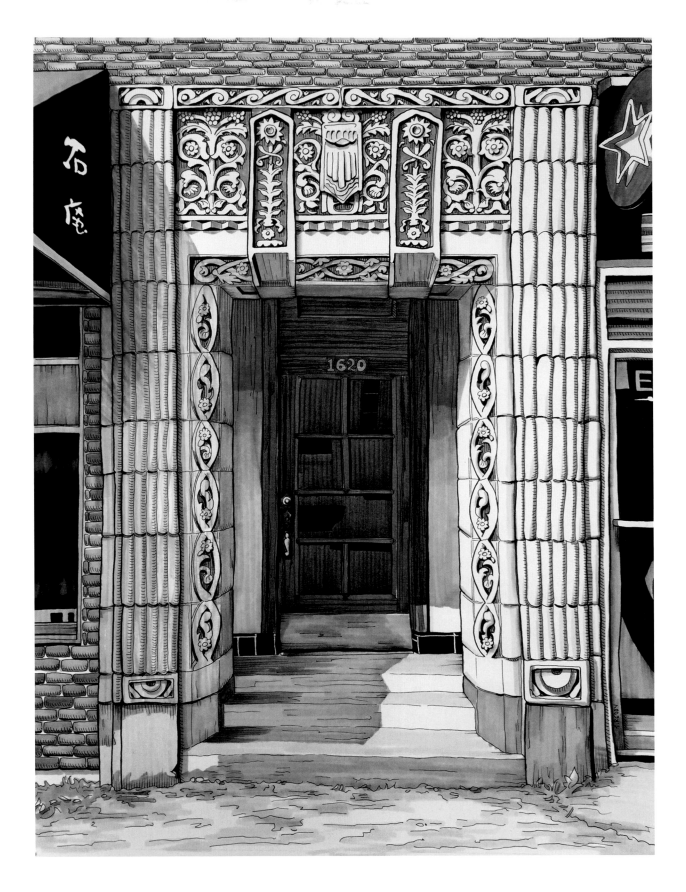

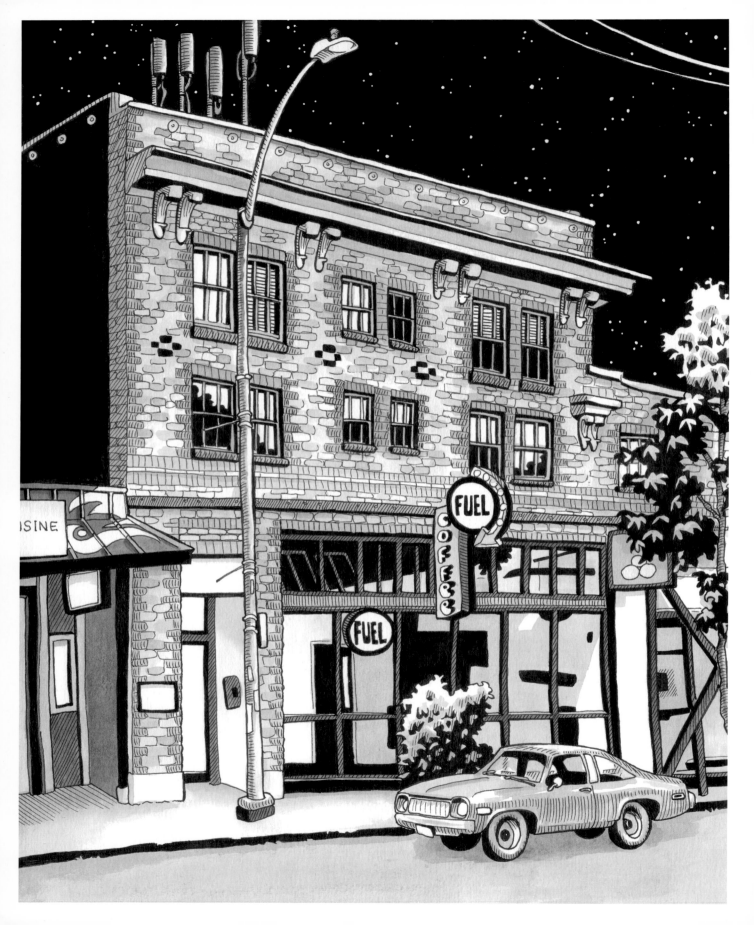

FINAL THOUGHTS

Even with the best of intentions, some drawings will go unfinished. Maybe something in the drawing isn't satisfying: there's no foreground, the composition is cramped, or the location or environment was unpleasant. Sometimes the weather turns bad, the ambient sound is too loud, or the scene changes drastically mid-sketch. But no drawing exercise is wasted.

Rather than thinking in terms of good or bad, think in terms of "effective." What can be applied to future drawings? Which parts of the drawing work? Did you do something you can use in a future drawing? Did you do something that distracts from the point of the drawing? Are you repeating yourself? Are you improving? Are you having fun?

Instead of thinking about making *good* drawings, make *many* drawings. Make your goal to fill a sketchbook and you will create many drawings that you can consider "good" if that motivates you. To reiterate a few main points:

- Draw often, make it a habit, and you can't help but discover techniques and attitudes that help your drawings express how you see the world.
- Drawing from life is better than drawing from photos, but drawing from photos is better than not drawing at all.
- Striving for accuracy and verisimilitude will improve your powers of observation, but allowing for distortions and inaccuracies may make drawing more relaxing and enjoyable, and will leave room for your own personal expression and style.

You're the boss of your drawing style, just as you control your speaking style. You can't help but express yourself in a way that is unique to you. When my son was a toddler, he was fiercely independent. If I stooped to tie his shoes, he would say, "Me do it!" Yes, his grammar was faulty, but he kept at it and now he's a lawyer (and can tie his own shoes). We learn to talk by talking. The same is true for drawing. Focus on communicating, on sharing yourself, and let the drawing take care of itself. If you get frustrated with your work, you may be comparing it with someone else's. But your goal is not to make someone else's work, just as your goal is not to speak someone else's words.

Wherever you are right now, look around. Open your sketchbook and draw it. Don't prejudge the outcome. Don't think about the final drawing. Just draw. Then do another one. And another. Each drawing informs the next. Each sketch is just one page in your very long book, not the book itself.

OPPOSITE *Fuel Coffee*

With experience—by drawing often and regularly—your favorite subjects may emerge, subjects that are meaningful to you and illustrate your unique life. This drawing includes some of my favorite subjects: bricks, clutter, detail, pattern, and it's a favorite coffee house only a few blocks from my home.

AFTERWORD

Thousands of sketchers around the world are part of a growing movement that started a mere ten years ago in our hometown of Seattle, Washington. That global community is called Urban Sketchers, and it exists both online and in cities and towns in almost every corner of the planet. Steve and I are both proud participants as sketchers and instructors.

You may ask, "What is an Urban Sketcher?" It is anyone interested in sketching the things he or she sees on location: people, places, architecture, events, and much more. We do this as a way to learn, to remember what we see, to be creative and make very personal art, and to record our experiences in a way that no quick camera snapshot ever could. Sketching is visceral, as the act of drawing connects your eyes, hand, and brain such that you really see and understand what you draw. Urban Sketchers are people who are curious about their world and passionate about recording their experiences in a sketchbook, working at all different abilities and in many different styles.

You may say, "But there is nothing interesting to draw where I live." My response is to simply look at the amazing work of the prolific Steven Reddy. For me, an architect who likes to draw buildings and spaces, the magic of Steve's work is that his sketches capture the ordinary, everyday things that you might never even notice, like his next door neighbor's house, cozy cafés and stores, or a collection of objects on a shelf. His drawings are accessible and fun and chock full of details that add character and invite you in to examine each and every form. Best of all, his sketches have th power to elevate the mundane and often overlooked elements of life to the level of Art. By looking at how Steve views his world through his sketches, he teaches us to look at our world a little differently, to really *see* what is around us every day.

You may say, "But I can't do this. I am not an artist." To that I say, yes, you can and yes, you are! Just pick up a pencil and start. Make the leap. It's not hard after looking at this inspiring book. Start small and pick a subject that is not too complicated. The more you sketch, the faster you'll get better. Steve sketches every day, and his passion shows in his work and the hundreds of sketchbooks he has filled over the years. Don't worry if you can't do what he does—no one else can! Your hand is unique. As you sketch, you will develop your own style, your own way of seeing the world through your sketches.

You may say, "But I can't be an Urban Sketcher." To that I respond, you probably are one already! You don't have to be standing in front of the Pantheon or even live in a city to be an Urban Sketcher, as there is great beauty and interest in the spaces and places wherever you are. As Steve shows us, the objects on your kitchen table or at your corner coffee shop, or even the gas meter outside your house, are all worthy of a closer look. Steve's sketches tell his story, and this beautiful book shows you how you can tell your story, too.

STEPHANIE BOWER
ARCHITECTURAL ILLUSTRATOR AND EDUCATOR

INDEX